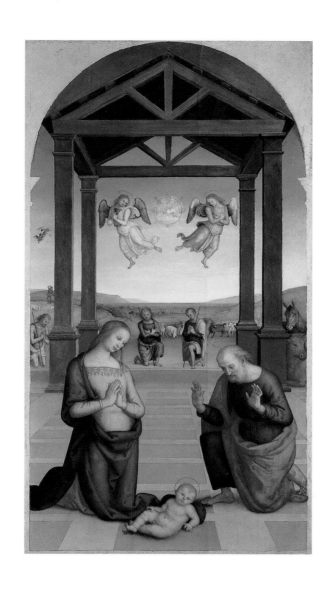

ONE HUNDRED MIRACLES

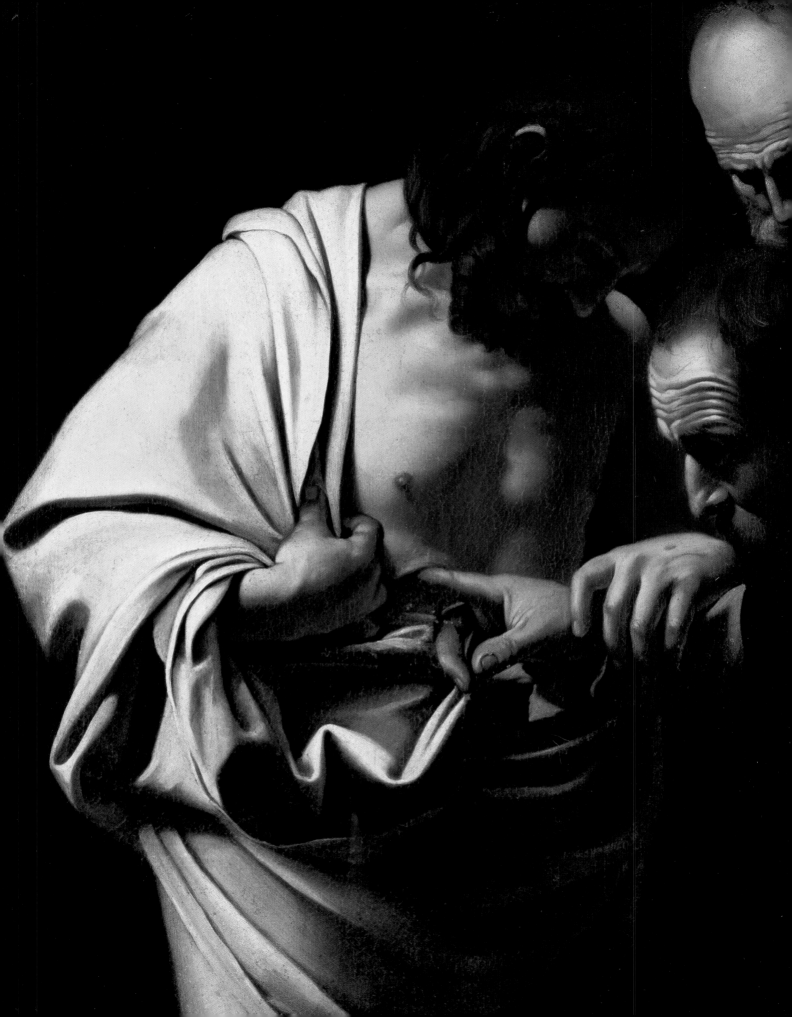

ONE HUNDRED
MIRACLES

CHRISTOPHER CALDERHEAD

welcome
BOOKS

NEW YORK & SAN FRANCISCO

Contents

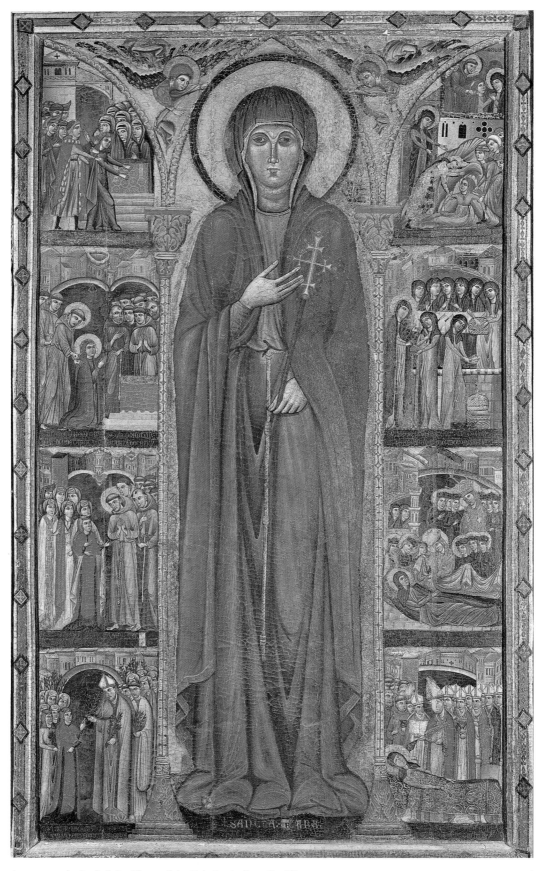

Anonymous (13th c.), *Saint Clare and the Eight Stories from Her Life.*
Tempera on a panel, Santa Chiara, Assisi.

Introduction

Christopher Calderhead

HOW STRANGE, HOW OUTLANDISH THESE stories are. They defy all logic. Such things don't happen in real life. But, of course, that's the point. These stories hold the imagination precisely because they upset the normal order of things. Bread rains down from heaven to feed a wandering band in the desert; waters well up from hard rock and gush out into the valleys below. The blind see. The lame walk. The dead are raised. Miracle tales recount unexpected divine interventions into the daily affairs of human beings.

When I ask people what they think of miracles, they usually recount a childhood sense of delight at the exploits of Jesus or the saints, which has given way in adulthood to a more skeptical vision. "Well, when I was young, I believed they were true…" and they trail off, not giving voice to what I suspect they think deep down: "Fairytales." Perhaps they don't want to be rude.

If these stories were simply accounts of actual events, then they could be proven or disproven. In the form they have come down to us, however, they are not pure history. Instead, they reflect generations of storytelling, often beginning as oral anecdotes, and only later taking literary form. Their authors weave theological reflections, ethical teachings, and their own understandings of the faith into the stories they tell. These miracle tales are as much works of the imagination as they are historical narratives.

I once asked a friend of mine, an observant Jew, what he would do if he found out that none of the events in Exodus actually happened. "I would do just what I do now," he said, "because I think it's a good way to live one's life." As early as the third century, people knew that the events described in the Bible were full of contradictions and confusing chronologies. Origen, one of the early theologians of the Church, wrestled with the inconsistencies of the four Gospels. Of course they play loosely with actual events, he explained: Their authors rearrange the "facts" in order to express spiritual truths.

So what is the appeal of these stories? Why have they engaged people's imaginations for so many centuries? Perhaps they have lasted because they speak in the language of myth; they speak in the language of dreams. Their reasoning is not logical, it is associative. The same themes and motifs recur again and again. To the religious imagination, these are not dead accounts of ages past, but living stories which become our own.

The people who composed the old spirituals knew this instinctively. When they sang, "Go down, Moses, way down in Egypt land: Tell ol' Pharaoh to let my people go," they weren't thinking about history. They were identifying completely with the children of Israel in their captivity. And they gathered strength as they remembered the story, and

knew—despite their current suffering—Pharaoh does not win in the end. The Exodus story provided them a ray of hope in an otherwise bleak world. It confirmed the injustice of their oppression. And, not incidentally, it helped embolden their descendants to challenge the powerful who held them down.

Miracle stories have provided people with patterns of hope and models of harmony. Francis taming the wolf of Gubbio holds out the possibility of human beings cooperating with the natural world, of recapturing Eden. Jesus healing the woman suffering from a hemorrhagic illness reintegrates an outcast into the community. Remigius filling the empty cask of wine celebrates the joy of hospitality.

Some of the stories in this book also reflect the shadow side of religious faith. Quite a number of miracles are purely partisan tales, designed to confirm the rightness and goodness of the Christian faith against all its rivals. Thus, Dominic burns books belonging to heretics; John the Evangelist knocks down a pagan temple through an act of prayer; and Elisha's curse summons bears from the woods to maul naughty boys who had the temerity to mock him.

These miracle tales have been central to the religious life of Christians for almost two thousand years. They shock, amuse, and edify. Some are foundational stories of the Christian faith; others are diversions, folk accretions to the Western religious tradition. All of them demonstrate the pious imagination at work.

About the Artwork
IT WAS THE ART WHICH GAVE RISE TO THIS book. I wanted to see how artists had used these stories, telling tales in paint and bronze. If the narratives are shaped by the imagination, how much more so are the artworks which give them concrete form.

It has been interesting to see which stories have attracted the attention of artists and their patrons. Certain religious figures have been immensely popular and have been painted again and again. The leaders of medieval and Renaissance Italian city-states had an almost insatiable desire for images of their patron saints and their exploits. Monastic communities commissioned many works celebrating the lives of their founders.

For artists, the challenge of depicting these stories has been enormous. Icon painters in the Orthodox tradition, eschewing naturalism, painted densely theological images, devotional in their nature and conducive to prayer. The early Italian painters often cleverly combined many aspects of a single narrative within a unified composition. They had a delightful convention when showing people being raised from the dead: As a saint extends a hand in benediction,

the figure of the resucitated is depicted twice—once lying on the ground, and again, standing and restored to life. The story gains immediacy by unfolding in a single scene. As the Renaissance took hold, painters sought to render the figure in a manner which was closer to ordinary human perception. The Baroque painters, with their emphasis on emotion and movement, understood the mythic nature of these accounts. Their theatrical compositions make no attempt at literal rendition: The stories take place in an atmosphere filled with flying angels and swirling celestial effects. The few modern artists who have tackled these tales use them freely, inventing a new and personal iconography as they go.

In the Western tradition, the High Middle Ages and the Renaissance were the height of miracle painting. With the shock of the Reformation and the Tridentine reform in the Roman Catholic Church, these stories became less popular, more tightly vetted by ecclesiastical authorities. By the nineteenth century, miracles had become a rare subject for artists.

About the Text
EACH ARTWORK IS ACCOMPANIED BY AN original summary of the story depicted. Biblical references have been given when appropriate. Although I have retold the Bible stories in my own words, I have chosen to use direct quotations whenever bib-

lical characters speak, following the New Revised Standard Version.

When a single primary source exists for a non-biblical story, that too, is indicated in a sidenote. Many of the saints' tales come from the thirteenth century collection called the *Golden Legend.* Collected by the Archbishop of Genoa, Jacopo da Voragine, this often fanciful compendium was a principle source for medieval and early Renaissance artists and their patrons.

Because these miracles are not, strictly speaking, historical, and often contain mythological elements, they don't easily submit to a neat timeline. I have, therefore, grouped stories together that take place within a particular period in history and presented them in a loosely chronoligical order.

THE BOOK CLOSES WITH THE ULTIMATE miracle of the Christian tradition—the resurrection. As the women gather at the empty tomb on the first Easter morning, they are told to go and tell the story: Christ is risen from the dead. The miracles in this book do just that, in words and images.

Miracles
of the
Old Testament
and the
Apocrypha

Lot's Wife

The story appears
in Genesis 19.

SODOM AND GOMORRAH WERE CITIES LYING ON THE plain near the Dead Sea, renowned for the utter depravity of their inhabitants. Incensed at their wickedness, God determined to destroy them. There was a man who lived in Sodom whose name was Lot. He was the nephew of Abraham, and God decided to save him from the destruction of the city.

One evening, two angels, who looked like ordinary men, arrived at the gate of the town, where Lot met them. Although they intended to spend the night in the public square, he insisted they come and stay with him as his guests. When the townspeople heard of it, a threatening crowd gathered around Lot's house, intent on raping the two strangers. Lot's pleas for his guests fell on deaf ears and the crowd surged forward to beat down the door.

Suddenly, the angels reached out and struck the crowd with blindness. The mob was thrown into confusion. The angels told Lot that they intended to destroy the city; he and his family must flee at once to the hills. Lot rushed to the homes of his future sons-in-law, men engaged to his daughters, to warn them, but they laughed, and refused to leave. So, early in the morning, as the sun was beginning to dawn, Lot, his wife, and two daughters left the city, running for their lives. The angels warned them not to look back.

As soon as they had reached a safe distance from the city, the heavens opened, pouring fire and sulfur down on Sodom and Gomorrah. Lot's wife looked back, and was transformed into a pillar of salt.

A MIRACLE IS, BY DEFINITION, SOMETHING OUT OF THE ORDINARY, a sign or wonder that results from divine intervention in the world as we know it. The first chapters of Genesis describe a world so unlike our own that it is impossible to talk of the miraculous: The whole account is fantastical. The beginning of Genesis speaks in the language of myth, only tenuously connected to historical time. It describes the creation of the world, humanity's primordial innocence and fall, the disaster of Noah and the flood, and the confusion of languages at the Tower of Babel. In a world where people build towers that can literally reach the heavens, how is one to parse out anything so mundane as a miracle?

Raphael was commissioned by Pope Leo X to decorate the loggias—covered colonnades—of the Vatican Palace with frescoes. The work was carried out between 1518 and 1519 by the painter and his assistants, and included an ambitious sequence of scenes from the Old Testament.

A stout Lot, holding his daughters' hands, looks fixedly at the ground before him. His wife, lingering behind, has turned to salt. Even her flowing, windswept robes have been frozen in place. The city burns ominously behind them.

It is only when we reach the stories of the patriarchs, Abraham, Isaac, and Jacob, that we begin—and only just begin—to recognize people existing in the kind of

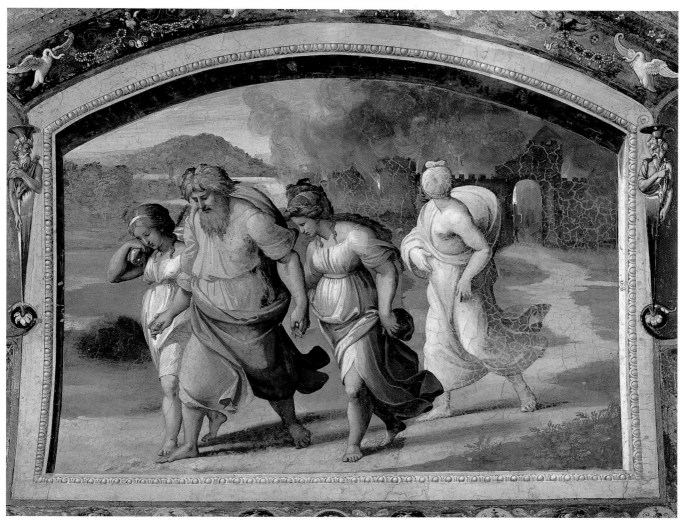

Raphael (1483–1520), *The Flight from Sodom*, 1519.
Fresco, Loggia, Vatican Palace, Rome.

ordinary time we inhabit. Mythic beginnings begin to give way to a kind of historical narrative. Extraordinary things may happen here, but they happen in a world whose logic we understand. So our first miracle is the transformation of Lot's wife.

The destruction of Sodom is an admonitory tale. The cities on the plain are symbols of vice. Genesis describes Lot as dallying and unsure; the angels have to push and hurry him out of the city. They make one thing clear: As you escape, don't look back.

In his homilies on Genesis, the early Church father Origen uses the story to illustrate how single-minded we must be when fleeing vice. Lot obeys the angels' warning and escapes to safety without a thought for what he has left behind. His wife, on the other hand, hearing the crackling flames behind her, turns around and looks. Is it fear? Or does she regret the house and home she has lost? Origen compares her to the Israelites in the Sinai desert who, having been delivered from slavery, begin to long for the comforts of their Egyptian captivity. The path to virtue is hard and plunges us into the unknown; but having embarked on it, we are warned not to look back.

Moses and the Burning Bush

The story appears
in Exodus 3.

OSES WAS TENDING HIS FATHER-IN-LAW'S SHEEP IN the wilderness of Sinai. In the distance, he saw a bush: It was on fire, but the fire did not consume it. Curious, he drew closer.

A voice called out to him from the bush: "Moses, Moses." It was the Angel of the LORD.

"Here I am," he answered.

"Take off your sandals—the place you are standing is holy ground," the voice commanded. "I am the God of your father, the God of Abraham, the God of Isaac, and the God of Jacob."

Moses was afraid, terrified to be face-to-face with God. The voice continued, "I have observed the misery of my people who are in Egypt; I have heard their cry on account of their taskmasters. I have come down to deliver them from the Egyptians, and to bring them up out of that land to a good and broad land, a land flowing with milk and honey. So come, I will send you to Pharaoh, to bring my people, the Israelites, out of the land of Egypt."

Moses hesitated. Who was he, that he could go to Pharaoh and say such a thing? God had promised to be with him. But what would he say to the Israelites? When they asked him who had sent him, what answer could he give?

God said to Moses, "I AM WHO I AM. Thus you shall say to the Israelites, I AM has sent me to you. This is my name forever."

Marc Chagall, born in Russia, explored Jewish themes throughout his career. This dreamlike canvas includes several scenes from Exodus. Their positions on the canvas guide the viewer's eyes from right to left, as though reading a Hebrew text. On the right, Moses, in white, his feet unshod, kneels before the burning bush. From his head, two small yellow beams of light emerge, an iconographic convention that dates to the Middle Ages. Sheep are scattered on the hillside behind him. The flames of the bush curl upward toward the shadowy figure of the Angel of the LORD, represented in the midst of a circle of refracted light.

On the left, Chagall's imagery becomes more surreal. The body of Moses is an aggregate of tiny human figures. At its base, a cloud separates the frustrated Egyptian army, in red, from the Children of Israel. The Hebrews, in blue above the cloud, become a representation of Mount Sinai. At its peak, the head of Moses, glowing with the same golden color as the angel's refracted halo, receives the tablets of the Law.

MOSES LED THE PEOPLE OF ISRAEL OUT OF SLAVERY IN EGYPT, through the desert and the encounter with God at Mount Sinai, and into the Promised Land. This Exodus story is one of the great foundational myths of Judaism and Christianity. Its theme of deliverance runs through all the subsequent books of the Bible.

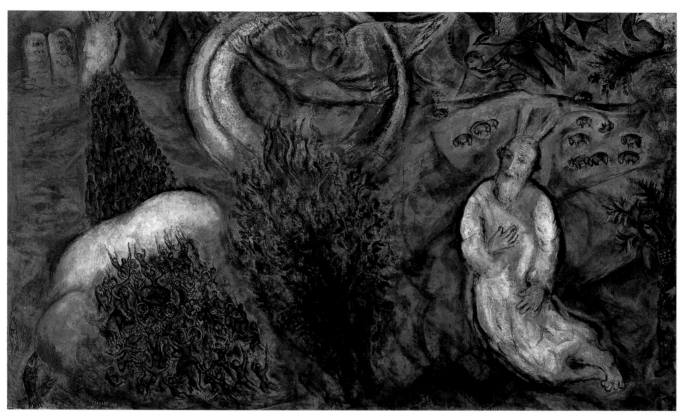

Marc Chagall (1887–1985), *Moses Before the Burning Bush*, 1966.
Oil on canvas, Musée National Message Biblique Marc Chagall, Nice.

Moses was a child of the enslaved Hebrews in Egypt. Adopted by Pharaoh's daughter, he was raised in the royal court, rising as a young man to a position of overlord to his own people. A violent incident led to his exile, where he married Zipporah and tended sheep for his father-in-law, Jethro.

At the burning bush, Moses received his call to lead the people. It was a terrifying commission. He must return to Egypt, where he was wanted for murder, and confront Pharaoh, the king, with a demand: Let the Hebrews go.

The portrait of the divine in the story is full of mystery. The miracle of a bush, burning but not consumed, is a powerful metaphor for the presence of the holy in the world. God speaks from the bush, but not directly; the voice is mediated by the Angel of the LORD. Even the divine name is a mystery. "I AM," God says, when Moses asks who he should say sent him. This name is held sacred; to this day, devout Jews will not pronounce it aloud. Moses stands before a deity who is not just a tribal god, but the very source of being itself.

Later, Christian commentators would draw a parallel between the burning bush and the Virgin Mary, who bore God's incarnate Son. She, a limited and mortal human being, carried within her the unlimited expanse of the divine. Icons of the burning bush in the Orthodox churches often show Mary and her son in the center of the flames, visually expressing this theological idea.

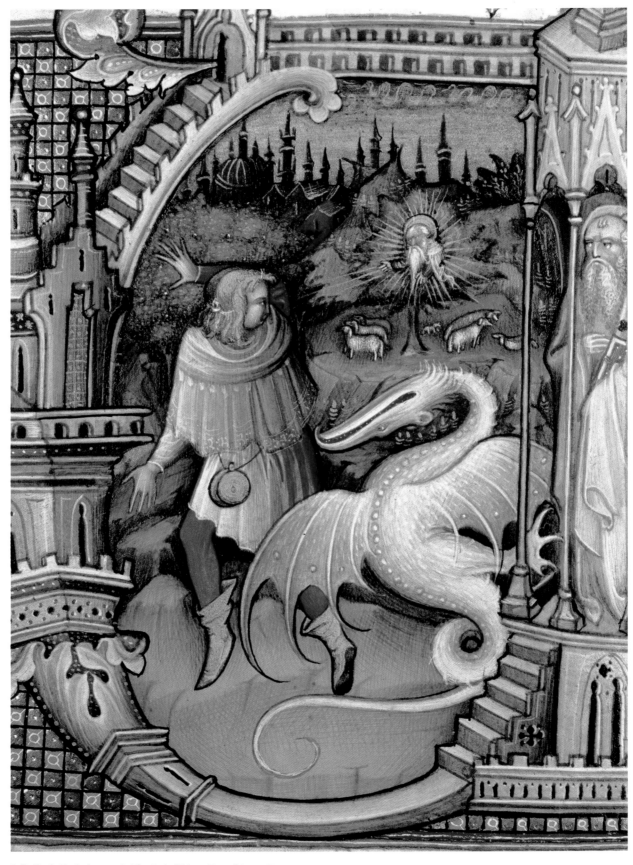

Belbello da Pavia (1430–73), *The Rod of Moses Turned into a Dragon.*
Manuscript illumination, Biblioteca Nazionale, Florence.

The Rod of Moses

OSES HESITATED BEFORE THE BURNING BUSH. HOW would he convince the people that God had sent him? What proof could he give?

The voice from the bush spoke: "What is that in your hand?"

"A staff," Moses answered.

"Throw it on the ground," the voice commanded.

He threw it down, and it became a snake. Moses jumped back in fright.

"Reach out your hand and seize it by the tail."

Moses reached down and grasped the serpent's tail: It stiffened, turning back into his familiar staff.

"Thus they will believe that the Lord, the God of their ancestors, the God of Abraham, the God of Isaac, and the God of Jacob has appeared to you."

The story appears in Exodus 4.

AT THE BURNING BUSH, MOSES IS FULL OF QUESTIONS AND DOUBTS. God gives him three magical signs to perform before Pharaoh as proof that he has sent him. The first is the transformation of his staff into a living snake. For the second sign, Moses is enabled to turn his hand leprous and then restore it to health. For the third sign, Moses is to turn Nile water into blood. Armed with these three signs, Moses is given the courage to face Pharaoh.

Still he balks, complaining, "O my Lord, I have never been eloquent … I am slow of speech and slow of tongue."

"Who gives speech to mortals?" God asks him in reply. Moses must go to Pharaoh as God commands. His brother, Aaron, however, will be there to help.

When Moses and Aaron appear before Pharaoh, the king asks them for a sign that they are God's messengers. Aaron throws down the rod, and it becomes a snake. Pharaoh's magicians throw down their rods as well, and they turn into a nest of snakes. The snake of Moses swallows them all. These signs and wonders are of little avail before the cruel tyrant— ten plagues will be visited on Egypt before he lets the Israelites go.

The reluctance of Moses is assuaged by the conjuring tricks God gives him to perform, yet they have no power to convince Pharaoh to release his slaves. Miracles in the Bible are never ends in themselves. It is neither Moses' words nor his ability to awe Pharaoh with wonderworks which releases the people from captivity. Instead, these stories end, as they begin, with the irresistible force of the divine will. Once the miracle has served its purpose, giving Moses courage to face Pharaoh, it recedes into the background, a detail within the divine drama of deliverance.

The painting is from the Visconti Hours, *a luxurious book of daily prayers and devotions produced for the princely family of Milan. As in many illuminated books, the illustration here occupies the center of a lavishly ornamental initial letter, conceived as an architectural frame, complete with stairways, parapets, and sculpted saints.*

Moses leaps back from a creature more akin to a dragon than a simple snake. In the background, a bearded God sits in the burning bush, surrounded by Moses' neglected sheep, which are blissfully unaware of the marvel in their midst.

The Crossing of the Red Sea

The story appears
in Exodus 14.

 HE ISRAELITES DEPARTED FROM EGYPT, SETTING OUT across the desert. When they came to the edge of the Red Sea, they stopped and made camp there.

When Pharaoh saw that they had gone, he had a change of heart. He mounted his chariot and led an army out to recapture his former slaves. The Israelites saw the approaching Egyptians and turned on Moses in fear. "Was it because there were no graves in Egypt that you have taken us out to die in the wilderness?" they cried out to him.

God told Moses to stretch out his staff over the waters of the sea. And the pillar of fire and cloud, in which the Angel of God dwelt, moved behind the Israelites to block Pharaoh's advance. Moses stretched out his staff, and the sea parted. A path emerged from the waves as the water rose up on either side like solid walls. And the Israelites crossed the sea, walking on dry land.

Early in the morning, before it grew light, Pharaoh's army, his chariots and horses, entered the sea in pursuit of the Israelites. God told Moses to stretch out his staff once again. The Egyptian chariots became mired in mud, and the army began to flee in panic. The waters rushed in and drowned them all.

THE TALMUD REPORTS THAT AS THE SEA SWALLOWED PHARAOH'S army, the angels began to burst into song. God, in sorrow, asked how they could sing when his own creatures were being drowned. There is pathos in the midst of victory as the unrighteous meet their end.

In his *Life of Moses*, the fourth-century theologian Gregory of Nyssa interprets the story allegorically. Gregory uses the story of Moses as a pattern for the soul seeking perfection. The aim of life, Gregory argues, is to grow ever closer to God: to become, as he puts it, "God's friend."

The remnants of the Egyptian army disappear into the sea in this painting by Bernardino Luini. The Lombard painter's composition contrasts the chaotic muddle of horsemen and chariots with the gentle waves lapping harmlessly along the shore. The Egyptians meet their end only a few feet from the safety of land.

At each stage of development, the diligent seeker of the divine passes through dangers, gradually growing in virtue. When Gregory comes to consider the crossing of the Red Sea, he equates it with the moment of baptism. Just as the Israelites leave Egypt behind by passing through the sea, so the believer enters a new life through the baptismal water. Gregory sees this as a decisive moment, at which the believer turns his back on his old way of life and embraces the new.

For Gregory, the Egyptians represent the undisciplined intellect and destructive desires. Their horses, pulling the chariots forward, are the unbridled passions that drag the unwise to their destruction. In the waters of baptism, the tyrant that once enslaved the believer is drowned. The soul is free to journey onward, unencumbered with vices and sinful longings.

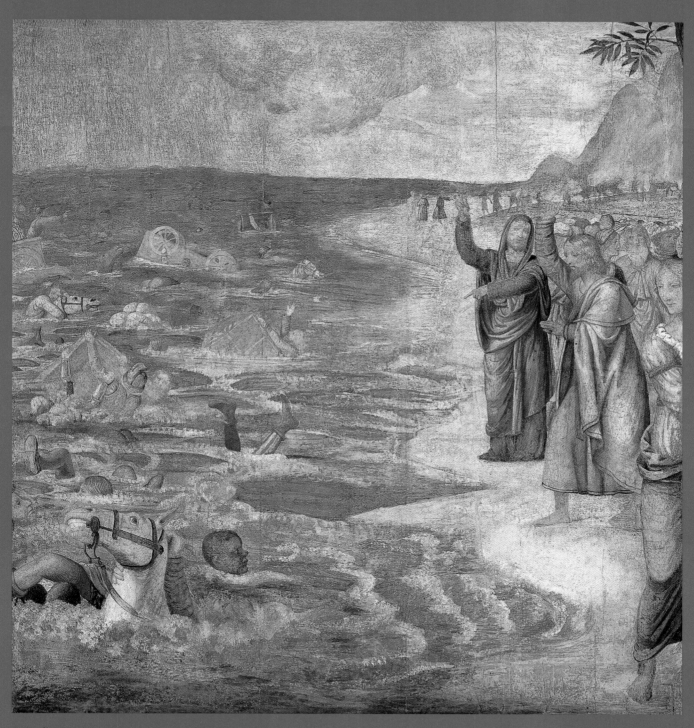

Bernardino Luini (c. 1475–1532), *Crossing of the Red Sea*, c. 1520–23.
Fresco transferred to canvas, Pinacoteca di Brera, Milan.

[OVERLEAF]
Andrea Previtali (1480–1528), *Crossing of the Red Sea*.
Accademia, Venice.

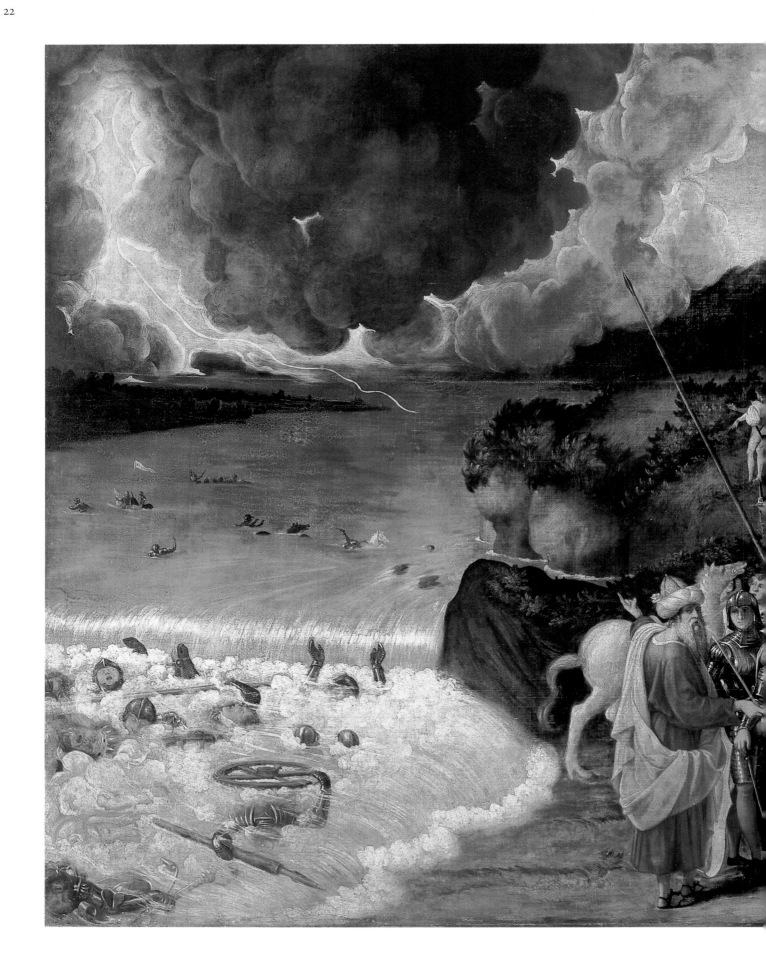

The Manna in the Wilderness

The story appears
in Exodus 16.

 HE CHILDREN OF ISRAEL LEFT THE RED SEA AND
began their journey through the wilderness, a pilgrimage which
would last forty long years. Soon, the supplies of food they had
brought from Egypt ran out, and they grew hungry. They began
to murmur in discontent.

God heard their murmuring, and said to Moses, "I am going to rain down bread
from heaven for you." And he told him to gather the Israelites and instruct them to
go out every morning and gather just enough bread for one day, and no more. On
the eve of each Sabbath, the day of rest, they should collect a double portion, which
they could keep for the following day.

Early the next morning, there was a fine layer of dew around the camp. When it
lifted, a thin substance lay on the ground—flaky, white and delicate. It tasted of
honey. The Israelites looked at it and asked, "What is it?"

"It is the bread the LORD has given you to eat," Moses answered.

So they went out and gathered their daily bread. Some of them collected more than they needed and kept it overnight, but the next day, it was foul and full of worms. This angered Moses, who reminded them not to hoard the bread, but to trust in the daily supply.

On the eve of the Sabbath, they gathered double portions, and on this day, the bread kept overnight was fresh and good to eat the next day. Some, foolishly, went out to gather on the Sabbath, but they found nothing. Again, Moses was angry, and reproved those who were disobedient.

They called this bread "manna," and for forty years in the wilderness, it was their daily food.

The Mirror of Human Salvation, a popular devotional picture book of the late Middle Ages, places this image of the gathering of the manna next to an image of Jesus' Last Supper.

Medieval commentary and preaching were deeply concerned with finding echoes between Biblical stories. Drawing both mystical and moral lessons from these juxtapositions, they looked for recurring themes in the scriptures. The manna and the bread of the Last Supper stand side by side, bread from heaven, given to sustain the faithful.

THE THEME OF TRUST RUNS THROUGHOUT THE BOOK OF EXODUS.
The Israelites learn slowly and with difficulty to follow God as they wander in the
wilderness. God feeds the people on their journey; they receive just as much as they
need—no more, no less. Those who try to take matters into their own hands, hoarding
the manna overnight, are sorely disappointed to find their greed frustrated. Instead,
they must trust in God to provide for them day by day. The seventh day rest of
the Sabbath may not be interrupted by the gathering of food; on the sixth day, God
delivers a double portion.

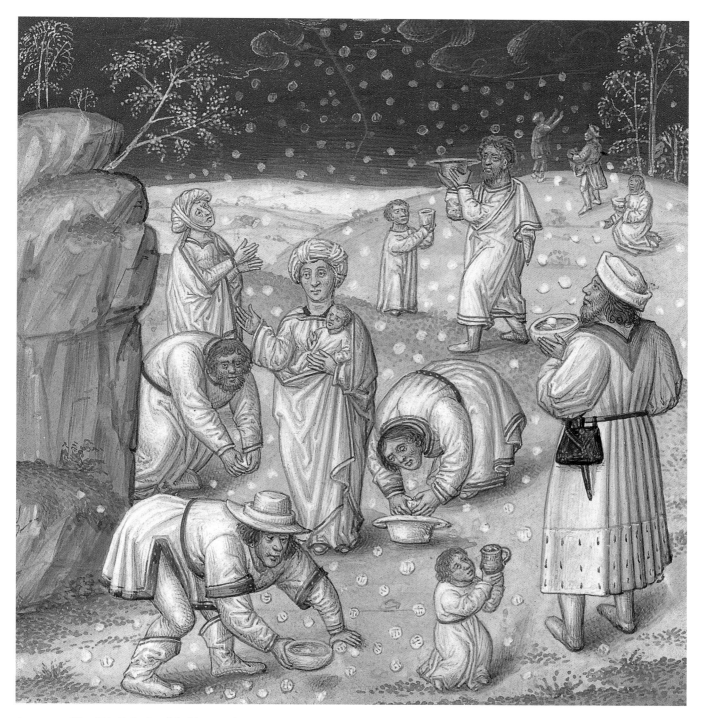

Anonymous (Flemish), *Gathering of the Manna*, 15th c.
Manuscript illumination, Musée Condé, Chantilly.

Christian commentators see the manna as an Old Testament prefiguration of the bread of the Eucharist. Jesus took bread at his last supper and gave it to his disciples with the words, "Take, eat, this is my body, which is given for you." And ever since, Christians have gathered for the ritual meal, a remembrance of Christ's death and resurrection. The daily bread of the Eucharist, identified with Christ who came down from heaven, is foreshadowed by the daily portion of manna which sustained the Israelites in the wilderness. It sustains Christians on their own journey through life.

Charles Le Brun (1619–90)
Moses Striking Water from the Rock.
Oil on canvas, Louvre, Paris.

Moses Strikes the Rock

The story appears
in Exodus 17.

HE ISRAELITES MOVED DEEPER INTO THE WILDERNESS, advancing by stages on their journey. When they arrived at Rephidim they encamped, but there was no water there. Tired and thirsty, they complained to Moses.

Moses asked them, "Why do you quarrel with me? Why do you test the LORD?" And he turned to God and said, "What shall I do with this people? They are ready to stone me."

God sent him on ahead, accompanied by a group of elders. "I will be standing there in front of you on the rock," God said. "Strike the rock, and water will come out of it, so that the people may drink." Moses took his rod and did as God commanded. As he hit the stone, water gushed out, pouring into the valley. The people's thirst was quenched. Moses named the place "Massah," meaning "test," and "Meribah," meaning "quarrel."

AN AIR OF MENACE BROODS OVER THIS STORY. THE PEOPLE CONTINUE to grow restive in the desert. The manna has delivered them from hunger, but now they are thirsty. Soon there is a spirit of rebellion in the camp. Moses does not know what to do.

God provides the water they crave, but it comes at a price. The names "Meribah" and "Massah" stand as indictments of the people's lack of trust. Although their thirst has been quenched, the miraculous spring stands as a witness to their infidelity.

Le Brun uses all his skill to communicate the feeling of thirst and desperation in this dramatic composition. The miracle is pushed into the background; Moses stands in the shadow of a huge rocky outcropping. In the gloom, the parched Israelites grope for water. The brightly lit figures in the foreground express various states of relief. The mother on the right has set to breast-feeding her child, even as she gives an old man a drink. Contrasts of light and shadow express the emotional shift from desperation to relief.

Later writers read the story in a more positive light. They would frequently evoke the image of waters flowing in the desert as a sign of God's unfailing provision. In John's Gospel, water is a central image for the outpouring of God's Spirit. Jesus goes to the Temple during a festival commemorating this miracle and shouts, "Let anyone who is thirsty come to me, and let the one who believes in me drink." On the cross, his words "I thirst" come as a shock; the source of life-giving water is exhausted, poured out over parched humanity.

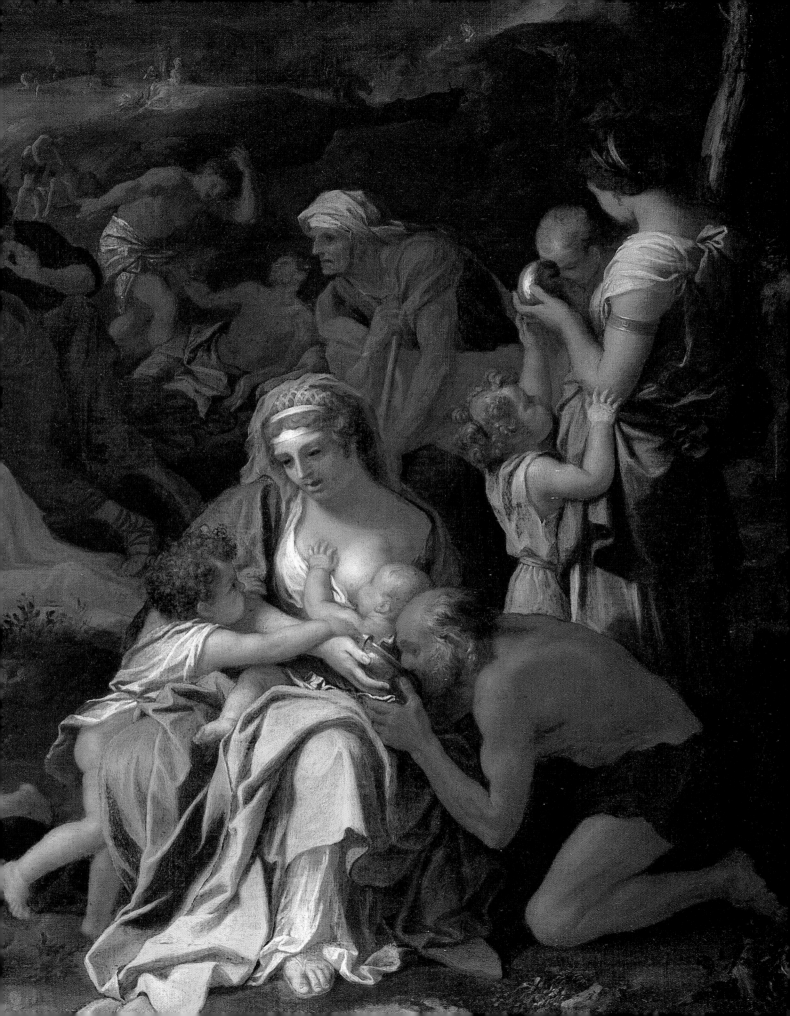

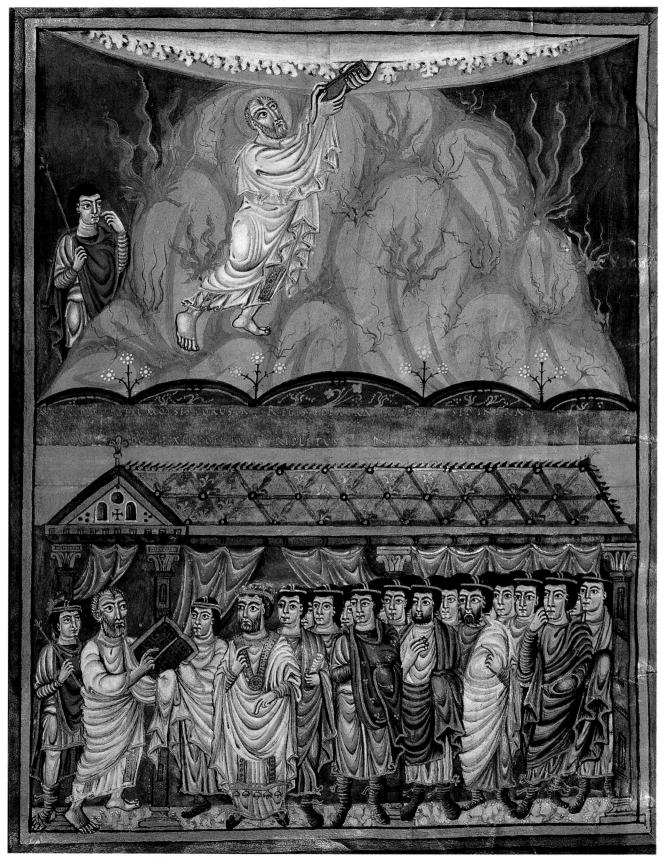

Anonymous, *Moses Receiving the Tablets of the Law on Mount Sinai*, 9th c.
Manuscript illumination, Bibliotheque Nationale, Paris.

Moses Receives the Tablets of the Law

AT LAST THE ISRAELITES ARRIVED AT THE HOLY mountain of Sinai, where Moses had seen the burning bush. The glory of the LORD descended on the mountain, which was wreathed in thick clouds. Moses was commanded to climb Sinai to receive the Law from God. The people were told to remain in the valley below.

Moses ascended the mountain and, as he entered into the cloud, God spoke to him. The LORD gave him the Ten Commandments, written by God himself on tablets of stone. Moses remained on Sinai for forty days.

The people, restless in Moses' absence, made an idol for themselves: a golden calf. They proclaimed a festival, and set to singing and feasting in the presence of their statue. God's anger was roused, and he sent Moses to take control of the Israelites.

As Moses descended the mountain, he heard the sound of revelry from the camp. He came upon them as they danced before the golden calf. In fury, he flung the tablets of God to the ground, smashing them into pieces.

The people were ashamed and frightened, and Moses punished them. He burned the statue and ground it to dust. Then he went back up the mountain, taking with him two tablets he had carved himself. On these, he rewrote the words of God.

Moses brought the second set of tablets down from the mountain, and enclosed them in the Ark of the Covenant, which was placed in the Tabernacle in the camp.

The story appears in Exodus 19–34, interspersed with legal and cultic regulations.

GLORY, TERROR, AND TRAGEDY ARE INTERTWINED IN THIS FOUNDATIONAL myth of ancient Israel. The encounter between God and Israel at Sinai results in a covenant that joins God and his people in everlasting accord. But at this crucial moment, the people fail. Before Moses has even returned with the tablets, the Israelites have already broken the first and second commandments. They turn away from the LORD and make for themselves an idol to worship instead.

The Exodus story presents God as a mighty, terrifying force. To approach the divine unprepared is to court death. The distance between God and ordinary humanity is vast, and Moses acts as an intermediary between those two worlds. The first set of tablets, given directly by God and miraculously imprinted with God's own writing, are destroyed in Moses' moment of rage. The second set, a copy of the first, contains the words of God, but are written by a human hand.

The ninth-century Carolingian Renaissance produced a number of important manuscript Bibles. Monasteries under court patronage became centers of textual criticism, weeding out scribal errors which had crept in over centuries of hand copying. Large master Bibles were produced to disseminate the corrected text. Their illuminations, influenced by Late Antique examples, took on a lively, painterly quality. In the upper register of this painting from the Bible of Charles the Bald, *Moses receives the law from God, veiled in the heavenly arc above. Below, he explains the law to the gathered Israelites.*

The people are unprepared to meet God in the wilderness. Tragically, because of their unfaithfulness, they do not receive the Law directly, but only a facsimile of it. The divine will never be apprehended directly.

Balaam's Donkey

The story appears
in Numbers 22.

BALAK, THE KING OF MOAB, WAS FEARFUL OF THE Israelites passing through his kingdom. He sent a request to Balaam, a diviner and priest, to come and pronounce a curse on the advancing Israelites, but was refused. Balak was adamant, and sent a second entreaty. Finally, Balaam agreed to see the king, and he set off on his donkey to meet Balak. But God was angry with Balaam, and he sent his angel to block the priest's way. When the donkey caught sight of the sword-wielding angel standing in their path, he quickly turned away. Balaam, who could not see the angel, struck the donkey, forcing him to return to the road. As the pair reached a narrow stretch of the pathway, the angel blocked their way again. The donkey cowered in fear, scraping Balaam's foot against the adjacent wall. Balaam became so enraged he beat the donkey, forcing him to go forward. With nowhere left to turn, the donkey stopped and lay down in the road. Balaam, consumed with fury, hit the animal again.

Nuremberg was an important early center of printing in Germany. The Nuremberg Bible, *lavishly illustrated with woodcuts, is one of the finest examples of this flourishing art. The woodcuts were hand-tinted, and colorful initials were painted in by expert rubricators. The result was a book that could be produced in large numbers and yet stand up visually against even the finest manuscript Bibles.*

The donkey turned to his master and said pleadingly, "What have I done to you, that you have struck me these three times?"

Balaam shouted back, "Because you have made a fool of me! I wish I had a sword in my hand! I would kill you right now!"

The donkey replied, "Am I not your donkey, which you have ridden all your life to this day? Have I been in the habit of treating you this way?"

And Balaam answered, "No."

Then Balaam's eyes were opened and he saw the angel holding the sword before him. He fell to his knees and bowed his face to the ground. The angel chastised him for beating his donkey, and Balaam begged forgiveness. The angel sent him on his way, warning him to pronounce before Balak the exact words given him by God.

So Balaam went to Balak and pronounced a blessing on the people of Israel. The king was furious, but it was the only choice the faithful seer could have made.

vij die woner der hohe ding arnon. We dir mo=
aß. Du biſt vergägē du volck chamos. Du haſt
gegeben ir ſün in fluch.vnnd die tochter in ge=

¶ Das .XXII.Capitel.wy
Balach ſeinen bote ſendet zu Balaam das er
zu im keme vñ das volck iſrahel vermaledeyet.

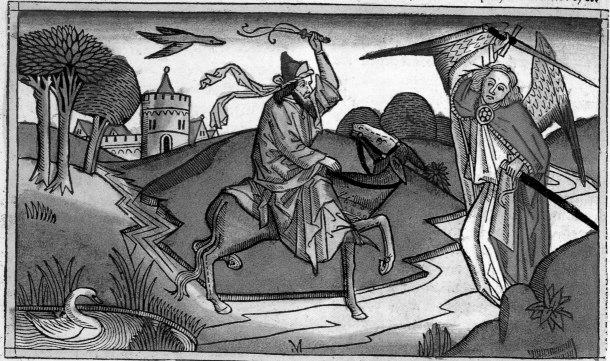

NS ſye giengen auſz
vñ ſatzte die herbergen in den felden
moaß.das da iſt gelegen bey ihericho
yenhalb des iordans.Wañ do Balach d ſun ſe=
phor het geſehen alle die ding die iſrahel tet dē

net auff dem fluß des landes d ſün āmon dz ſy
in voderten vñ ſprechē.Siß ein volck iſt auß ge
gangen von egipt dz do bedecket das antlytz d
erde.es ſitzt wid mich.Darümb küm vnd fluch
diſem volck.wañ es iſt ſtercker deñ ich.ob ich es

Anonymous, *Balaam's Talking Ass*, 15th c.
Woodcut, Victoria and Albert Museum, London.

THE STORY OF BALAAM'S TALKING DONKEY IS A FOLKTALE EMBEDDED
within a much longer narrative. The irony of a seer who cannot even see what his own
donkey sees is played out in delicious detail. The more the animal balks, the angrier
Balaam grows, until God opens Balaam's eyes, and he himself perceives the angel.

Balak views Balaam's power of prophecy as pure magic. Intending to buy a
convenient curse, he sends the priest a generous offer. But Balaam refuses the king's
money; his prophecies are not for sale. He can only speak the words given to him
by God. Whether he pronounces a blessing or a curse is not within his control. The
incident with the donkey reminds Balaam that if he should disobey God, he will incur
God's displeasure. The angel is sent as a warning.

Balaam's response to the donkey stands as a testimony against him. He accuses the
animal of making a fool of him, when it is he who is foolish for not perceiving the
angel. He wishes for a sword with which to kill his faithful donkey, while the armed
angel stands ready to mete out exactly the same justice to him. At the end, Balaam is
reminded that he must be as faithful a servant to his master, God, as his donkey has
been to him these many years.

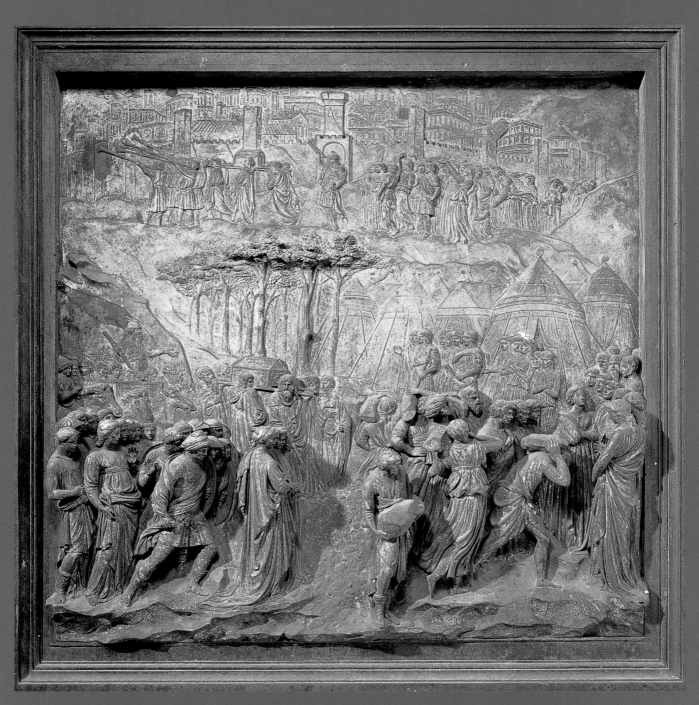

Lorenzo Ghiberti (1378–1455), *The Israelites in Jordan; The Conquest of Jericho*, 1452.
Gilded bronze from the Gates of Paradise, Baptistry, Florence.

The Walls of Jericho
Fall at the Trumpets' Blast

AVING WANDERED THROUGH THE WILDERNESS FOR forty years, the children of Israel at last arrived at the promised land. They crossed the Jordan river and laid siege to the walled town of Jericho. An angel of the LORD appeared to Joshua, the leader of the Israelite host, and instructed him on how he was to take the city.

The story appears in Joshua 6.

Joshua gave orders to the priests and armed men. Seven priests carrying seven trumpets made from the horns of rams went out in procession around the city, followed by the Ark of the Covenant. The armed men escorted them, one company leading the march, and one guarding the rear.

On six consecutive days, the caravan circled the city once. On the seventh day, they circled the city seven times. On the last circuit, Joshua commanded the army to give a great shout. The rams' horns sounded, the people cried out with all their strength, and the walls of Jericho collapsed before their very eyes. The city was delivered into their hands.

THE WRITERS OF THE OLD TESTAMENT CREDIT ISRAEL'S TRIUMPH over her enemies to one source: complete dependence on God. The conquering Israelites do not take the land through their own power—the land is delivered to them. The God of Israel chooses a small nation, an insignificant people, and places it at the center of the unfolding divine drama. The tumbling of Jericho's walls is not accomplished through siege engines or massed attack. Instead, the armies of Israel follow a precise ritual, and the walls collapse at the sound of their trumpets.

Within this political history of conquest, there is a religious message. The story of Jericho's walls asserts the primary importance of placing faith in the divine, before whom any barrier will fall. It warns against trusting in one's own powers alone. The victory at Jericho does not belong to the armies of Israel: It belongs to God.

The "Gates of Paradise," Lorenzo Ghiberti's final set of bronze doors for the Baptistry in Florence, was completed by 1452.

Ghiberti spent twenty-five years completing his masterpiece. Abandoning the Gothic framework of their predecessors, these doors are signature pieces of the emerging Renaissance. Large square frames enclose exquisitely detailed reliefs of a highly classicizing style. The image shown here was taken before the recent restoration of the doors. The dirt and wear actually accentuate the figures beautifully.

As the Old Testament unfolds, this message is delivered again and again. Whenever the people forget their dependence on God, disaster strikes. The books of history and the warnings of the prophets are a continual call to trust in God.

Samson Destroys the Temple of Dagon

HE ISRAELITES WERE OPPRESSED BY THEIR NEIGHBORS the Philistines, who ruled over them. An angel appeared to a woman of the Israelite tribe of Dan, and told her she would bear a son who would be consecrated to the Lord. He would never drink wine or strong drink, or even cut his hair; these were the signs of his consecration. So Samson was born and became a mighty warrior, with such incredible strength that he could tear a lion apart with his bare hands.

Samson defied the Philistines, and made war against them. Time and again they tried to capture him, but he could not be taken. Then one day, he fell in love with a woman named Delilah. The lords of the Philistines offered her money to betray him: "Coax him, and find out what makes his strength so great, and how we may overpower him."

So Delilah asked Samson the secret of his might. Three times, he lied to her. But the fourth time, as she begged and cajoled, he told her: No razor had ever touched his head.

That night, as Samson slept on her lap, Delilah summoned a man to shave the hair from his head; immediately Samson's great power left him.

Moody shadows dominate this theatrical, baroque painting of Samson toppling the Temple of Dagon. To emphasize Samson's great strength, the painter shows him as a tiny figure at the base of the columns he overthrows. The lushly rendered architecture—seen here as a classical European church, with Corinthian columns and coffered vaults—collapses in disaster. The unfortunate Philistines, their arms thrown over their heads, disappear in the avalanche of stone.

"The Philistines are upon you, Samson!" Delilah cried. He jumped up to face his enemies, but his strength was gone. The Philistines seized and bound him, put out his eyes, and threw him into prison. There, slowly, his hair began to grow back.

The Philistines held a great feast for their god, Dagon. The people were triumphant, and they called for Samson to be brought to the temple. As he was led in by an attendant, Samson asked if he could rest a moment by leaning against the pillars. Then, with a shout to God, he pushed on the stone with all his strength. The pillars gave way and the temple crashed down, killing Samson and the thousands of gathered Philistines.

SAMSON IS AN AMBIGUOUS CHARACTER—AMORAL, WILD, AND WILY. Dedicated to the Lord from his birth, he is a Nazirite, one of a class of holy men who never drank or cut their hair. His actions arise from a sacred frenzy, an ecstatic outpouring of power. Unlike the military heroes Joshua or David, who rally troops to defend the Israelites from their enemies, Samson taunts and harasses the Philistines with riddles and personal vendettas.

The writer of Judges presents this strange man as an example of God's ability to use human foolishness, even wickedness, in a righteous cause. Samson is ill-mannered and poorly behaved, but his purpose is virtuous and noble. His final act of power brings the temple down, sacrificing his own life for the future of his people.

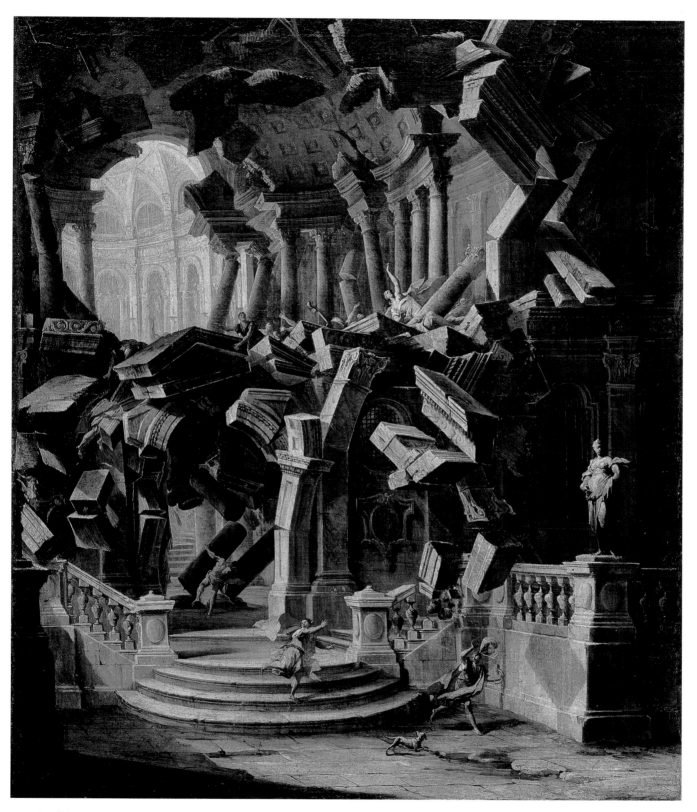

Antonio Joli (1700–77), *Samson Destroying the Temple.*
Oil on canvas, Museo Civico d'Arte Medievale e Moderna, Modena.

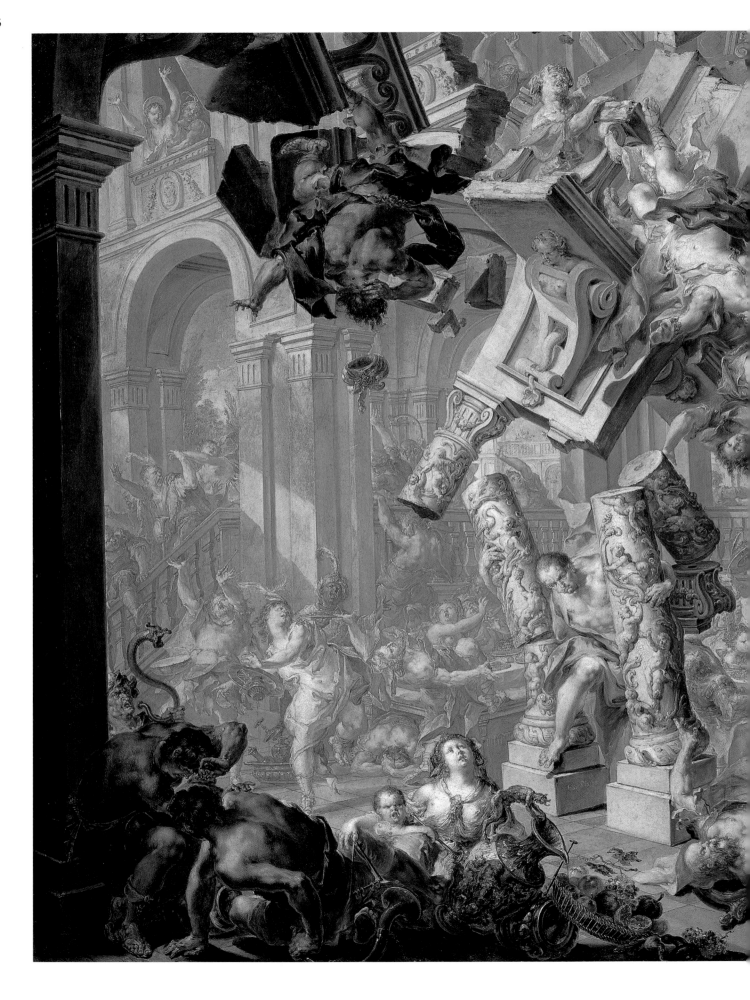

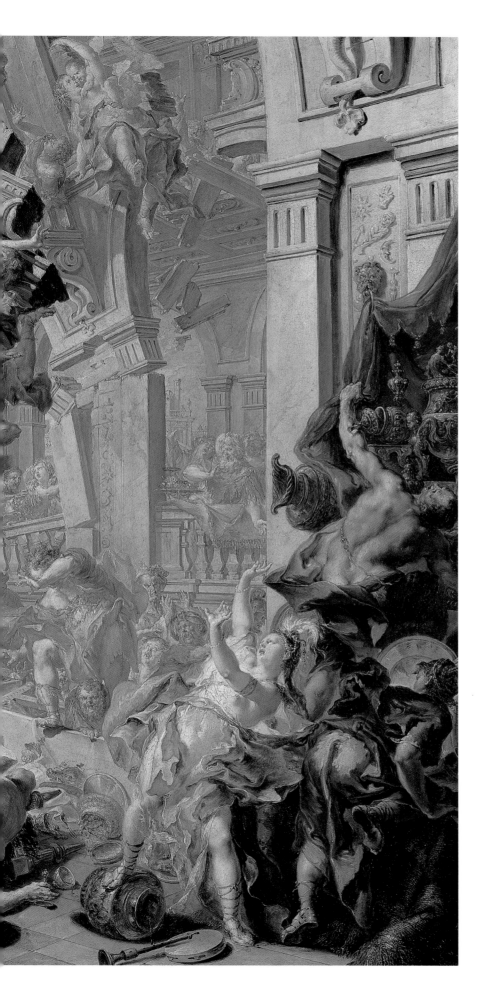

Johann Georg Platzer (1704–61), *Samson's Revenge.*
Oil on canvas, Desterreichische Galerie, Vienna.

David and Goliath

The story appears
in 1 Samuel 17.

HE ARMIES OF ISRAEL AND PHILISTIA FACED ONE another across the valley of Elah. In the Philistine camp there was a fearsome man named Goliath, who stood ten feet tall. He wore heavy armor, and the spear that he carried was as thick as a weaver's beam. Each day he came out and taunted the Israelites: "Today I defy the ranks of Israel! Give me a man, that we may fight together!" But no one in the Israelite army was willing to confront the giant, and the standoff lasted for forty days.

One day, a man from Bethlehem sent his youngest son, David, to the Israelite encampment with some provisions for his older brothers, who were soldiers there. Just as David arrived, Goliath repeated his challenge and the Israelite men drew back in fear. David asked, "Who is this uncircumcised Philistine that he should defy the armies of the living God?"

News of young David's words reached the king, who summoned him immediately. The king was dismissive of David's brave attitude: "You are just a boy," he told him. But David insisted that he could slay the giant, and so the king allowed him to try.

Unaccustomed to the weight of the king's armor, David refused to wear any shielding. Instead, he went down to the riverbed, picked up five smooth stones, and tucked them in his shepherd's pouch. Armed only with his staff and a sling, he went to confront Goliath. The giant looked at the boy and scoffed. "Am I a dog that you come to me with sticks?" he asked.

David replied, "You come to me with sword and spear and javelin, but I come to you in the name of the Lord of hosts." And he placed one of the stones into his sling, swung it round, and fired it at Goliath. The stone hit the giant squarely on the forehead and he dropped to the ground. David approached his foe and, taking the giant's own sword, cut off Goliath's head.

The Philistines panicked at the sight of their fallen hero and began to flee. The Israelites quickly attacked and were victorious.

Caravaggio constrains his figures in the tightest possible space. There is no setting: just darkness. The artist's use of plain dark backgrounds and his incisive realism were a marked departure from the Mannerism then prevalent in Rome. Caravaggio's work has a psychological intensity and sense of drama that anticipates the coming Baroque style.

THE MIRACLE IN THE DAVID AND GOLIATH STORY IS ONLY APPARENT when the story is viewed through the lens of faith. The difference between a lucky shot and an act of divine intervention is one of perception.

The force of arms does not triumph in this story. The king's armor is an impediment, not a benefit, to David. The key to his success is complete trust in the God of Israel. The Philistines do not face a merely human army, but one backed by divine will. And God chooses the weakest, least obvious soldier to win the battle. The brave young shepherd faces down his mighty adversary with nothing but a few stones and a sling. David's victory is an example of a theme which runs through the Old and New Testaments: Those who believe their strength makes them invincible are felled by the weak.

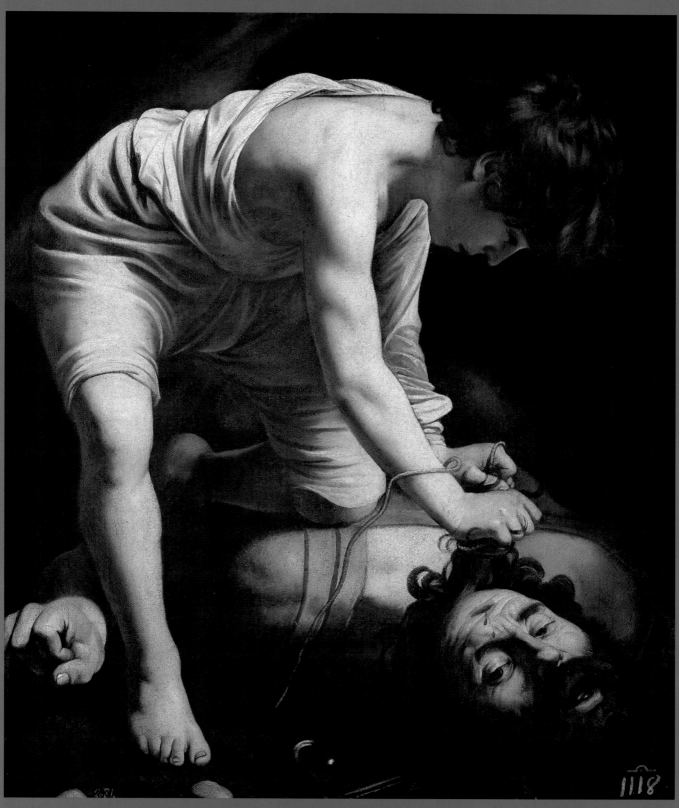

Michelangelo Merisi da Caravaggio (1573–1610), *David Victorious Over Goliath*, 1600.
Oil on canvas, Museo del Prado, Madrid.

Giovanni Girolamo Savoldo (1480–1548), *Elijah Fed by the Raven*, c. 1510.
Oil on panel transferred to canvas, National Gallery of Art, Washington D.C.

Elijah and the Ravens

THE PEOPLE OF THE KINGDOM OF ISRAEL STRAYED from the God of their fathers and turned to worship the foreign god, Baal. God was angry at their apostasy and sent his prophet, Elijah the Tishbite, to tell King Ahab and his queen, Jezebel, that God would send a devastating drought.

The story appears in 1 Kings 17.

Having delivered the divine message, Elijah retired to a desert valley east of the Jordan river. Famine began to grip the land. But Elijah was sustained by God, who sent ravens to him every morning and evening, carrying bread and meat. He drank from the stream flowing through the valley.

The drought was long and fierce. When the stream dried up, Elijah went down to the coast to live with a widow and her son, and God continued to miraculously provide him with food.

THE HISTORY OF ISRAEL AFTER THE REIGNS OF DAVID AND SOLOMON is one of political and religious division. Under Solomon's son, Rehoboam, the united kingdom was split in two. The southern kingdom, called Judah, remained under the rule of the Davidic royal family. The northern kingdom, which retained the name of Israel, was governed by a succession of dynasties.

In the reign of Ahab, the kingdom of Israel reached a low point. Ahab's foreign queen, Jezebel, encouraged the worship of Baal—a god especially associated with the giving of rain and the fertility of the soil. Elijah is chosen to defy the cult of Baal, and to champion the cause of the Lord, the God of Israel. The Bible presents this religious controversy in stark terms: Not only is the people's well-being in danger as they fall into foreign cults, but the very principle of monotheism is at stake. The threat of drought is an assertion of the Lord's absolute power over the forces of nature, and a denial of the power of Baal.

Giovanni Girolamo Savoldo was a native of Brescia in northern Italy. Elijah was popular among monastic communities, and the iconography of this painting connects Elijah's sojourn in the desert with the experience of hermits who remove themselves to remote wastelands. In the background, the scene of his ascension to heaven is depicted.

Once Elijah has announced God's decision to send the drought, he withdraws into the wilderness. In the desert, Elijah lives the Exodus experience of utter reliance on God. In a place where there is no food, God miraculously provides for him. Sent by God, the ravens sustain Elijah for the battles he will have to face.

Eventually, Elijah will face down the prophets of Baal, and the Lord will triumph. The rain will fall again and Ahab and Jezebel will meet their downfall.

Elijah Defeats the Prophets of Baal

The story appears
in 1 Kings 18:17–40.

THE TERRIBLE DROUGHT HAD LASTED THREE LONG years. Elijah was now ready to challenge the prophets of Baal to a final contest. He went to King Ahab of Israel and told him to assemble the people and the prophets of Baal on Mount Carmel.

When they had all gathered, Elijah addressed the crowd. "How long," he asked, "will you go limping with two different opinions? If the LORD is God, follow him; but if Baal, then follow him."

The crowd was silent. So Elijah issued this challenge: Build two altars, one for Baal, and one for the LORD of Israel. Prepare a bull for sacrifice on each altar, but put no fire to it. Call upon the god of each altar, and the deity who answers with fire will be proven to be the true God.

The crowd shouted their assent. "Well spoken!" they said.

The prophets of Baal killed a bull, cut it up, and laid it on their altar. All morning, they cried out to Baal to hear them, but there was only silence from heaven. As the day wore on, they began to cut themselves with knives—this was their custom—but nothing happened.

The Mannerist painter Domenico Beccafumi designed thirty five scenes from the Old Testament for the pavement of the cathedral in his native Siena. Carefully pieced-together marble, deeply etched with black lines, evokes the quality of drawing in pen and ink. The water-carriers depicted here have barely completed their task of dousing the sacrifice when the fire rains down from heaven; the men with their water vessels lie scattered around the altar.

Then Elijah called on the people to come close. He laid twelve stones on the ground and dug a trench around them. He cut up the bull for the offering and laid it with kindling on the stones. Then he instructed the people to douse the altar with water. Once, twice, three times he commanded them to soak the offering.

Then Elijah called out to God: "Answer me O LORD, answer me, so that this people may know that you, O LORD, are God."

Fire rained down from heaven on the altar and consumed the offering. The fire even lapped up the water in the trench. The people shouted, "The LORD indeed is God!"

They seized the prophets of Baal and put them to the sword. And the rains returned.

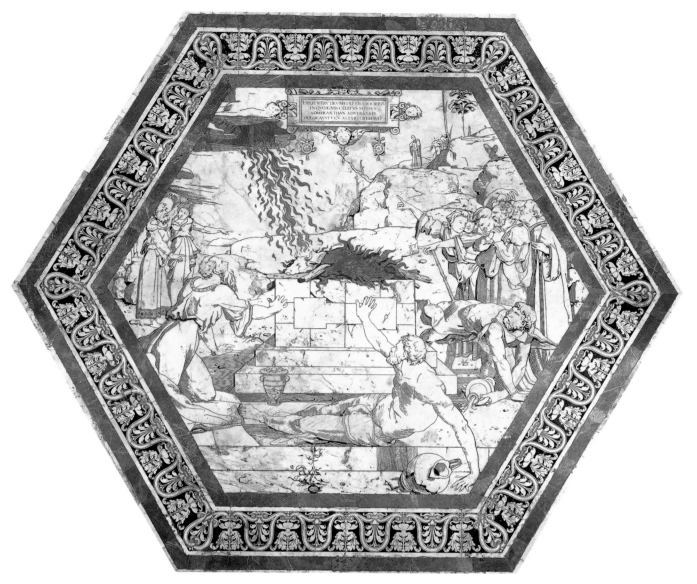

Domenico Beccafumi (1486–1551), *The Sacrifice of Elijah*.
Marble intarsia of the floor, Duomo, Siena.

THE BATTLE FOR THE LOYALTY OF THE PEOPLE REACHES A DRAMATIC
conclusion on Mount Carmel. The God of Israel triumphs and the prophets of his
rival, the foreign god Baal, are put to death.

This story of conflict reflects more than a violent religious and political struggle for
control. It expresses an emerging understanding of the nature of God. Is he simply a
local tribal deity, or is he the only God, the ruler of heaven and earth? The implication
of the narrative is that he is unique, and the gods of the nations are powerless fictions.
The prophets of Baal can implore their god all day—he will never answer.

Elijah's taunting sarcasm is part of a tradition within the Bible that attacks the
worship of idols. Statues have tongues, but cannot speak; they have ears, but cannot
hear. Those who worship idols are just like them, warn the psalms.

The story of Elijah and the prophets of Baal asserts the belief that Israel is called to
the worship of a single God, the creator of the universe. To follow the gods of nations
is presented as pure folly.

Elijah and the Fiery Chariot

The story appears
in 2 Kings 2.

HEN ELIJAH'S WORK ON EARTH WAS DONE, GOD determined to take him directly to heaven in a whirlwind.

Elijah and his disciple Elisha set off from the town of Gilgal. The prophet said to Elisha, "Stay here: The LORD has sent me to Bethel."

But Elisha would not leave his master: "As the LORD lives, and as you live, I will not leave you."

At each stage of their journey, Elijah tried to leave his disciple behind, but Elisha was adamant, and would not be parted from his master. At last, the two men reached the bank of the river Jordan. Elijah took his mantle, rolled it up, and snapped it against the surface of the flowing river. The waters parted, and they walked across on dry land.

Elijah turned to his faithful follower and said, "Ask what you want of me, before I am taken away from you."

Elisha answered him, "Let me inherit a double share of your spirit."

"What you have asked is hard," Elijah replied. "But if you see me at the moment I am taken from you, it will be as you ask. If not, it will not be so."

As they continued on their way, a chariot of fire appeared, drawn by flaming horses. As it carried Elijah away to heaven in a whirlwind, Elisha shouted after him, "Father, my father! The chariots of Israel and its horsemen!"

Elisha tore his clothes in mourning for the loss of his master. Then he stooped down and took up the mantle of Elijah. Walking back to the river, he invoked Elijah's God, struck the water, and the stream parted. He had inherited Elijah's spirit and power.

Reflecting the stylistic continuity of the icon-painting tradition, this image was painted more than two hundred years after the collapse of the Byzantine Empire. Orthodox Christianity emphasizes the authority of icons passed down with little change from one generation to another. This painting reflects that conservatism, remaining completely Byzantine in spirit.

The art of the icon is a theological art, expressing religious ideas in graphic terms. Eschewing the use of illusionist perspective, the icon arranges the horses symmetrically around the central figure of the prophet. Elijah is surrounded by wheels, evoking perhaps the wheels of another biblical vision—Ezekiel's chariot that announces the presence of God.

THE EXPRESSION "TAKING UP THE MANTLE" HAS ENTERED OUR LEXICON as a way of describing the passing of authority from one leader to the next. In order to succeed his master, Elisha must first undergo a trial: Accompany Elijah on his journey and witness his ascension. His parting of the river, using Elijah's mantle, is proof that he has inherited his master's power.

Elijah's chariot of fire picks up a motif which runs through his life. In his challenge to the prophets of Baal, Elijah called down fire from heaven to consume his offering to God. Later, lonely on a desert mountaintop, he encountered wind, earthquake, and fire which announced God's presence. Now the fire returns to carry him away.

In later times, it came to be believed that Elijah's return to earth would herald the opening of the messianic age.

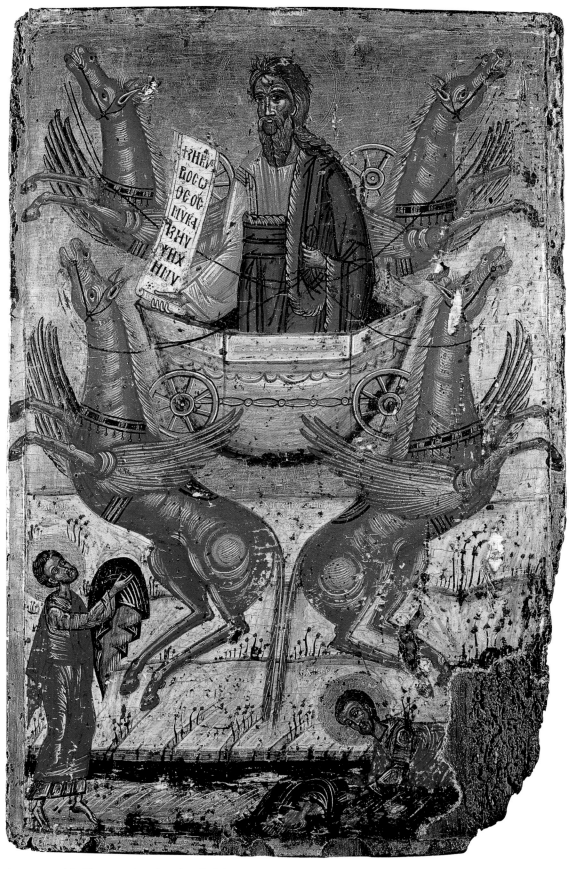

Anonymous, *The Fiery Ascension of Prophet Elijah*, late 17th c.
Greek icon, Collection of Dr. Amberg-Herzog, Koelliken, Switzerland.

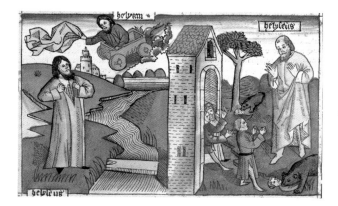

Anonymous, *Elijah Ascends to Heaven in a Whirlwind; The Boys Who Mocked Elisha Are Eaten by Bears*, 15th c. Woodcut, Victoria and Albert Museum, London.

Elisha, the Boys, and the Bears

LISHA DECIDED TO TRAVEL FROM JERICHO TO BETHEL. As he was walking along, a group of boys ran out to taunt him. "Go away, bald head! Go away, bald head!" they shouted.

Elisha stopped and turned around to look at them in anger. He called on God to curse them. Immediately two she-bears emerged from the woods nearby and attacked the boys. Forty-two of them were mauled. Elisha went on his way, and journeyed to Mount Carmel.

The story appears in 2 Kings 2:23–25.

OF ALL THE MIRACLE STORIES IN THE BIBLE, THIS IS ARGUABLY THE most unpleasant. Although it seems intended to convey awe for the power of God's prophet, it has quite the opposite effect. The punishment is completely out of proportion to the misbehavior of the boys. It is particularly disturbing because it follows so closely on Elisha's taking up of Elijah's mantle. He has just been granted power and authority, and this is one of the first ways in which he uses it.

Most commentators dispatch this amoral folktale with a quick note and move on. Some older Bibles put it under the heading "Irreverence Cursed." But this incident can serve as a useful reminder of the mixed heritage of the Bible. It is a book compiled over many centuries by a myriad of authors: It does not have a single, unified viewpoint. The writer of this particular tale presumably approved of Elisha's actions. Its survival within the larger narrative gives us an insight into a worldview at the time it was written, which is radically different from our own, and which is, in fact, at variance with much of the rest of the text.

The Nuremberg Bible *pairs the departure of Elijah and the incident of the bears. On the left, Elisha appears as a young man, tearing his robe in grief as his master disappears into heaven. On the right, he has aged considerably and is portrayed as old and bald-headed. He towers over the boys, while the two bears set to work on their victims. The somewhat naïve quality of the hand-tinted woodcuts matches the tone of this folktale perfectly.*

Elisha, the Widow, and the Oil

The story appears
in 2 Kings 4:1–7.

HERE WAS A MAN WHO WAS A MEMBER OF THE COMPANY of the prophets, who had a wife and two children. When he died, he left his widow destitute. Her creditors threatened to sell her children into slavery to reconcile her debts. In desperation, she sought help from Elisha. The prophet asked if she had anything at all with which to pay what she owed.

"Your servant has nothing in the house," she said, "except a jar of oil."

Elisha told her to borrow every clay vessel she could lay her hands on. Then she and her children should close themselves in the house, and begin pouring the oil from the jar into each of the vessels.

She ran home and did as he had told her. Her children brought her one vessel at a time, and she poured and poured. As each jar was filled, she shouted, "Bring me another vessel!" Finally, her son said to her, "There are no more." And immediately the oil stopped flowing.

She returned to Elisha and told him that all the clay vessels had been filled from her single jar. He said to her, "Go sell the oil and pay your debts, and you and your children can live on the rest."

WIDOWS WERE PARTICULARLY VULNERABLE IN THE ANCIENT WORLD. Without a man to support them, they had very few ways of earning their living. Starvation was a real possibility.

In a cruel turn of fate, the woman in this story finds herself at the point of losing everything. Not only is her husband dead, but he has left her with no way to provide for her household. Without assistance, she will lose even her children. Elisha intervenes on her behalf. The single jar of oil is not exhausted until all the vessels have been filled. Not only are the widow and her children saved from debt or slavery, they are even left with a surplus.

A member of the Capuchin Order, Bernardo Strozzi was born in Genoa and ended his days in Venice. Elijah's tanned, wiry body contrasts the soft white flesh of the widow and her innocent son. She holds the oil jar and one of the vessels, while her son extends a small clay pot to show the prophet.

The "company of the prophets" was a religious brotherhood that looked to Elisha for leadership and guidance. The widow has every reason to go him in her time of need; her husband had been one of his followers. In this story, Elisha is looking after one of his own.

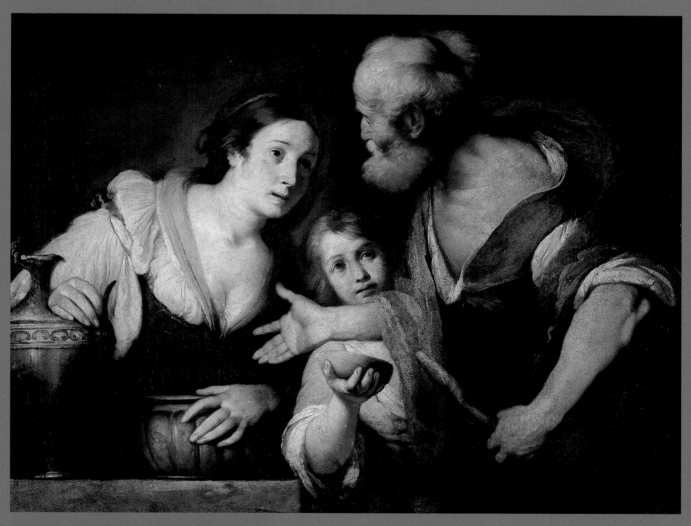

Bernardo Strozzi (1581–1644), *The Prophet Elisha and the Widow of Sarepta*, c. 1640.
Oil on canvas, Kunsthistorisches Museum, Vienna.

Elisha Heals Naaman

The story appears
in 2 Kings 5.

 **AAMAN WAS A POWERFUL MAN IN THE COURT OF THE
king of Aram. He was commander of the king's army, and the
LORD had granted him victory in battle. Although he enjoyed
the favor of the king and held a position of great authority, he
suffered from leprosy.**

There was a servant in his house, an Israelite girl who had been captured in an
Aramean raid. When she heard of Naaman's misfortune, she said to his wife, "If
only my lord were with the prophet Elisha who is in Samaria! He would cure him of
his leprosy."

When Naaman's wife told him what her servant girl had said, he determined to
go and seek out the prophet.

Elisha heard of Namaan's distress and invited him to his home. So Naaman set
off to meet the man of God. When he arrived at the prophet's house, he was met at
the door by a messenger who said, "Go wash in the Jordan seven times, and your
flesh shall be restored and you shall be made clean."

Naaman was angry and stormed off. Could the prophet not have come out to
meet him? Were there not rivers in Aram for him to wash in? His servants tried to
reason with him.

"Father," they said, "if the prophet had commanded you to do something
difficult, would you not have done it?"

Naaman decided to do as Elisha had told him. He went down and washed in the
Jordan seven times. His leprosy vanished. Fully healed, Naaman hurried back to
Elisha's home, and the prophet greeted him. From then on, he announced, he would
worship only the God of Israel. Elisha sent him on his way and wished him peace.

POWER, WEALTH, AND CONTROL ARE AT THE CORE OF NAAMAN'S LIFE.
As a commander of the Aramean army, he is accustomed to giving orders and having
them obeyed. His leprosy confronts him with a situation over which he has no control.
He attacks his disease as a strong man would, using his influence with the king and seek-
ing out the prophet through diplomatic channels. He departs for Israel laden with gifts.

*The dignity of the nude Naaman shines out in this small devotional
work by the Netherlandish painter Cornelis Engelbrechtsz. Divested of
all his finery, the commander is portrayed washing, while a well-
dressed servant holds a cloak on the riverbank. The surrounding
countryside is filled with Naaman's armed entourage.*

The story exposes the limits of
human power. Elisha's refusal to meet
Naaman at the door is unusual treat-
ment for the commander. Naaman
expects the man of God to parlay
with him as his rank deserves, and to
put on a show of prayer and ritual.
Instead he finds himself in a position
of obedience and must follow Elisha's instruction to the letter.

The wisest characters in the story are the servants. The captured slave girl is the one
who knows where Naaman can go for help. When he fumes with rage at the prophet's
gate, it is his servants who calm him and encourage him to wash in the Jordan. By fol-
lowing their advice, he is healed. The proud commander discovers he is simply human.

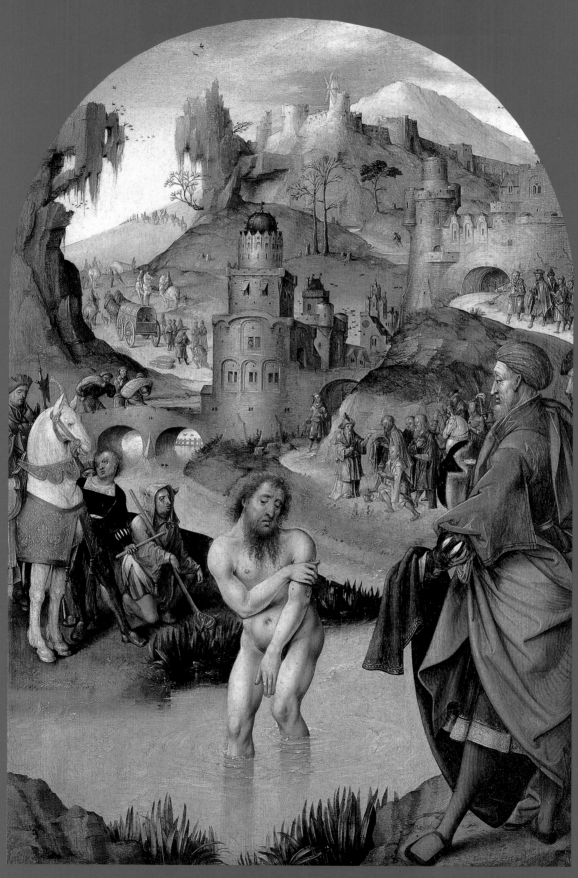

Cornelis Engelbrechtsz (1468–1533), *The Prophet Elisha Heals the Syrian Captain Naaman of Leprosy*, 1520.
Oil on oakwood from an altarpiece, Kunsthistorisches Museum, Vienna.

The Vision of Ezekiel

The story appears in Ezekiel 1–3.

ZEKIEL WAS AMONG THE JUDEANS CARRIED INTO captivity when Jerusalem fell to Nebuchadnezzar. One day as he stood by the banks of the river Chebar, in the land of his captors, he saw a great cloud in the north. As it rushed toward him, he observed flashes of fire. There in the midst of the cloud were four creatures that gleamed like polished bronze. One had a face like a human being's; the second, a face like a lion's; the third, a face like an ox's; and the last, a face like an eagle's. Each had four wings—one pair covered their body, while another pair spread out above. The four creatures moved in unison, their wings touching. When they stopped, their wings dropped to their sides; when they moved, their wings made a mighty roaring sound.

Below them appeared tall wheels, which shone like precious jewels. All along the rims of the wheels were eyes, and the wheels moved in perfect harmony with the creatures.

Above them was a dome, which gleamed like crystal, and on top of this, a throne. One who looked like a human being sat on the throne, and fire flashed all around him. The glory that surrounded him was refracted into the colors of the rainbow.

Ezekiel fell prostrate before this apparition, and then he heard a voice. "O mortal, stand up on your feet, and I will speak with you," the voice said. Ezekiel was filled with the spirit, and stood. The being on the throne commissioned him to go to the exiles of Israel as a prophet.

Then Ezekiel was lifted up and borne away. He heard the rush of the wings, the rumbling of the wheels, and the noise of the creatures brushing against each other.

When the vision had disappeared, he went to the exiles by the river. For seven days, he sat there, stunned.

THE LINE BETWEEN A MIRACLE AND A VISION IS SOMETIMES DIFFICULT to draw. Although this is essentially an apparition, experienced by Ezekiel in a trance-like state, it exerts a powerful physical effect on him. The spirit enters him, lifts him to his feet, and miraculously carries him away in the heavenly chariot.

Raphael departs significantly from the text in this painting. He concretizes the details and simplifies the description. The wheels are gone, as is the crystalline dome. The creatures take form as solid, recognizable animals, while the divine being is rendered Zeus-like, accompanied by small winged putti. Renaissance solidity and verisimilitude, along with a strong taste for classical forms, replace the otherworldly, visionary prose of the prophet.

Ezekiel experiences a *theophany*, a moment of divine self-revelation, which marks the beginning of his prophetic career. Ezekiel compares his vision with physical things—gemstones, polished bronze, animal forms, and human beings. He is careful never to make these comparisons concrete. The dome, for instance, *looks like* crystal; it is not actually made of the semi-precious stone. His words can evoke, but never fully describe, what he has seen. Even the human form seated on the throne is difficult to describe. This inexpressible glory bespeaks the majesty and mystery of the divine.

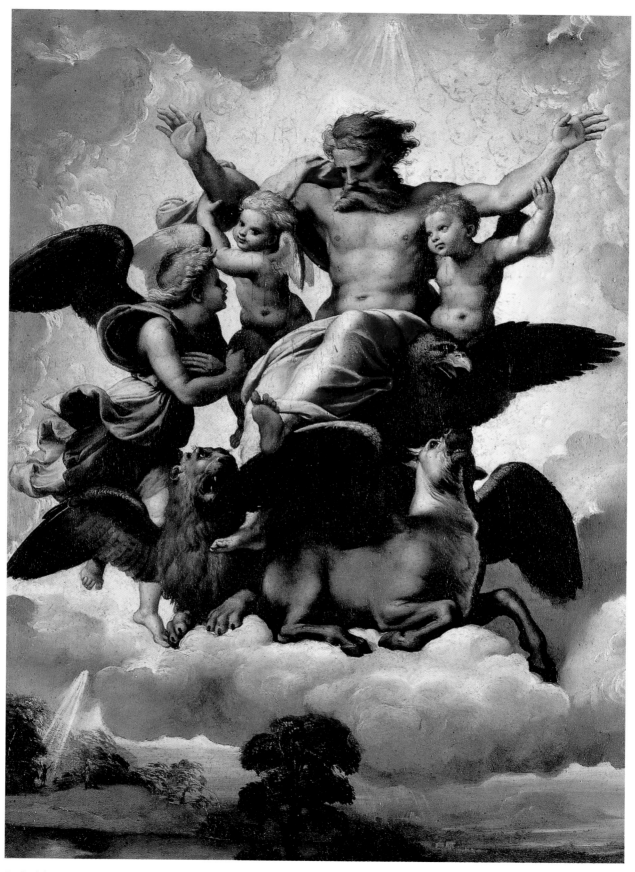

Raphael (1483–1520), *The Vision of the Prophet Ezekiel*, 1518.
Oil on wood, Galleria Palatina, Palazzo Pitti, Florence.

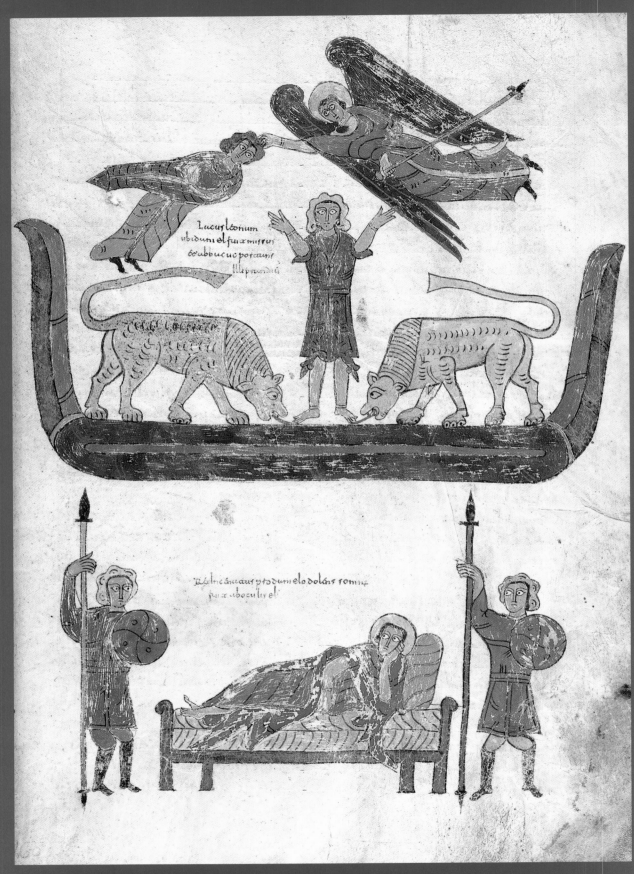

Anonymous, *Daniel in the Lion's Den*.
Manuscript illumination, The Pierpont Morgan Library, New York.

Daniel in the Lions' Den

DANIEL WAS AN EXILE FROM JUDAH, LIVING IN THE royal court of his captors. Loyal to the God of Israel, he went into his room three times a day to open a window facing Jerusalem and pray. Daniel's devotion and wisdom endeared him to king Darius, who raised him to a position of great power. The favor he found with the king incited the other courtiers to jealousy. Though they could find no charge to bring against Daniel, they plotted to use his faithfulness to the God of Israel against him. The courtiers went to Darius, and convinced him to make a decree: For thirty days, no one in his realm could pray to anyone but the king. The flattered Darius signed the order.

Daniel, aware that he was disobeying the king's decree, continued to pray to God. His enemies immediately denounced Daniel to Darius. The king was greatly disturbed, and tried save Daniel. But the order could not be revoked; what Darius had written was immutable law.

As evening fell, Daniel was brought before the king, who said to him, "May your God, whom you faithfully serve, deliver you!" And Daniel was thrown into a den of hungry lions. All that night, Darius refused food and could not sleep. Early in the morning, he ran to the den and called out for Daniel.

"O king, live forever!" the faithful Daniel cried. "My God sent his angel and shut the lions' mouths so that they would not hurt me, because I was found blameless before him; and also before you."

Darius raised Daniel out of the pit and ordered the conspirators to be thrown into the lion's den instead; before they even reached the ground, the lions had torn them limb from limb.

The story appears in Daniel 6.

Beatus of Liebana, an eighth-century Spanish monk, edited a treatise of commentary on apocalyptic writings. The second part of the Book of Daniel contains visions of the end of the world and therefore figures prominently in the text.

Daniel is shown in the lions' den, his hands stretched upward in an attitude of prayer. The docile lions lick his feet. Below him, the king, his eyes wide open, lies fretting on his bed, flanked by soldiers. Into the scene, the artist has interpolated a story from the Apocrypha. Suspended above Daniel, the prophet Habakkuk is carried by an angel, who holds him by his hair. Having been interrupted by the angel while preparing his own supper, Habakkuk has been transported from Judah to offer food to Daniel in the den.

DANIEL'S ORDEAL IN THE LIONS' DEN REFLECTS HOW DIFFICULT IT was for Jews of the Exile to remain faithful while living under foreign domination. Surrounded by pagan influences and sometimes persecuted for their faith, they struggled to maintain the dietary laws and uphold the worship of the God of Israel. The miraculous vindication of Daniel is meant to give hope that God will never abandon the steadfast.

King Darius claims total authority: His word must stand forever. Yet, despite the pomp and flattery that surrounds him, Darius is powerless to overturn his own decree. He is tricked by his own courtiers, who use his pretensions to absolute power against him. In the end, even he must trust in God to save Daniel. He is revealed to be nothing more than a man, whose earthly power cannot stand against the Almighty.

Tobias and the Angel

The story comes from the book of Tobit.

OLD TOBIT WAS A RIGHTEOUS MAN WHO FELL INTO poverty and was smitten with blindness. As he prepared himself to die, he summoned his son Tobias to his side. He advised his son to live a good life—to perform acts of charity and mercy. He also asked him to go on a journey to collect a large sum of his money being held by a man named Gabael, who lived in far-off Media.

As Tobias prepared for the trip, he encountered a stranger—the angel Raphael in disguise—who promised to guide him to Gabael's house. On the first night of their journey they camped by the Tigris river. When Tobias went down to wash his feet, a huge fish jumped out of the water. "Catch hold off the fish and hang on to it," the angel shouted. So Tobias grabbed the slippery creature and brought it to their camp, where the angel instructed him to cut out the gall, the heart, and the liver, and save them.

As they continued on their journey, they came near the home of Tobias' kinsman Raguel. Now Raguel had a daughter named Sarah, who was both wise and beautiful. She had been married seven times, but each time, on her wedding night, a demon had killed the groom as he entered her private chamber.

When they arrived at Raguel's house, the angel negotiated a marriage between Sarah and Tobias. But the young man had heard of the demon's curse and was afraid. Raphael instructed him to take the fish's liver and heart and burn them in the bridal chamber on his wedding night. Tobias did as the angel had told him. The demon, repelled by the stench, fled.

After the wedding was over and the money had been fetched from Gabael, Tobias, Sarah, and Raphael returned to Tobit. Tobias took the fish gall and, placing it on his father's eyes, cured him of his blindness. When Tobit called Raphael to reward him for all his help, the angel revealed himself. With a final admonition to them to continue their good works, he disappeared from sight.

Best known for his landscapes, Jean-Charles Cazin makes a foray into a Biblical theme with this painting. Active in the last half of the nineteenth century, he renders the story as a genre scene of two young men walking near a river. The angel Raphael's halo and slightly archaic robe is the only hint that this is not a contemporary scene.

COMMENTATORS DESCRIBE THE STORY OF TOBIT AS A LITERARY romance. Its theme is the importance of ethical living and faithfulness to God. Moral uprightness is rewarded, and family ties are strengthened.

Tobit's character is exemplary: He is generous to the poor; he invites needy Israelites to eat with him at his table. When the evil king Sennacherib executes some of the Israelites, Tobit gives them a decent burial. On one occasion, after burying a body, he sleeps outside the house—presumably because he is ritually unclean from having touched a corpse. As he slumbers, the droppings from sparrows nesting on the wall above fall into his eyes and blind him. Despite all his charitable acts, Tobit is stricken with a life of poverty and deprived of his sight. Throughout, he remains faithful to God, even in the face of his misfortune. In the end, his devotion is rewarded when divine intervention restores his vision and wealth.

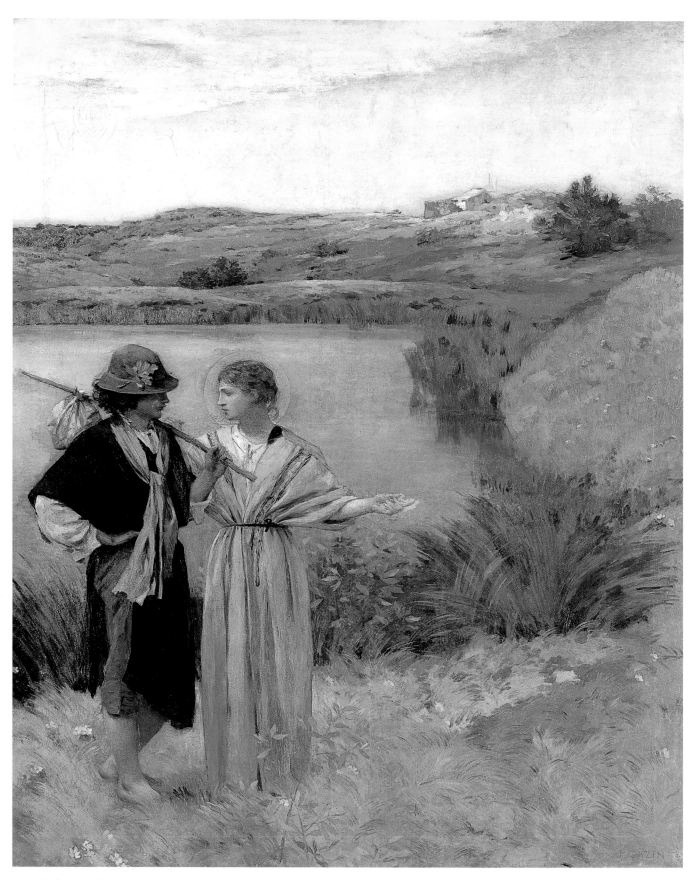

Jean-Charles Cazin (1841–1901), *Tobias and the Angel.*
Oil on canvas, Musée des Beaux-Arts, Lille.

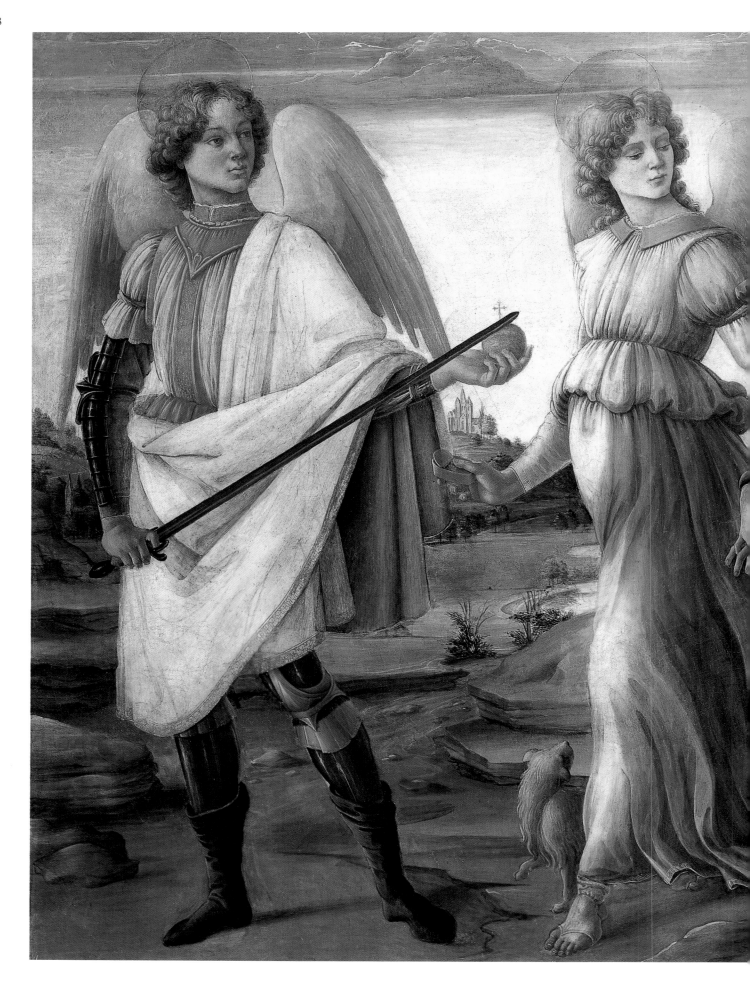

Filippino Lippi (1457–1504)
The Three Archangels and Tobias.
Tempera on panel,
Galleria Sabauda, Torino.

Miracles
in the
Life of Christ

Anna and Joachim
Meet at the Golden Gate

Variations of the story appear in the *Golden Legend* and in the *Gospel of Pseudo-Matthew*.

OACHIM WAS A RIGHTEOUS AND PROSPEROUS MAN of the tribe of Judah who owned large flocks of sheep. He divided his income into three parts: One third he would give to the poor; one third he would give for the support of the Temple in Jerusalem; and one third he kept for the support of his household.

When he was a young man, he had married a woman named Anne. For twenty years, they had had no children. One day he went to the Temple to attend the sacrifice, but the priest expelled him, claiming that if the Lord had denied Joachim and Anne progeny, they should not worship with those who were able to raise children for God.

Joachim was devastated and did not return home. He went straight out to his herdsmen, and took the flocks to a faraway country, leaving Anne to wonder what had become of her husband.

One day, an angel appeared to Joachim and told him that he and Anne would have a child; he must return to Jerusalem at once. The angel delivered the same message to Anne, telling her to meet her husband at Jerusalem's Golden Gate.

When the couple were reunited in the holy city, they kissed one another. At that moment, Mary, the mother of Jesus, was conceived.

THE BIRTH NARRATIVES OF JESUS IN THE GOSPELS ARE BRIEF. MARK, which is probably the earliest Gospel, simply begins with Christ's baptism, giving no details of his birth or childhood. Matthew and Luke recount the familiar nativity story, and John opens his Gospel with a mystical poem about the incarnation of Christ.

The silences and gaps of the Gospels left space which pious imaginations filled with wonders and miracles. The tale of Joachim and Anne gives Mary a history of her own, presenting her as a woman whose own miraculous beginning destines her to be a worthy mother to the Savior. As the Middle Ages progressed, Mary would be seen in increasingly exalted terms. Believed to have been born without original sin, spotless and pure, the story of her birth echoes the nativity of her son.

Wilhelm Ziegler portrays the Golden Gate of Jerusalem as a painted northern Renaissance entryway. Through a side arch, we see Saint Anne at home. The angel appears and sends her to meet her husband. Beyond them, we spy into the recesses of the house. At the Gate, the couple embraces one another with great intensity.

The idea that Mary was conceived at the moment of her parents' kiss comes out of popular myth, and is not found in the texts. Early Christianity exalted virginity and was often wary of human sexuality. By portraying Mary's birth as miraculous, popular piety further distanced her from the perceived taint of sexuality. With a kiss, her Immaculate Conception becomes a concrete event.

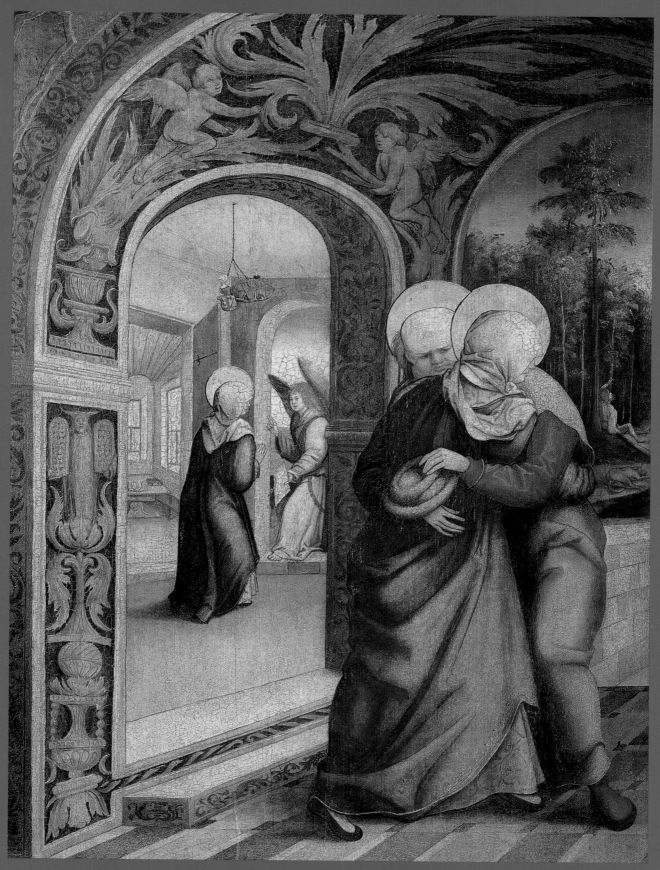

Wilhelm Ziegler (1480–1543), *Meeting of Anne and Joachim at the Golden Gate.*
Tempera on wood, Louvre, Paris.

The Virgin Birth

The story as it appears here is told in the Gospel According to Luke. A variant of the story appears in Matthew.

GOD SENT THE ANGEL GABRIEL TO NAZARETH IN Galilee, where he appeared to a young virgin named Mary, who was betrothed to a man named Joseph. "Greetings, favored one! The Lord is with you," the angel said. Mary was perplexed by this greeting. The angel continued, "Do not be afraid, Mary, for you have found favor with God. And now you will conceive in your womb and bear a son, and you will name him Jesus." And the angel promised her that the child would grow up to inherit the throne of David, and that his kingdom would never end.

Mary asked the angel, "How can this be, since I am a virgin?"

"The Holy Spirit will come upon you," the angel said, "and the power of the Most High will overshadow you; therefore the child to be born will be holy; he will be called Son of God."

And Mary answered, "Here am I, the servant of the Lord; let it be with me according to your word." And the angel left her.

Melchior Broederlam was a painter in the court of Philip the Bold, Duke of Burgundy. In this panel, God the Father looks down from a sparkling blue heaven upon the scene, which is executed with great charm. The Virgin Mother, resting on her bed, looks over at Joseph, who is seeing to his hose. Although the Gospels are silent as to Joseph's age, here and in popular folklore he is seen as somewhat doddering— why else would he marry a woman who would remain a virgin? (In the Middle Ages, Mary's perpetual virginity was unquestioned.)

Now the emperor decreed that all the people should be registered, and everyone in the realm was obliged to return to their native town to do so. Joseph, who was of the house of David, returned to Bethlehem with Mary, and there she gave birth to a son. She wrapped the baby in swaddling bands, and laid him in a feeding trough because there was no place for them at the inn.

Angels appeared in the fields, where shepherds were tending their flocks that night, and announced the birth of the Messiah. The shepherds found the child lying in the manger wrapped in swaddling cloths, just as the angels had described.

INNUMERABLE CHRISTMAS PAGEANTS HAVE NOT DULLED THE IMPACT of this story. In the popular retelling, the different traditions of Luke and Matthew have been conflated to create a single narrative. Luke's account is the most comprehensive, giving us the annunciation scene and the adoring shepherds. Matthew emphasizes Joseph's role and adds the visit of the Magi.

The scriptural warrant for the virgin birth is an interpretation of a prophecy from Isaiah: "All this took place to fulfill what had been spoken by the LORD through the prophet: 'Look, the virgin shall conceive and bear a son, and they shall name him Emmanuel,' which means, 'God is with us.'" Although the original Hebrew simply refers to a "young woman," the Septuagint translates the term as "virgin."

Matthew 1:22–23.

The virgin birth describes the completely unique nature of the Messiah. Jesus is not conceived as an ordinary child. Instead, he is both human and divine, with an earthly mother and a heavenly Father.

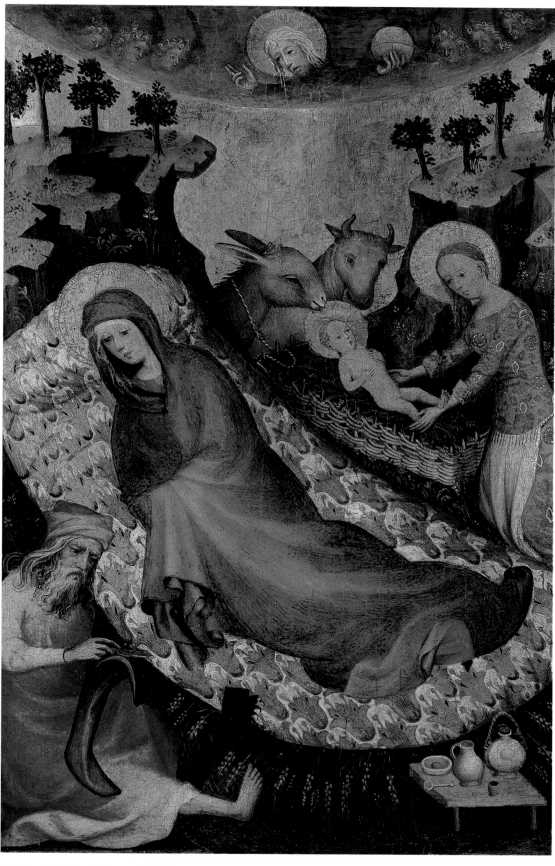

Melchior Broederlam (1381–1409), *Nativity*, c. 1399.
Tempera on oakwood, Museum Mayer van den Bergh, Antwerp.

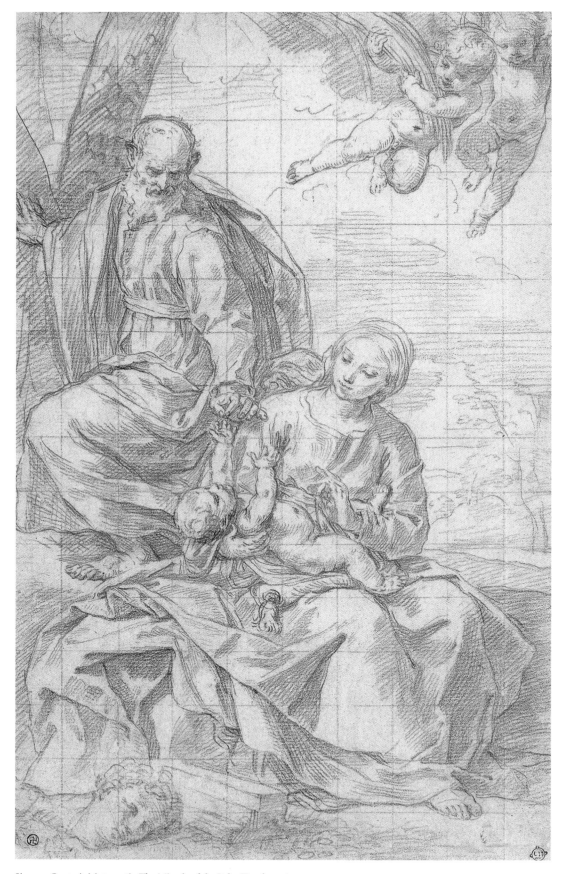

Simone Cantarini (1612–48), *The Miracle of the Palm Tree*, late 1630s.
Red chalk on laid paper, National Gallery, Washington D.C.

The Miracle of the Palm Tree

 OSEPH TOOK MARY AND JESUS DOWN INTO EGYPT. On the third day of their journey through the desert, they were weary from the heat of the sun. Mary asked if they could stop and rest under a palm tree which stood by the road. As she sat in the shade of the tree, she looked up and saw fresh fruit hanging from the branches. Mary told Joseph she was hungry and longed to eat some of that fruit. Joseph told her the tree was too tall and straight; there was no way for them to reach the fruit. Besides, he said, what they really needed was water. Their skins were empty, and the animals they rode were thirsty.

Jesus, lying in his mother's lap, looked up and said to the tree, "Bend down." And the tree bent down immediately. They gathered all the fruit they wanted, and ate contentedly.

The tree remained bent down until Jesus said to it, "Rise up again, and stand as tall as the trees of paradise. And release from your root a stream of water so that we may drink."

And the tree stood up, and from its base, water began to flow. Joseph was delighted, and filled the skins. They all drank and were refreshed.

The story appears in the Gospel of Pseudo-Matthew.

MATTHEW'S GOSPEL RECOUNTS THAT WHEN KING HEROD HEARD OF the birth of Jesus, he was afraid. He sent his soldiers to kill the children of Bethlehem to eliminate his potential rival. Joseph, warned in a dream, took Mary and the child to safety in Egypt.

The apocryphal *Gospel of Pseudo-Matthew* picks up where the canonical Gospels leave off. It portrays a loving family group and explores the relationships among them. Its tone is intimate; it takes delight in small details. Mary and Joseph are not in the least surprised by the miracles Jesus performs. They enjoy the playful ease with which their child provides food and water in the wilderness and they praise God for their good fortune.

The canonical Gospels often report the discomfiture of the witnesses to Christ's miracles. The signs and wonders disturb people and provoke questions. Here, in this story, Christ's extraordinary abilities are taken for granted.

This drawing by Simone Cantarini is a sketch for a finished painting. The grid ruled over the drawing allowed him to transfer his design onto canvas. Cantarini has minimized the fanciful aspects of the story: The tree bends gently, allowing Joseph to reach the fruit, which he offers to Mary and her son. Two little putti in the upper right help pull the tree downwards.

The author imagines how, as a child, Jesus takes delight in his own powers, using them to please his parents. Even the natural world shares his enjoyment: The family is accompanied on their journey by leopards, panthers, and lions which emerge from the wilderness and tamely serve as escorts. Later in the book, Jesus fashions small sparrows out of clay. Shouting "Fly!" he brings them to life and they flutter away. This is a world of pure folktale.

The Miracle at Cana in Galilee

The story appears
in John 2:1–11.

ESUS AND HIS DISCIPLES WERE INVITED TO A
wedding at Cana in Galilee. Halfway through the feast, the
wine ran dry, and Jesus' mother, who was also there, turned
to her son and said, "They have no wine." Jesus instructed the
servants to fill six huge jars with water. He then told them to
draw some out and take it to the steward of the feast. Amazingly, the water had
turned to wine. The steward called the bridegroom over and commended him,
"Everyone serves the good wine first, and then the inferior wine after the
guests have become drunk. But you have kept the good wine until now."
Unaware of the miracle that had taken place, the guests continued their
celebration. This was the first of Jesus' miracles.

THE MIRACLE AT CANA APPEARS ONLY IN THE GOSPEL ACCORDING
to John. It is a story about perception: who sees what is happening, and who does not.

As it tells the story, the Gospel barely mentions the actual moment of the miracle. There is no flash of wonder; the water is silently altered. Only the servants are aware of the transformation. The steward, the bride and groom, and the other revelers believe the wine is simply flowing freely. The Gospel divides the characters into two types: those who are trapped in earthly literalism, and those who perceive what is happening on a spiritual plane. John invites his readers to look at the story again, to perceive the richer, spiritual level.

This huge painting (21.9 x 32.5 ft.) was made for the refectory, or dining hall, of the monastery of San Giorgio Maggiore in Venice. Veronese has set the scene in the courtyard of an imaginary Venetian palace. Christ sits at the very center of the composition, his mother to one side, the calm fulcrum of the lively scene. The perspective lines converge on his head. To the right, in the foreground, we see the steward talking to the bridegroom, dressed in white, as a servant pours wine from a stone jar. In the center foreground, the musician in white, playing the viola, is said to be a self-portrait of the artist.

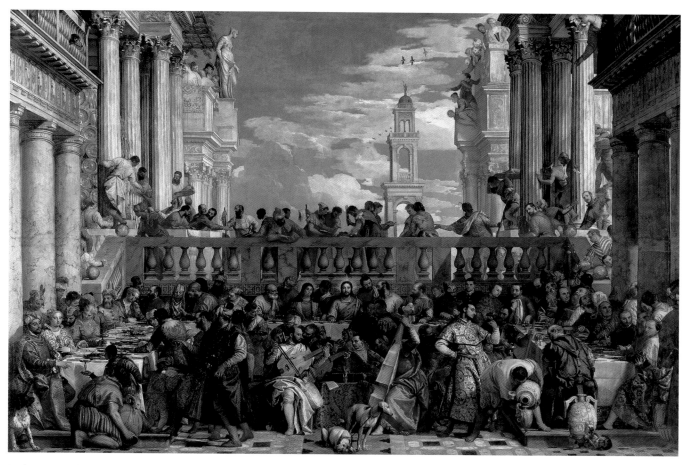

Paolo Veronese (1528–88), *The Wedding at Cana*, 1563.
Oil on canvas, Louvre, Paris. Detail on overleaf.

Placing the miracle at a wedding, the Gospel evokes a long tradition of marriage imagery in the Old Testament:

> You shall no more be termed Forsaken;
> and your land shall no more be termed Desolate;
> but you shall be called My Delight Is in Her …
> For the Lord delights in you …
> and as the bridegroom rejoices over the bride,
> so shall your God rejoice over you.

Isaiah 62:1-5.

Here Isaiah uses the wedding to describe the mystical reuniting of earth and heaven at the coming of the Messiah. Spousal love becomes the guiding metaphor for the relationship between humanity and the divine. The time of deliverance, when the Messiah arrives, is expressed through the metaphor of feasting and banquets and joy. By placing the first miracle at a wedding, the Gospel is telling us the Messiah has arrived.

The literal bridegroom in the story is the young man being married in Cana. The spiritual bridegroom is Christ, come to espouse the world.

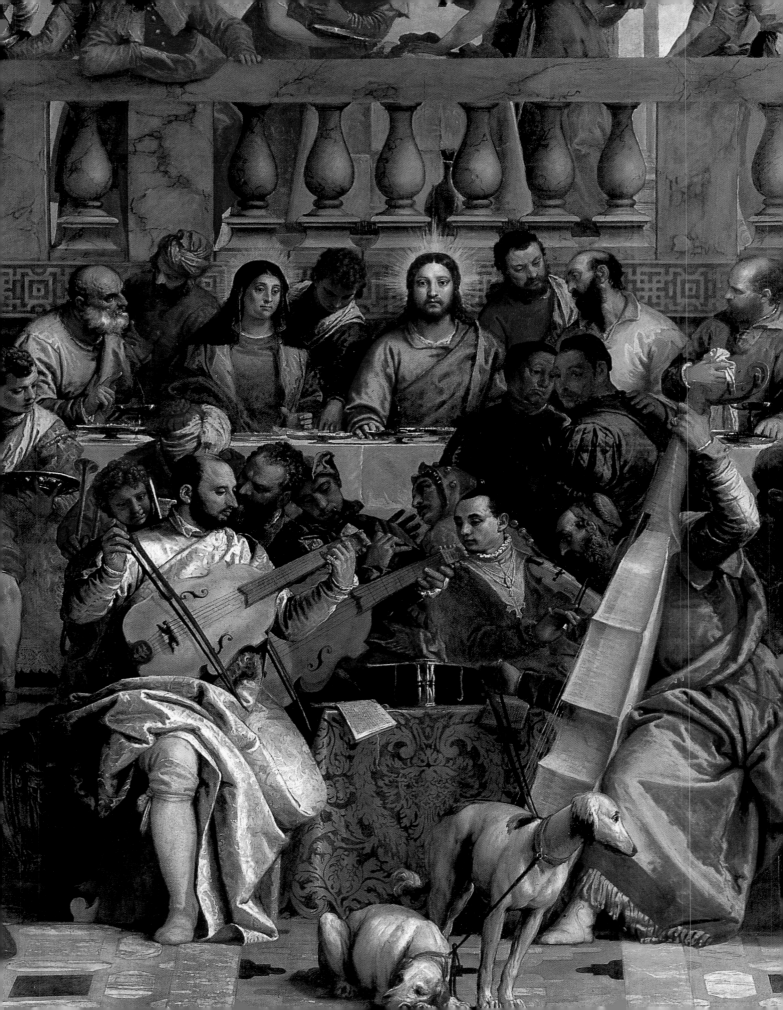

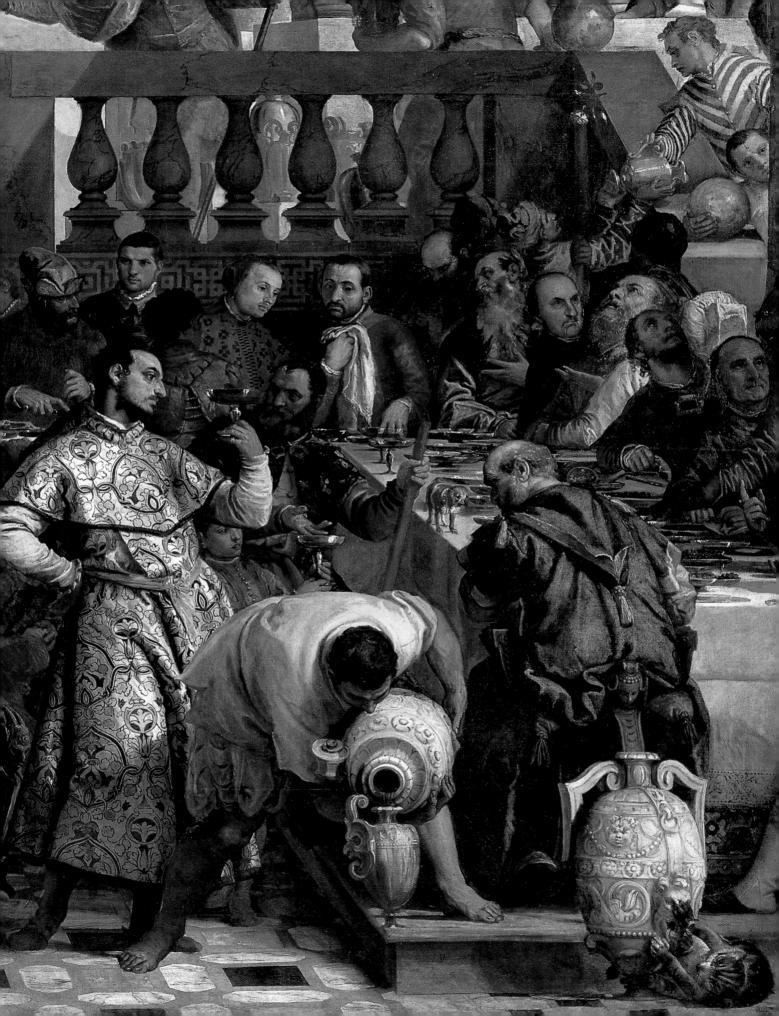

The Miraculous Draft of Fishes

This story appears
in Luke 5:1–11.
A variant of the story
appears in John 21.

 S JESUS WAS TEACHING BY THE SHORE OF THE SEA OF Galilee, the growing crowds pushed forward in their eagerness to hear him speak. Noticing two empty boats at the water's edge, he stepped into one of them, and asked Simon, the fisherman who owned it, to push him a short way from the shore. From the boat, he continued addressing the assembled group.

When he was finished, he turned to Simon and told him to move his boat into deeper waters and let down the fishing nets. Although he had caught nothing the night before, Simon did as Jesus instructed. The nets quickly filled with fish, and as they were drawn in, the nets began to tear. The other boat was called in to help. Soon, both vessels were so laden with fish, they started to sink under the weight.

Simon fell to his knees and begged Jesus, "Go away from me, Lord, for I am a sinful man."

Jesus responded, "Do not be afraid; from now you will be catching people."

Simon and his fishing partners, James and John, the sons of Zebedee, brought the boats to shore, and left everything to follow Jesus.

CHRIST'S INNER CIRCLE OF TWELVE APOSTLES WERE MEN CALLED from ordinary walks of life—men like these fishermen, who witness an extraordinary sign in the midst of their daily work and leave everything to follow Jesus.

As some commentators have pointed out, there is nothing inherently miraculous in the story—the large catch of fish could simply be a stroke of good fortune. But Simon, skilled fisherman that he is, recognizes the startling overabundance of the catch as a sign of Christ's power.

Simon immediately claims he is unworthy, and begs for Jesus to leave. But Jesus does not accept his excuses. None of the disciples are called because they are qualified. It is not who they are now that matters, but who they will become. Later, Simon will be renamed Peter, the "rock" on which Jesus says he will build his Church. Simon is not called because he is good, but because he is willing to be transformed.

Jesus uses the fishing metaphor to bring Simon and his companions into a new life. Leaving their nets and boats behind, they will trawl for a richer catch, gathering people into the Kingdom of God. Just as the disciples themselves were ordinary people, pulled from every station in society, so they will go out to proclaim the Good News to rich and poor, good and bad, learned and unlettered alike

The tapestry shown here is made after a cartoon, or prototype, by Raphael. The tapestry maker has brightened the colors considerably: The cartoon is a study in rich blues and greens. Here, the colors are in a higher key. Christ's robe has been rendered a rich red, and the hills and figures in the distance sparkle in bright tones.

Peter lurches to his knees in his boat filled with fish, as Jesus reaches out his hand in a gesture of blessing. The gunwales of the laden boat almost touch the water. Behind them, two men strain to bring up the heavy nets. In the placid waters, the reflections of the figures are carefully rendered. In the distance, the departing crowd lingers on the seashore.

Raphael's original cartoon is housed in the Victoria and Albert Museum in London.

Raphael (1483–1520), *The Miraculous Draught of the Fishes*.
Tapestry, Pinacoteca, Vatican Museums, Rome.

Anonymous (Netherlands), *The Healing of the Paralytic*, c. 1560–90.
Oil on panel, National Gallery of Art, Washington, D.C.

The Healing of the Paralytic

JESUS WAS TEACHING IN A HOUSE IN CAPERNAUM, A town by the Sea of Galilee. People came from all around the neighboring countryside, and from as far away as Jerusalem, to hear him. They filled the house, spilling out into the street.

While Jesus was speaking, four men arrived, carrying a paralyzed man in his bed. Finding the doors blocked with people, they climbed to the roof. They tore through the tiles, and lowered the man in his bed down into the room where Jesus sat.

Seeing their faith, Jesus looked at the man and said, "Son, your sins are forgiven." The scribes and Pharisees began to mutter to one another, "What kind of blasphemy is this? Only God can forgive sins."

Jesus looked at them and asked, "Which is easier, to say? 'Your sins are forgiven,' or to say, 'Stand up, take up your bed, and walk'? But so you may know that the Son of Man has authority on earth to forgive sins," he turned and said to the paralyzed man, "Stand up, take your bed, and go to your home." The man stood up, lifted his bed, and walked out the door. The people who saw it were amazed and glorified God.

The story appears in Matthew 9:1–8; Mark 2:1–12; and Luke 5:17–26.

IN THIS HEALING STORY, A VISIBLE SIGN CONFIRMS AN INVISIBLE power. Gospel miracles often point beyond themselves. The healing of the paralytic is not an isolated event, but a sign of the radical reordering of humanity's relationship to the divine.

When Jesus sees the tenacious effort of the paralyzed man and his companions, his first words address the state of the man's soul: "Son, your sins are forgiven." The scribes and Pharisees, devout people with a deep understanding of the religious traditions they shared with Jesus, are aghast and offended at Christ's appropriation of divine power.

Jesus poses them a challenge. He cannot prove something invisible—the act of forgiveness. But he can show them something that anyone can see—a paralyzed man walking. And not only walking, but strong enough to carry his bed away with him. The man's act of extraordinary faith has not only restored him to his full physical strength, but it has become the key to a new relationship with God.

This painting reflects a sixteenth-century shift in pictorial sensibility. Most of the images in this book were originally designed to be used as ritual objects: decorating altars, providing a focus for prayer, or presenting edifying stories to be used for instructing the faithful. Jesus and the saints are their central figures and their tone is devotional, provoking a sense of awe and wonder. This anonymous painting from the Netherlands is of a more private, personal nature.

The moment of the miracle is pushed to the background. In the distance, we see the tiny figures of the crowd surrounding the house while the friends are gathered on the roof and the paralytic lies in his bed in front of Jesus. The main subject of this painting is the healed man, carrying his bed. His long shirt blows in the breeze, showing off his powerful legs, restored to their full function. He is a humble man, a person inhabiting recognizable space.

The Feeding of the Five Thousand

The story appears in Mark 6:30–44 and Matthew 14:13–21. Variants of the story appear in Luke 9:10–17, John 6:1–14, Mark 8:1–9, and Matthew 15:32–39.

 ESUS AND HIS DISCIPLES WERE OVERWHELMED BY the crowds that flocked to see them. Needing a time of rest and quiet, Jesus suggested to his disciples that they retreat to a deserted place on the shore of the Sea of Galilee. But they were seen departing by boat, and their intended destination was discovered. A huge crowd went ahead on foot and met them as they arrived. When Jesus saw the throngs of people, his heart went out to them. They were lost, like sheep without a shepherd. So he sat down and began to teach.

As the afternoon grew long, the disciples approached Jesus and told him to send the crowds away. It was late; they should go into the nearby villages and buy themselves something to eat.

Jesus said to the disciples, "You give them something to eat."

They were incredulous—think how much money would it take to feed such a crowd! Jesus asked them what food they carried with them. They checked their provisions and found five loaves of bread and two fish. Jesus told them to settle the throngs of people on the grassy slope. Taking the five loaves and the two fish, Jesus said the blessing and began to break the bread. The disciples distributed the food to the crowd.

This mosaic from Ravenna depicts a beardless Christ dressed in imperial purple. He is flanked by pairs of disciples, who hold the loaves and fish for him to bless. Christ and the disciples face us, placing us in the role of the crowd who will be miraculously fed.

Everyone ate, and all were satisfied. When they gathered the remnants, they filled twelve baskets with what was left over. Five thousand men were fed that day.

BREAD IS ONE OF THE MOST IMPORTANT SYMBOLS IN THE GOSPELS. When Jesus is tempted by the devil in the wilderness, Satan tells him to transform stones into bread, and Jesus responds, "One does not live by bread alone, but by every word that comes from the mouth of God." Later, he teaches the disciples to pray, "Give us this day our daily bread."

Matthew 4:4.

Matthew 6:11.

On its simplest level, the miracle of the loaves and fishes is about satisfying the physical hunger of the crowd. But Jesus implies there is a deeper significance to the story. The feeding of the five thousand is followed, in Mark and Matthew, by an almost identical miracle, in which four thousand are fed.

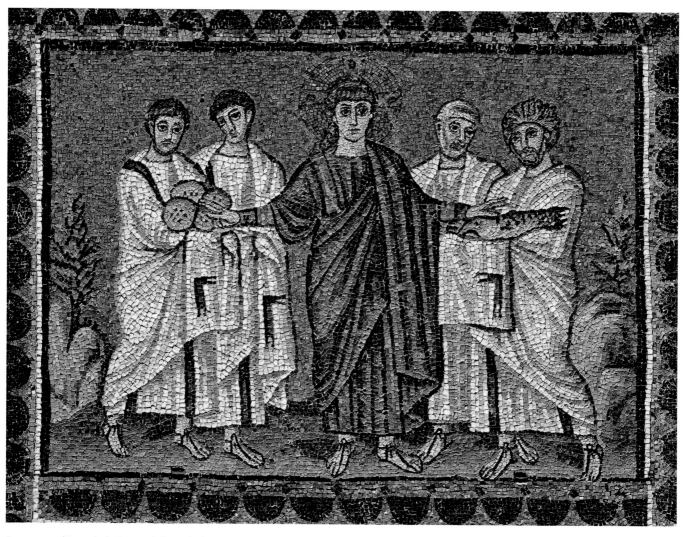

Anonymous (Byzantine), *Jesus and the Multiplication of the Loaves and Fish*, 6th c.
Mosaic, Sant'Apollinare Nuovo, Ravenna.

After these two events, Jesus tells his disciples, "Beware the yeast of the Pharisees." Mark 8:14–21.
They misunderstand his meaning, and assume he is concerned that their provision of
bread is inadequate. So he asks them how many baskets they had gathered up when
the five thousand were fed.

"Twelve," they reply.

And then he asks how many baskets they collected after the four thousand
had eaten.

"Seven," they say.

Jesus, exasperated, asks, "Do you not yet understand?"

Many commentators remark on the symbolic numbers, twelve and seven. The first
represents a renewed Israel; the second, the nations of the gentiles. The organization
of the crowd into companies and the food provided in a desert place echo the story
of Exodus.

Jesus is calling forth a new Exodus, Jews and gentiles together, to be sustained by
God as they journey into the promised land.

Christt Walks on the Water

The story appears
in Matthew 14:22–33.
Variations appear
in Mark 6:45–52 and
John 6:15–21.

AFTER HE HAD FED THE FIVE THOUSAND, JESUS instructed the disciples to take a boat across the Sea of Galilee. He remained behind to send the crowds home. When they had gone, he climbed up the mountainside to pray alone.

Night fell, and a strong wind began to blow on the lake. All night, the disciples strained at their oars, fighting the large waves. Early in the morning, before dawn, Jesus appeared, walking towards them on the surface of the sea. They were afraid and cried out, "It is a ghost!"

Jesus answered them, "Take heart, it is I. Do not be afraid."

Peter said, "Lord, if it is you, command me to come to you on the water."

Jesus said, "Come."

So Peter stepped over the side of the boat, and began to walk toward Jesus. The wind was still strong, and when Peter noticed it, he lost his nerve, and began to sink. "Lord, save me!" he cried out. Jesus stretched out his hand to grab hold of Peter.

"You of little faith, why did you doubt?" he asked Peter. The two got into the boat, and the wind was still.

THIS MYSTERIOUS STORY DESCRIBES A MOMENT OF DIVINE REVELATION. Jesus, having just fed the five thousand, now reveals himself as having power even over the forces of nature. In the original Greek of the story, his cry, "It is I," can also be rendered "I AM." Jesus uses the name of God from Exodus and applies it to himself. The disciples see Jesus as they have never seen him before.

Matthew's Gospel adds a further detail to the story, of which variants appear in Mark and John. Peter, as he is portrayed so often in the Gospels, is impetuous, bold, even foolish. He immediately grasps the situation and asks to leave the safety of the boat. At first, he succeeds, imitating Christ and walking on the water. But when he begins to consider his situation, he knows he is—quite literally—in deep water. His doubts begin to drag him down; soon he is floundering in the waves. He is saved from danger when he calls out to Jesus, and receives the gentlest of rebukes.

Lorenzo Ghiberti made two sets of doors for the Baptistry in Florence. This panel, from his first set, follows the late-Gothic pattern established by Andrea Pisano almost a hundred years before. Ghiberti arranges his figures within a quatrefoil frame. The ship, bursting with disciples, struggles over the waves, its sails furled. One group huddles, as though debating what to do, while several others struggle with the ropes in front. Jesus stands placidly on the sea, reaching his hand out to Peter, who has sunk to his knees in the surf.

Believers through the centuries have drawn a powerful spiritual lesson from the story of Peter joining Jesus on the water. Peter is a symbolic figure for anyone in danger, whether a Christian facing persecution in the early centuries of the Church, or an alcoholic today wrestling with the more intimate demons of addiction. In the face of overwhelming challenges, Peter must not rely on his abilities alone or be distracted when the waters rage and foam. Throwing all his trust onto a power higher than himself, he is caught by Jesus' outstretched hand.

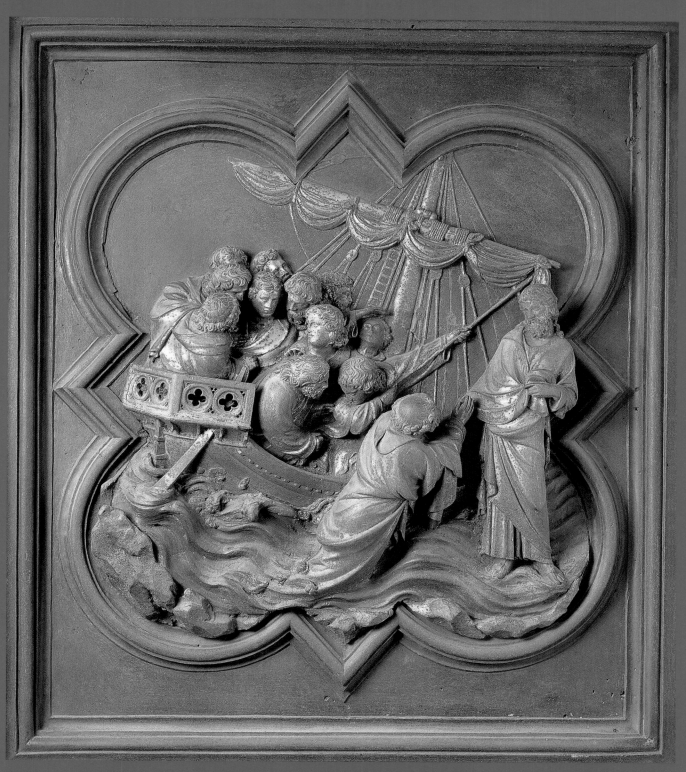

Lorenzo Ghiberti (1378–1455), detail from *Life of Christ*, 1424.
Gilded bronze from the north doors of the Baptistry, Florence.

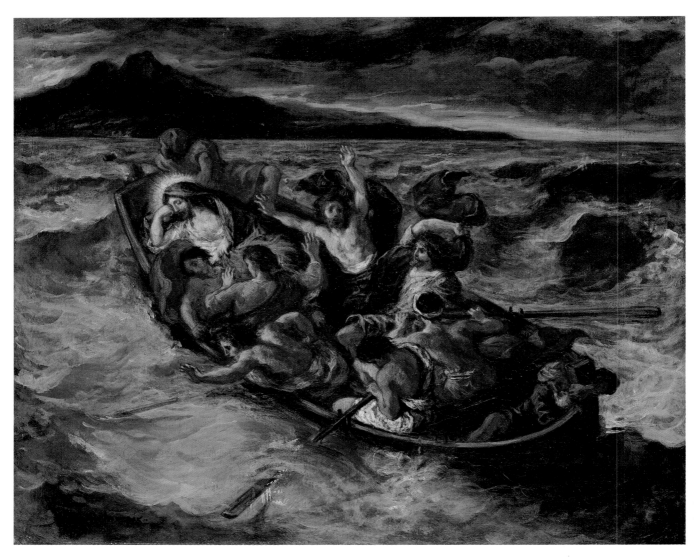

Eugène Delacroix (1798–1863), *Christ Asleep During the Tempest.*
Oil on canvas, Metropolitan Museum of Art, New York.

Christic Stills the Storm

 ESUS WAS TEACHING BY THE SHORE OF THE SEA OF
Galilee. As evening fell, he said to his disciples, "Let us go across
to the other side." So they set out in a boat, leaving the crowd on
the shore. When they were far out on the lake, a storm began. As
the wind blew more and more fiercely, the waves grew, and the
boat was nearly swamped. Through it all, Jesus lay in the stern, sleeping on a
cushion. The disciples woke him in alarm, shouting, "Teacher, do you not care we
are perishing?"

Jesus looked up and spoke to the sea: "Peace! Be still!" And the sea was instantly
calm. He asked them what they had to fear. Where was their faith?

The disciples were silent. But they asked each other, "Who is this, that even the
wind and the sea obey him?"

The story appears
in Mark 4:35–41,
Matthew 8:23–27,
and Luke 8:22–25.

THE DIVINITY OF CHRIST IS OFTEN EXPRESSED OBLIQUELY IN THE
Gospels. This is particularly true of the three synoptic Gospels: Matthew, Mark and
Luke. In small moments of surprise and insight, the disciples begin to grasp that Jesus is more than he appears to be. His power and authority extend beyond the normal scope of an ordinary human being.

The genius of this story is that it leaves the reader to answer the disciples' question: "Who is this, that even the wind and the sea obey him?" Although the disciples remain perplexed, the reader is meant to see a growing body of evidence that Christ is, in fact, displaying divine power. One of the psalms describes the actions of God in precisely the same terms that we find in the Gospel account:

*Delacroix was a leading painter of the French Romantic movement.
He portrays the heaving boat under a glowering sky. One disciple loses
his nerve and throws his hands up in the air, while others strain at the
oars. Jesus, softly haloed, is oblivious to the scene surrounding him.
Rough brushstrokes and the tilted, unbalanced composition heighten
the sense of movement and danger.*

> He made the storm be still,
> And the waves of the sea were hushed.

Psalm 107:29.

In stilling the storm, Christ carries out a work the scriptures ascribe to God.
Rather than tell his disciples who he is, he lets his actions speak. Right up to the end,
the disciples will ponder what kind of man this is that they are following. Only after
Jesus has been crucified and they experience his resurrection will they begin to
understand him as divine.

Christ Heals the Woman with an Issue of Blood

The story appears in Mark 5:25–34, Matthew 9:20–22, and Luke 8:42–48.

MAN NAMED JAIRUS HAD A DAUGHTER WHO WAS AT the point of death. He came to Jesus and asked him to come and heal her. As they were hurrying to Jairus' house, the crowds followed, pressing in on Jesus from every side.

There was a woman in the throng who had suffered from hemorrhages for twelve long years. She had spent all she had on physicians, but they had been no help; her condition only grew worse. She knew that Jesus was a healer, and she thought to herself, "If I but touch his clothes, I will be made well." So she reached out and felt his cloak. The hemorrhaging stopped at that instant.

Jesus turned around and said, "Who touched my clothes?"

The disciples were incredulous. With the crowd pushing against him, how could he ask such a question? Jesus was firm: He had felt power go out from him.

The woman knew he was speaking of her. With trepidation, she fell on her knees before him and told him what she had done and why.

Jesus said to her, "Daughter, your faith has made you well; go in peace and be healed of your disease."

And he continued on his way to the house of Jairus.

WHEN SHE REACHES OUT TO TOUCH JESUS' GARMENT, THE WOMAN commits a serious offense: She transmits her own ritual uncleanness to him.

The laws of ritual purity lay down strict regulations about contact with things and people that are unclean. These include dead bodies, people with various diseases, and certain bodily fluids. Once a person has been defiled by contact with the unclean, he must undergo rites of purification.

In William Blake's ethereal, somewhat sentimental rendering of the Gospel story, Jesus gazes peacefully at us. Surrounded by children and a calm crowd, he is in no hurry, and no one jostles him. The old crone who bends down to touch the hem of his robe is the only figure who seems to move in the placid scene.

The question that Jesus poses puts the woman in a very difficult position. She has every reason to be frightened: Jesus has been tainted by her touch. But his reaction dispels all her fears.

In this miracle, Jesus does more than grant health to an ailing woman. Throughout his ministry, he transcends barriers. Just as he reaches out to societal outcasts, surrounding himself with despised prostitutes and tax collectors, so he reaches across the barrier of ritual regulation. The woman with the hemorrhage bore the double indignity of disease and the shame attached to it. Now her faith has made her whole.

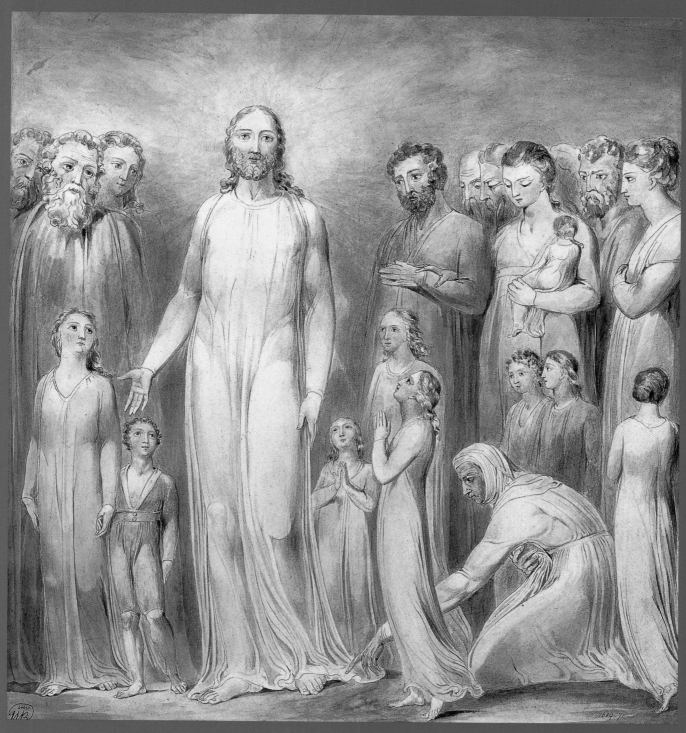

William Blake (1757–1827), *The Healing of a Woman with an Issue of Blood*.
Watercolor, Victoria and Albert Museum, London.

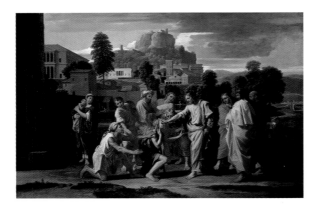

Nicolas Poussin (1593–1665)
Jesus Healing the Blind of Jericho, 1650.
Oil on canvas, Louvre, Paris.

Christ Heals the Blind at Jericho

The story appears in Matthew 20:29–34. Variations of the story appear in Mark 10 and Luke 18.

JESUS WAS ON THE ROAD BOUND FOR JERUSALEM, where he was to suffer and die. As he and the disciples left Jericho, two blind men began to shout after him: "Have mercy on us, Son of David!"

The crowd surrounding Jesus grew angry and told them to hold their peace. But the men would not be dissuaded and shouted even more loudly.

Jesus stopped and asked the blind men, "What do you want me to do for you?"

They begged him to restore their sight. He had compassion for them and reached out and touched their eyes. At once, they could see. They got up and followed him to Jerusalem.

ON HIS FINAL JOURNEY TO JERUSALEM, WHERE HE WILL BE BETRAYED and crucified, Jesus passes through Jericho, a town only fifteen miles from his destination. Matthew places this story immediately before Christ's triumphal entry into the holy city.

The two blind men use the term "Son of David" when they call out to him. It is a messianic title, placing Jesus in the royal line. They express their hope that he is the chosen savior of Israel.

Matthew's story is not simply about physical healing. It is a figure for the nature of discipleship. Once Christ grants the blind men their sight, they follow him. The road up to Jerusalem leads inexorably to the cross. The blind men, who now perceive their Lord clearly, are embarking on a journey that will entail suffering.

In the Gospels, when the lame walk, the deaf hear, and the blind see, their cures are not ends in themselves. These people have been freed to begin again, embarking on a journey with their Lord.

Nicolas Poussin painted this image for a wealthy merchant in Lyon. It subsequently entered the collection of Louis XIV, and is now housed in the Louvre. Poussin reduces the figures to a minimum. The blind men, agitated, kneel before the calm figure of Jesus. The canvas is neatly divided into two halves. On the left, the blind men and the abbreviated crowd are full of movement. On the right, the placid apostles surround Jesus. Christ seems to reach across the void, pulling the blind men out of confusion into the steady, faithful realm of the disciples.

Born in France, Poussin spent most of his career in Rome. He was inspired by the remains of Roman antiquity and by the work of Raphael. His style is characterized by a rational, classical spirit.

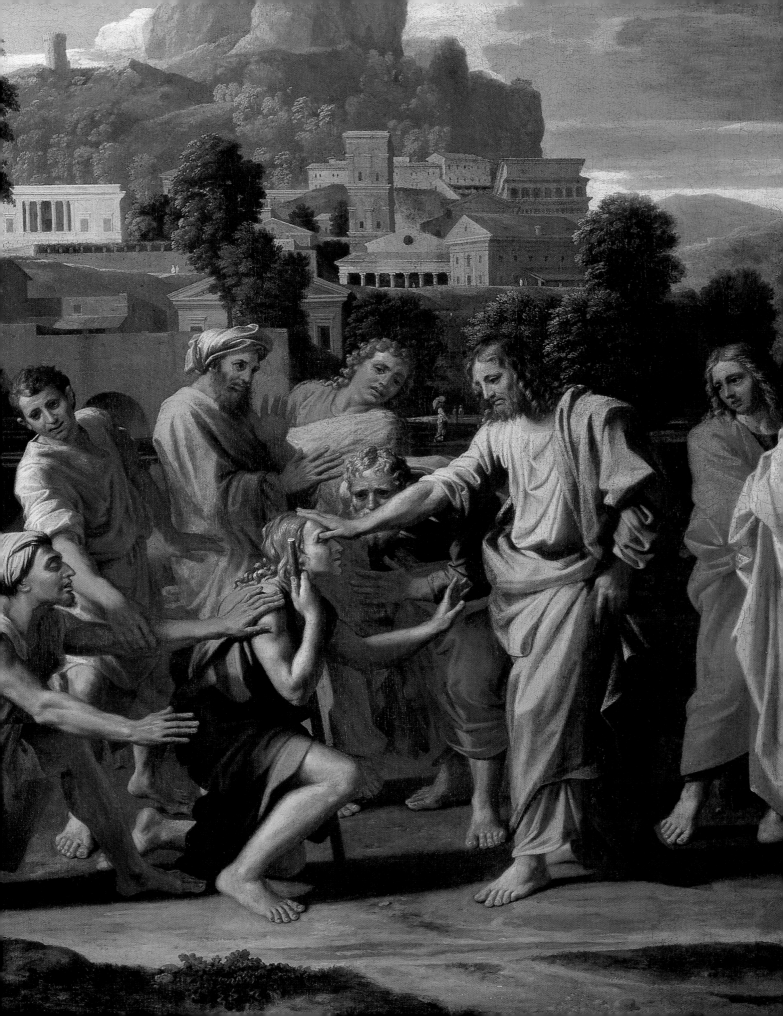

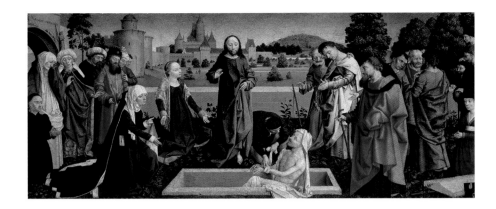

The Raising of Lazarus

The story appears
in John 11.

AZARUS, A MAN WHOM JESUS LOVED, WAS GRAVELY ill.
His sisters, Mary and Martha, sent word to Jesus to come quick-
ly, hoping he could heal their brother. When Jesus received their
message, he said, "This illness does not lead to death; rather it is
for God's glory, so that the Son of God may be glorified through
it." And he waited several days before setting out to Bethany, where Lazarus and
his sisters lived.

When he finally arrived, Lazarus was already dead. Martha ran to meet him as
he approached the village. "If you had been here, my brother would not have died,"
she wailed. He replied, "I am the resurrection and the life. Those who believe in me,
even though they die, will live."

Joined by Mary, who wept as she approached him, and a crowd of mourners,
Jesus made his way to Lazarus' grave. He, too, began to cry.

*The scene is set in an idealized north European landscape. Outside a
walled town, the crowd gathers in a graveyard. At the center stands
Christ. Lazarus emerges from his cold tomb as Mary and Martha, his
sisters, fall to their knees in wonder. To the left, townspeople react with
amazement. The disciples, to the right, look on in quiet awe, as Peter
gestures toward the tomb. At the margins on either side, the two
donors of the painting are depicted kneeling in prayer.*

Jesus told them to remove the
stone which sealed the tomb.
Martha tried to stop him: Lazarus
had been buried for four days—by
now his body would have begun to
decay. "Did I not tell you that if you
believed, you would see the glory of
God?" he asked her. So they rolled
away the heavy stone and Jesus
shouted, "Lazarus, come out!" And
the dead man emerged from his tomb, still wrapped in his grave clothes. "Unbind
him," Jesus said, "and let him go."

THE RAISING OF LAZARUS IS THE LAST OF CHRIST'S MIRACLES OR,
more properly, "signs," in the Gospel According to John. Christ's act of giving life to
Lazarus is presented as the immediate cause of his own betrayal and death. The Gospel

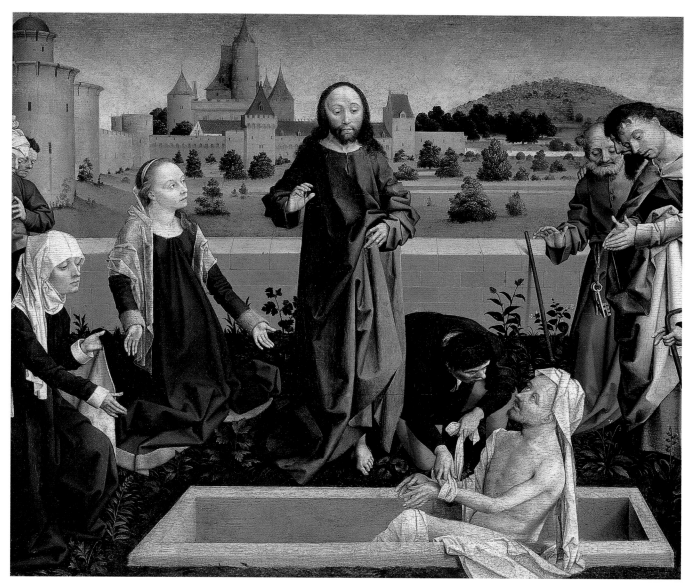

Colin d'Amiens (fl. mid-15th c.), *The Resurrection of Lazarus.*
Oil on wood, Louvre, Paris.

portrays Christ as both fully human and fully divine. His life is not taken from him; he freely lays it down. In this, the culminating miracle, he demonstrates his power over life and death.

When Jesus hears of Lazarus' fatal illness, he purposely delays journeying to Bethany, much to the confusion of the disciples. By the time he finally arrives, Lazarus has already been dead for four days—long enough for the body to have begun to rot in its grave. Jesus waits so that the miracle will be an unmistakable sign.

For the religious authorities, this is the final offense. Hearing reports of these wonders, they determine that Jesus himself must be executed. They fear that these signs will cause a rebellion which the Romans will crush, destroying the nation. They begin to lay plans to arrest and kill Jesus.

Christ knows that his actions will lead to his death—portrayed in John as the moment of his glorification—when he will hand over his life for the sake of the world. His final sign before his own death is to give life to another.

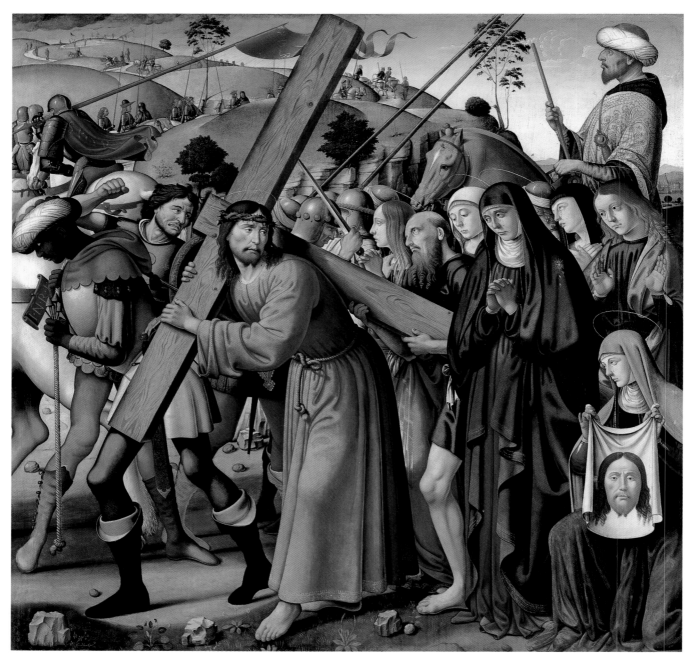

Biagio di Antonio (fl. 1475–95), *The Carrying of the Cross*.
Oil on wood, Louvre, Paris.

Veronica's Veil

ONDEMNED TO DEATH, JESUS CARRIED HIS CROSS through the streets of Jerusalem toward Calvary. His disciples had abandoned him, but a group of faithful women followed him to the end. As he toiled under the heavy weight of the cross, Veronica stepped out of the crowd and wiped his face. His image was miraculously imprinted on her cloth.

Some years later, the Emperor Tiberius fell ill. He sent one of his servants to Jerusalem, seeking medicine for his ailment. The servant encountered Veronica, who told him she had an image of Christ, which she had received from the Lord. If the Emperor beheld this image, she said, he would be made whole.

He asked if he could buy it with silver or gold, but Veronica would not sell the sacred cloth. Instead, she agreed to accompany him to Rome, where they could display it before the Emperor.

When they arrived in the imperial city, the servant went to Tiberius and told him of the veil. Fine fabrics were laid down in the Emperor's chamber, and the sacred cloth was brought in. When he beheld the image, he worshipped it, and was healed.

There are many variations of the Veronica story. Parts appear in the *Golden Legend* and in the *Acta Sanctorum*.

THE PERSON OF VERONICA IS ENTIRELY LEGENDARY. HER NAME IS probably a popular corruption of the term *vera icon,* or "true image," applied to a relic kept in Rome.

A number of images in Western Europe have been thought to be miraculous portraits of Christ. These are not paintings, but imprints said to be taken directly from the face or body of Jesus. They have been the focus of pilgrimage and prayer from the Middle Ages to the present day. The Shroud of Turin is the most famous of these images.

The story of Veronica explains how the "true image" came to be. It places her within the drama of the passion of Christ, on the road to Calvary. She is identified with the faithful women described in the Gospels who were present at the crucifixion. The miraculous image is given to her when she takes pity on Jesus, and dries his brow.

Biagio di Antonio was a Florentine painter of the late fifteenth century. He painted this retable for the Antinori Chapel in the church of Santo Spirito in Florence. It is now housed in the Louvre.

Christ turns back to look at Veronica as he continues on his way to execution. She kneels at the right, surrounded by the other women. She holds out the cloth parallel to the picture plane, showing us the miraculous image—a picture within a picture.

In popular devotion, Veronica is remembered in the sixth station of the cross, where she is presented wiping the face of Jesus. In the stations, the more fanciful elements of the tale are left untold; she is honored because of her act of pity for the suffering Christ.

Christ Appears to the Disciples at Emmaus

The story appears
in Luke 24:13-35.

N THE DAY OF THE RESURRECTION, TWO OF THE disciples left Jerusalem, bound for the village of Emmaus. As they made their way, they discussed all that they had witnessed in the city.

Jesus met them on the road, but they did not recognize him. He asked them what they were talking about.

One of them replied, "Are you the only stranger in Jerusalem who does not know the things that have taken place in these days?" And the whole story poured forth: their hope in Jesus, the shock of the crucifixion, and the strange rumors of the resurrection they had heard that day.

Jesus said to them, "How foolish you are, and how slow to believe all that the prophets have declared!" And he began to explain to them how the whole of the scriptures, from Moses through the prophets, had predicted that the Messiah would suffer.

When they came to the village for which they were bound, Jesus began to walk away, but they asked him to stay. They sat down to eat. Jesus took some bread, said the blessing, and broke it to share with them. At that moment, their eyes were opened and they recognized him. Just as suddenly, Jesus vanished.

They hurried back to Jerusalem and found the apostles, who said that the risen Christ had shown himself to Peter. The two disciples told them that Jesus had appeared to them on their journey, and made himself known in the breaking of bread.

THE JOURNEY TO EMMAUS HAS OFTEN BEEN READ AS A MODEL FOR Christian belief. The disciples, talking on the road, know the Christian story; they have witnessed Christ's crucifixion and they have heard of the resurrection, but they are perplexed. In their encounter with the stranger, they are offered an interpretation of the scriptures which begins to explain what they have seen. When they invite the stranger to stay with them, and begin to share a meal, they perceive their risen Lord.

Rembrandt uses his dramatic light to play, as the story itself does, with the idea of perception. We perceive the risen Christ only indirectly, through the response of his astonished disciple. We see Christ in silhouette, moments before he disappears.

For the believer, the faith is about more than the recitation of information and events. A richer understanding begins to emerge when the bare facts start to resonate with the deeper themes in the scriptures. This understanding becomes complete with the sharing of a meal. The classic Christian reading of the story is to see it as an assertion that the risen Christ is perceived through both Word and Sacrament.

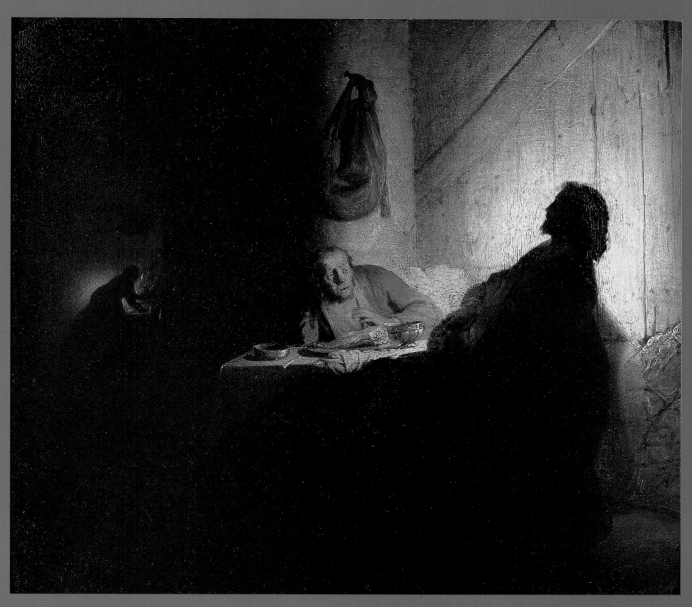

Rembrandt van Rijn (1606–69), *Christ at Emmaus*.
Oil on paper transferred to canvas, Musée Jacquemart-André, Paris.

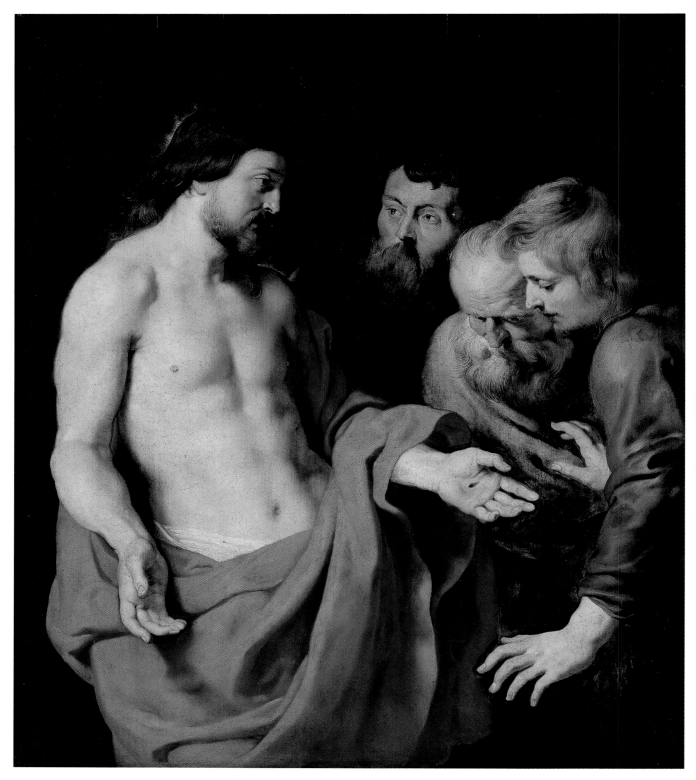

Peter Paul Rubens (1577–1640), *The Incredulity of Saint Thomas*, 1615.
Central panel of Rockox Triptych, Koninklijk Museum voor Schone Kunsten, Antwerp.

The Incredulity of Thomas

ON THE DAY OF THE RESURRECTION, AS EVENING fell, the disciples remained in hiding. They gathered in a house with all the doors locked. Suddenly, Jesus appeared among them. "Peace be with you," he said, and he showed them his wounds. Then he breathed on them and said, "Receive the Holy Spirit."

The story appears in John 20:19–29.

Thomas, one of the disciples, was not with them on that day. When he heard from the others that Jesus has risen from the dead, he scoffed and challenged them: "Unless I see the mark of the nails in his hands, and put my finger in the mark of the nails, and my hand in his side, I will not believe."

A week later, they were all gathered again in the same place, and this time, Thomas was there. Again Jesus showed himself and said, "Peace be with you." Then, turning to Thomas, he invited the doubting disciple to put his finger into the wounds. "My Lord and my God!" Thomas cried out in wonder.

Jesus said to him, "Have you believed because you have seen me? Blessed are those who have not seen and yet have come to believe!"

IN THIS TALE OF DOUBT OVERCOME, THERE IS A BLESSING FOR THE hearers. The closing words of Jesus are addressed to all the faithful who read this passage, for though they have not been witnesses to the resurrection, they have believed.

Embedded in the story is a complex theological argument. For the Gospel writer, the reality of the physical resurrection of Jesus was crucial. Jesus lives in his own wounded body. His physicality has, however, been transformed. The Gospel is careful to mention that the doors on both occasions were locked; this is a body that transcends time and space. And though Jesus is no longer subject to the ordinary laws of nature, he is physically present. This is not a vision or an apparition; this is not a ghost. Thomas is allowed to test his perception by touching the body of the risen Lord.

Rubens' intimate painting depicts a gentle Jesus holding out his hands for Thomas to see. The doubting man stares down at the wounds, his eyes bulging, as two other disciples look on. The story is about human flesh, tactile and living. The warm skin of the risen Christ contrasts with the taught, lined face of Thomas and the ruddy complexion of the young bearded apostle.

In the modern world, the claim of Christ's divinity meets with skepticism; in the ancient world, it was his humanity which was often called into doubt. During the doctrinal debates of the early centuries of the Church, stories like that of Thomas offered demonstrations of Christ's human nature.

Christ's dual nature, as both God and human being, is a central tenet of the Christian faith. It makes humanity's redemption possible. As Gregory of Nazianzus would write in the fourth century, "That which God has not assumed, he has not healed." By taking flesh, God assumes our human nature. By resurrecting Christ's body, God takes that humanity up into the Godhead. Human beings are reconciled to God.

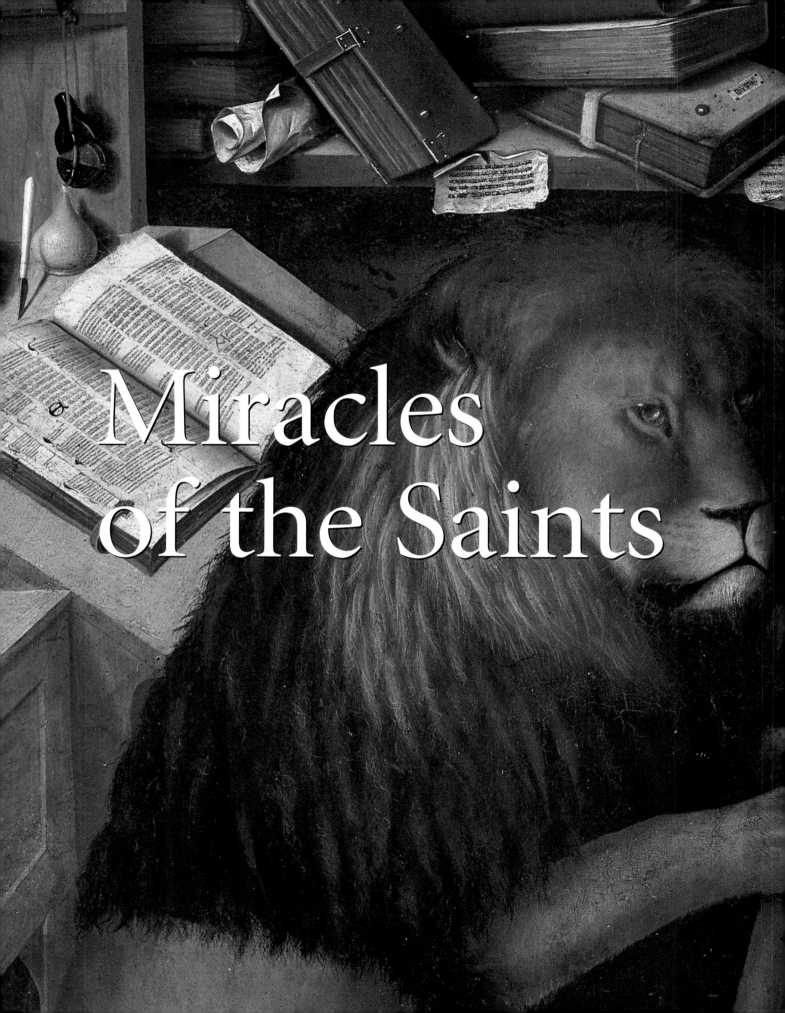

Miracles of the Saints

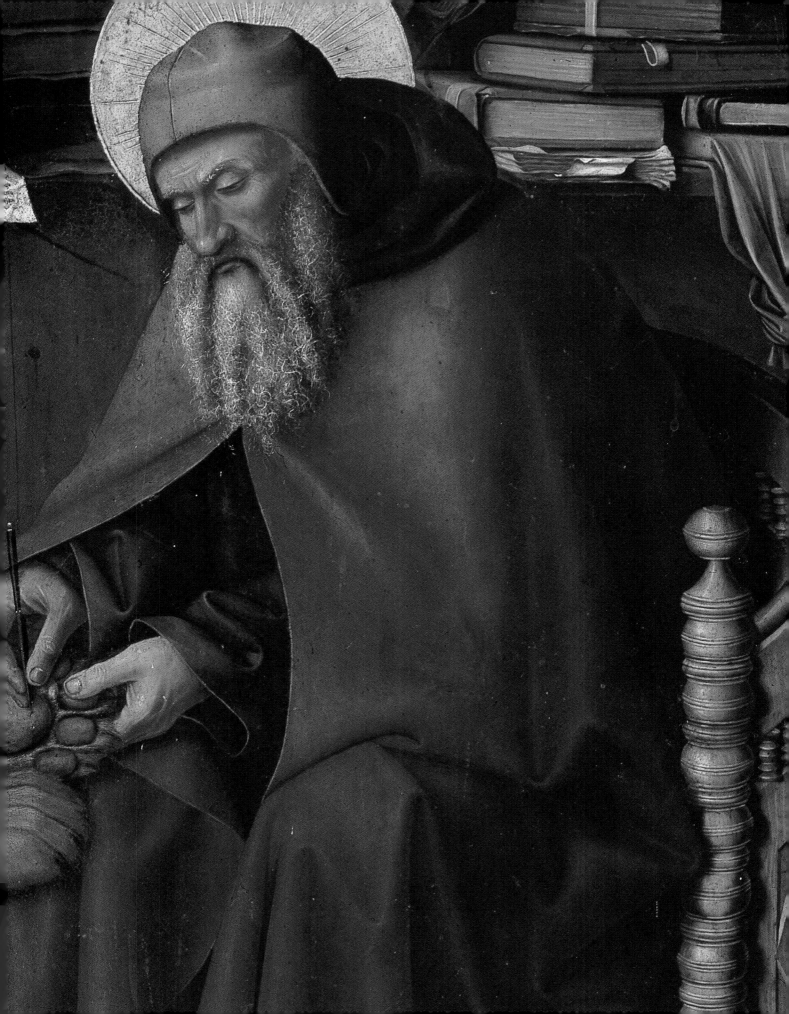

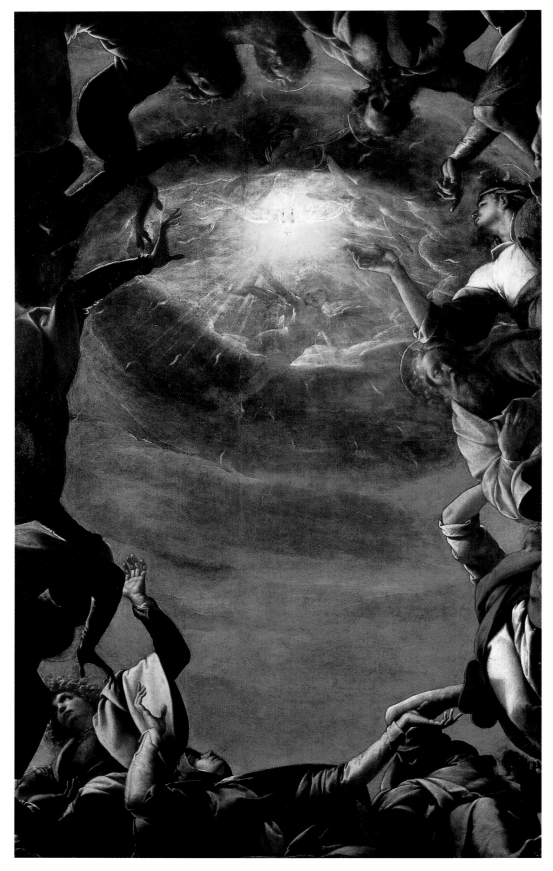

Pier Francesco Morazzone (1571–1626), *The Pentecost*.
Oil on canvas, Castello Sforzesco, Milan.

The Spirit Descends on the Apostles at Pentecost

IFTY DAYS AFTER THE RESURRECTION, ON THE FEAST of Pentecost, the apostles met together. Suddenly, the house where they had gathered was swept with a powerful wind. Tiny flames appeared and a little tongue of flame rested on each of them. Filled with the Holy Spirit, they began to speak in many languages.

Pilgrims to Jerusalem who had come for the feast began to gather, attracted by the sound. They were astounded by what they discovered—each one heard the apostles speaking in his or her own language. The crowd was perplexed, wondering what this signified. Some were dismissive, claiming the apostles were inebriated.

Peter stood up and addressed the crowd: "These are not drunks, as you suppose, for it is only nine o'clock in the morning. No, this is what was spoken through the prophet Joel:

'In the last days it will be, God declares,

that I will pour out my Spirit upon all flesh.'"

The story appears in the Acts of the Apostles 2.

IN GENESIS, THE STORY OF THE TOWER OF BABEL RECOUNTS HUMANITY'S attempt to build a man-made structure that would reach the heavens. God looks down on them as they work and responds to their hubris by confusing their speech, scattering them across the face of the earth.

In the story of Pentecost, that action is reversed. People come to Jerusalem from every corner of the known world, and all hear the apostles proclaiming the gospel in their own tongue.

Pentecost marks the moment in the New Testament when the Church is formed and starts to spread out to preach the gospel abroad. The apostles, having received the Spirit, are empowered as emissaries of God's word. No barrier will stand in their way. The outpouring of the Spirit is promised for all—young and old, slave and free, male and female.

Dramatically showing the scene from below, Morazzone throws the viewer into the midst of the apostles. As the sky opens to reveal the heavenly glory, the Spirit descends into our earthly realm in the form of a dove. The dove, interestingly, does not appear in the biblical account of Pentecost; its use as a symbol of the Holy Spirit comes from a different story, the baptism of Christ, in which the Spirit descends on Christ "like a dove."

At the Tower of Babel, human beings try to take heaven by storm, usurping the place of God. At Pentecost, God pours down the Holy Spirit, so that heaven may take the earth by storm.

Peter and John Heal the Lame Man

The story appears in the Acts of the Apostles 3.

THERE WAS A LAME MAN WHO USED TO BEG IN THE Beautiful Gate of the Temple in Jerusalem. One afternoon, Peter and John went to the Temple at the hour of prayer. As they passed the lame man, he called out to them, asking for alms.

Peter and John turned to him. "Look at us," Peter said, and the man looked up, hoping to receive money from them.

"I have no silver or gold," Peter said, "What I have I give you; in the name of Jesus Christ of Nazareth, stand up and walk."

Peter grasped the man's hand and lifted him up. His legs became strong, and he leapt to his feet. Then Peter and John walked into the temple with the beggar, who danced and jumped as he went.

AFTER THEY RECEIVE THE HOLY SPIRIT ON PENTECOST, THE APOSTLES carry on the work Jesus began. They perform miracles in Christ's name, curing the sick and casting out demons. They remain in Jerusalem and go up to the Temple regularly.

At the busy portico, Peter and John reach out their hands to the lame man, as John gestures heavenward. All around them, people come and go, unaware that a miracle is about to take place. Nicholas Poussin depicts the portico of the Temple with red stone classical columns and imposing steps—an idealized vision of the ancient city of Jerusalem.

With its wide gates and spacious porticoes, it provides a perfect place for them to preach the gospel to the pilgrims and devout who gathered there.

The healing of the lame man is one of the first miracles performed through the apostles. As the man leaps for joy, Peter turns to the astonished crowd that has gathered around and preaches to them. He offers a Christian reading of the Old Testament, reinterpreting the ancient texts in light of the resurrection of Jesus. The miracle which gives rise to his sermon provides a vivid illustration of Christ's power.

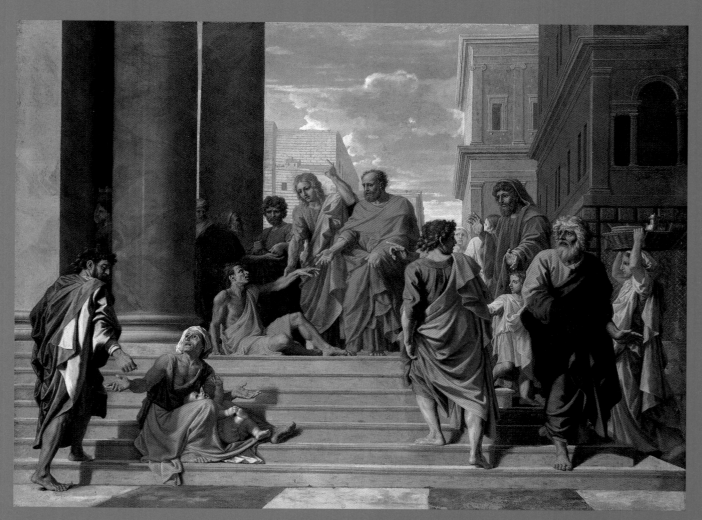

Nicolas Poussin (1594–1665), *Saints Peter and John Healing the Lame Man*, 1655.
Oil on canvas, Metropolitan Museum of Art, New York.

Peter, Ananias, and Sapphira

The story appears
in the Acts of the
Apostles 5:1–11.

 HE FIRST COMMUNITY OF BELIEVERS IN JERUSALEM shared all their earthly possessions. Those who had property would sell it and place the proceeds at the apostles' feet. They knew neither want nor poverty; all were provided for.

Among the believers, there was a couple named Ananias and Sapphira. They sold their property, but conspired to hold back a portion of the money they had made. When Ananias went to Peter and laid the money at his feet, Peter said, "Ananias, why has Satan filled your heart to lie to the Holy Spirit and keep back part of the proceeds of the land? While it was unsold, did it not remain your own? How is that you have contrived this deed in your heart?"

At these words, Ananias instantly collapsed, dead.

A few hours later, Sapphira arrived, unaware of her husband's death. Peter asked her how much they had received for the sale of their property. Sapphira lied, naming the same amount Ananias had laid at Peter's feet.

In this cartoon for a tapestry, Raphael emphasizes the power and authority of the apostles. As Ananias writhes in his death throes, the crowd recoils in horror. Peter's magisterial gesture, and the upright posture of his companions contrast vividly with the confusion below.

The cartoons were commissioned in 1515 by Pope Leo X, and intended as patterns for tapestries to be hung in the Sistine Chapel.

Peter asked her how she could have plotted with her husband and lied to the community. "Look," he said, "the feet of those who have buried your husband are at the door, and they will carry you out."

And Sapphira dropped dead, as her husband had before her. They removed her body and buried her next to Ananias, and the whole community was gripped with fear.

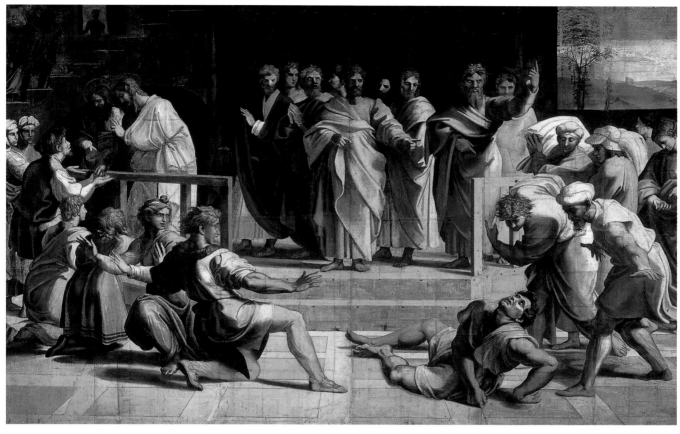

Raphael (1483–1520), *The Death of Ananias*, 1516.
Bodycolor on paper mounted on canvas (tapestry cartoon), Victoria and Albert Museum, London.

THE AUTHORITY OF THE APOSTLES IS ASSERTED IN A THREATENING display of power. Ananias and Sapphira are free to keep their possessions. The community shares its goods, but it does not coerce the members into selling their property. Their crime is the lie they tell, offering only a portion of their wealth, while claiming to have offered it all. Peter interprets this act as an attempt to deceive the Holy Spirit, who dwells among the believers. Their punishment is a swift and severe death. Though Peter does not actually strike them dead—he only confronts them with their wrongdoing—the result is fear, a dread that permeates the community.

There is a striking contrast between this miracle and the signs and wonders performed by Jesus in the Gospels. Though Christ speaks harshly at times, especially when he confronts hypocrisy and injustice, he never endangers anyone's life. In fact, quite the opposite is true—Christ's miracles are always liberating, not threatening.

The disciples exercise a kind of authority in this story that even Jesus did not claim. It challenges believers to ask just how much the apostles had learned from their master. Is this an abuse of their new-found power?

Peter Heals the Sick with His Shadow

The story appears
in the Acts of the
Apostles 5:12–16.

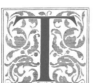

THE APOSTLES REGULARLY GATHERED IN SOLOMON'S Portico within the Temple precincts. There they taught, gathering many into the community of believers. God worked many miracles and wonders through them, and the people were in awe.

Seeing these signs, people from all the surrounding countryside brought those who were sick or tormented by demons to the apostles. They laid the afflicted out on mats in the streets so that Peter's shadow would pass over them as he walked by. All of them were cured.

THE APOSTLES CONTINUE TO GAIN AUTHORITY IN THIS STORY, WHICH is the direct continuation of the tale of Ananias and Sapphira. The people respect their preaching and join the band of the faithful in large numbers. Yet they are in awe of the apostles, and wary of approaching them. Unlike those who sought out Jesus and pressed in on him from every side, these crowds keep their distance. Peter's passing shadow is enough to heal them.

Painted for the Brancacci Chapel in the Florentine Church of Santa Maria della Carmine, this fresco is part of a series depicting the life of Saint Peter. Masaccio's vigorous perspective and full-bodied figuration reflect the pictorial discoveries of the early Renaissance. The play of light and shadow in the fresco, important to the story told here, is designed with the actual space in mind: The window of the chapel dictates the direction from which light enters the painting.

Masaccio's slightly imperious Peter walks right past the crumpled figures of the ill. In this portrayal, the frightened, sinful fisherman who once begged Jesus to leave him has been transformed into the prince of the apostles.

In the Acts of the Apostles, an institution begins to take shape. At first, the believers are simply referred to as those who follow the Way. Eventually, they have a name: Christians. As the emerging Church evolves its structures of authority, the apostles guide the early community.

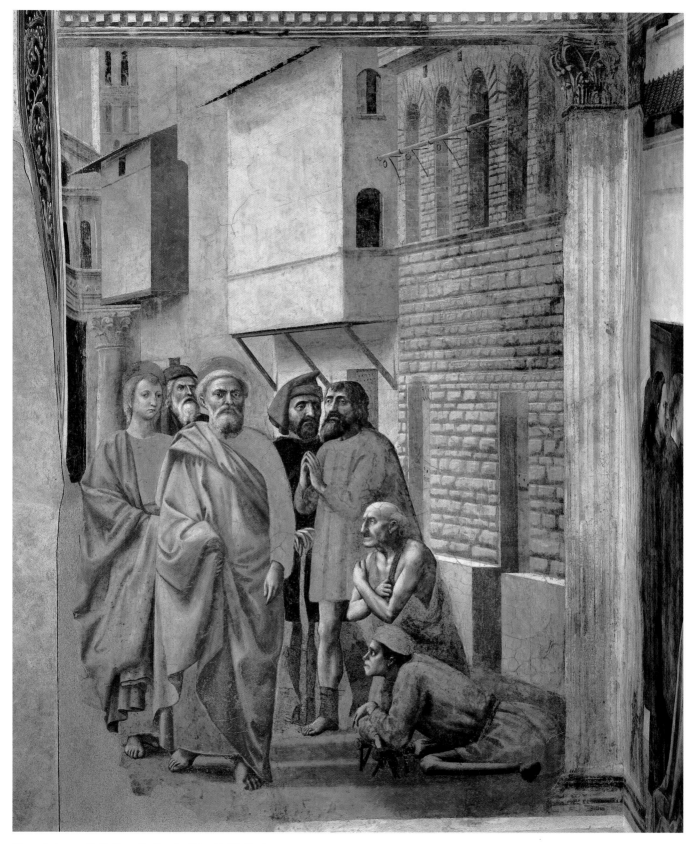

Masaccio (1401–28), *St. Peter Healing the Sick with His Shadow.*
Fresco, Brancacci Chapel, Santa Maria del Carmine, Florence.

Anonymous, *The Conversion of Saint Paul*, 13th c.
Manuscript illumination, Bibliotheque Sainte-Genevieve, Paris.

The Conversion of Paul

AUL WAS FERVENTLY OPPOSED TO THE EARLY Christian movement, and persecuted those who followed the Way of Christ. He obtained letters from the religious authorities permitting him to arrest Christians, and set off for Damascus to carry out his mission.

As he neared the city, a blinding light flashed from heaven, and Saul fell off his horse. As he lay stunned on the ground a voice asked, "Saul, Saul, why do you persecute me?"

Saul answered, "Who are you, Lord?"

The voice said, "I am Jesus, whom you are persecuting."

Saul's companions heard the voice, but saw nothing. When Saul rose from the ground, he was blind. They led him into the city.

In Damascus there was a disciple named Ananias. The Lord Jesus appeared to him in a vision and told him to go to the place where Saul was staying. He was to lay hands on Saul and heal him of his blindness. Ananias questioned the Lord: Was not this Saul a persecutor of the Church? The Lord said to him, "Go, for he is an instrument whom I have chosen to bring my name before gentiles and kings and before the people of Israel."

So Ananias did as he was told. He found Saul in the house which the Lord had described to him. He laid his hands on Saul, who regained his sight, and was baptized.

The story appears in the Acts of the Apostles 9.

PAUL HAS TWO NAMES. HIS HEBREW NAME, SAUL, IS USED IN THE Acts of the Apostles until he is commissioned as a missionary to the gentiles. Thereafter, he is called by his Roman name, Paul.

Saul's change of heart is one of the most dramatic and sudden conversion stories in the Bible. He is transformed from a persecutor into an apostle. Once he has been healed of his blindness, he will carry the Christian message out into the nations of the gentiles.

Saul's conversion is rich in allusion. The Gospels and Acts consistently use the metaphor of blindness to describe more than purely physical sight. Those who can see are those who perceive spiritual truths. Blinded by his own hatred of the Christian Way, Saul sets off to Damascus to accomplish his vengeful plan. The light of Christ which pours down on him from heaven is too bright for him. Struck with physical blindness, his body manifests his spiritual state. He hears the words of Christ, which leave him stunned. He only regains his sight once he encounters a disciple, a follower of the Way he has tried to extinguish. Once he can see again, he is able to perceive God at work in the Christian community.

It should be noted that the Ananias mentioned in this story is not the same character who appears earlier in Acts, married to Sapphira.

In the Psalter of the Abbey Saint Elizabeth de Genlis, *a Gothic manuscript from France, Saul tumbles from his horse against a background of burnished gold. The architectural frame evokes the early Gothic cathedrals. Saul's hand and the horse's hoof break the frame, giving dimension to an otherwise flat composition. The light from heaven has been rendered as tongues of red fire pouring down upon him.*

Peter Raises Tabitha from the Dead

The story appears
in the Acts of the
Apostles 9.

 ETER SET OFF ON A JOURNEY TO VISIT BELIEVERS AND preach in the villages scattered throughout the Plain of Sharon.

There was a woman named Tabitha living in the town of Joppa who was a faithful disciple known for her good works. When she grew ill and died, her friends sent two men to bring Peter to Joppa. When he arrived, Peter went to the place where Tabitha lay. Her body was set out in an upper room in her house, surrounded by mourning friends. Weeping and lamenting, they showed him all the tunics and garments Tabitha had made. Peter sent them all from the room and knelt down by the bedside to pray. Then he said to her, "Tabitha, get up!" Her eyes opened, and when she saw Peter, she took his hand and he helped her get out of bed.

Peter called the mourners back in, and they discovered Tabitha restored to life. Amazed and thankful, they praised God. Word of the miracle spread through the town, and many were joined to the faith.

THE RAISING OF TABITHA COMES AT A TURNING POINT IN THE ACTS of the Apostles. As Peter sets off on his preaching journey, the gospel is not only brought to the people of Israel, but is introduced to the gentiles. Peter's arrival in Joppa sets the scene for his later encounter with Cornelius the Centurion, the first gentile to be converted.

This story shares a number of motifs with other tales about the raising of the dead. Tabitha's friends send for Peter, as Jairus sent for Jesus to heal his daughter. When Peter arrives, he puts the mourners out of the room so that he can pray in peace with the body, just as Jesus did. The author of the Acts presents Peter's action as a continuation of the work Jesus began.

The detail of Tabitha's friends showing Peter the garments she made adds a touching immediacy to the tale. Peter's miracle takes place in the home of an ordinary, kindly woman who was noted for her generosity and the skilled work of her hands.

Eustache Le Sueur was a French Baroque painter noted for a cool, classicising style. He was a founding member of the Royal Academy of Painting and Sculpture. He is particularly noted for a series of large canvasses depicting the Life of St. Bruno he made for the monastery of the Grande Chartreuse in Paris, which are now in the Louvre. This painting was made for the church of Saint Etienne du Mont in Paris.

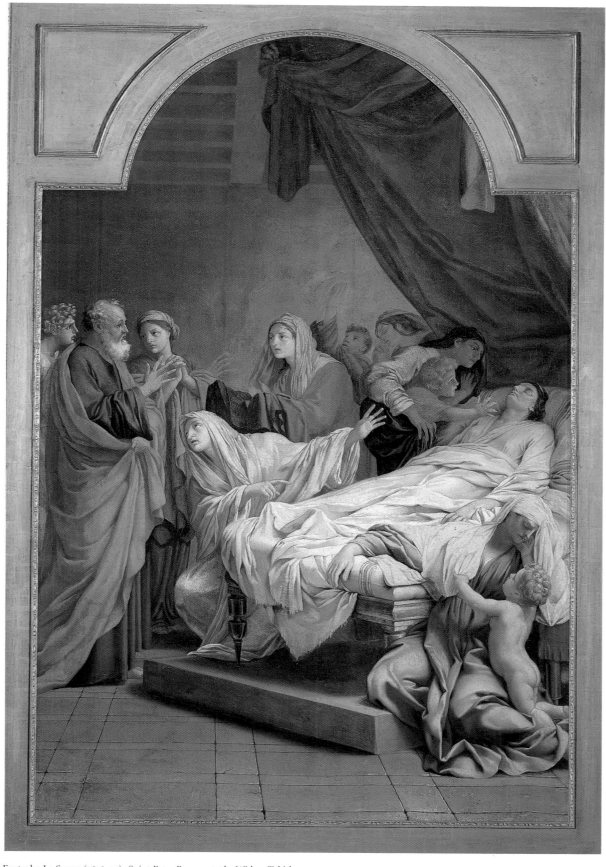

Eustache Le Sueur (1616–75), *Saint Peter Resurrects the Widow Tabitha.*
Oil on canvas, Art Gallery of Ontario, Toronto.

Peter Is Delivered from Prison

The story appears
in the Acts of the
Apostles 12:1–11.

KING HEROD AGRIPPA HAD GROWN VEXED WITH THE growing Christian movement. He arrested James and had him beheaded. He also arrested Peter, and threw him into prison.

The night before he was to be brought before the king and people, Peter was asleep between two guards. Suddenly, an angel appeared in his cell in a blaze of light. "Get up quickly," the angel ordered. Peter's manacles fell from his wrists. The angel told him to put on his belt and sandals and to wrap himself in his cloak.

The angel led him through the prison unnoticed, past two different sets of guards. Peter followed obediently, believing he was experiencing a vision. When they came to the iron gate of the prison, it opened by itself. As they walked down the lane, the angel suddenly disappeared, and Peter was alone. Only then did he realize that it was not a dream and he was actually free.

THE DISTINCTION BETWEEN A VISION AND A MIRACLE IS OFTEN hard to discern. Even as he walks through the prison and out into the night air, Peter distrusts his senses. It is only when he finds himself alone on the street that he knows something tangible has taken place.

These gilded bronze bas-reliefs were designed by Antonio Pollaiuolo for the Church of San Pietro in Vincoli in Rome, which contains the chains with which Peter was reputedly manacled. In these reliefs, Pollaiuolo imagines the prison as an idealized Renaissance palace, complete with carved swags and a coffered ceiling. The angel gently wakes Peter and leads him past the sleeping guards. As they approach the outer gate, they trample Roman armor underfoot. The gilding is used both to accentuate the details of the composition and to lend a sumptuous quality to the work.

The confusion continues after this portion of the story ends. Once Peter has been freed, he makes his way to the house of a believer named Mary and knocks on the door. The maid sees him outside, and in her excitement, runs to tell everyone that he has been released, while Peter remains left out in the cold. Mary and the others doubt the maid. They claim she must have seen his guardian angel. As they argue, Peter keeps knocking. When they finally go down and see him standing at the gate, they are overjoyed.

No one in the story expects a miracle. Confronted with the physical reality of Peter's escape, they seek to explain it away. But in the end, the plain fact of Peter standing alone in the street convinces everyone, even the saint himself, that he has been released through divine intervention.

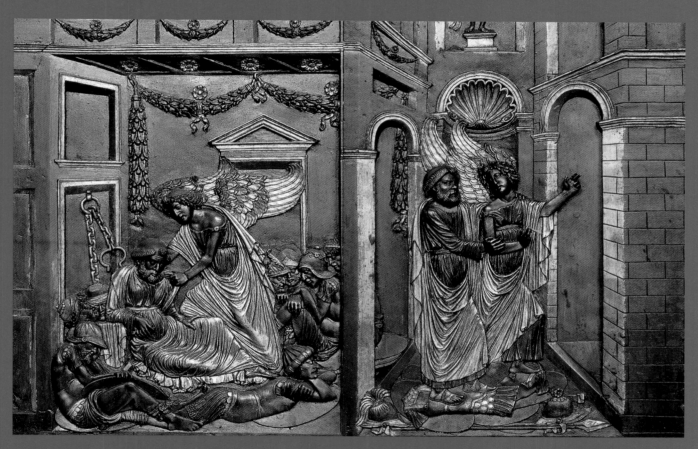

Antonio Pollaiuolo (1433–98), *Liberation of Saint Peter* (detail), 1477.
Gilded bronze bas-reliefs from the doors of the altar, San Pietro in Vincoli, Rome.

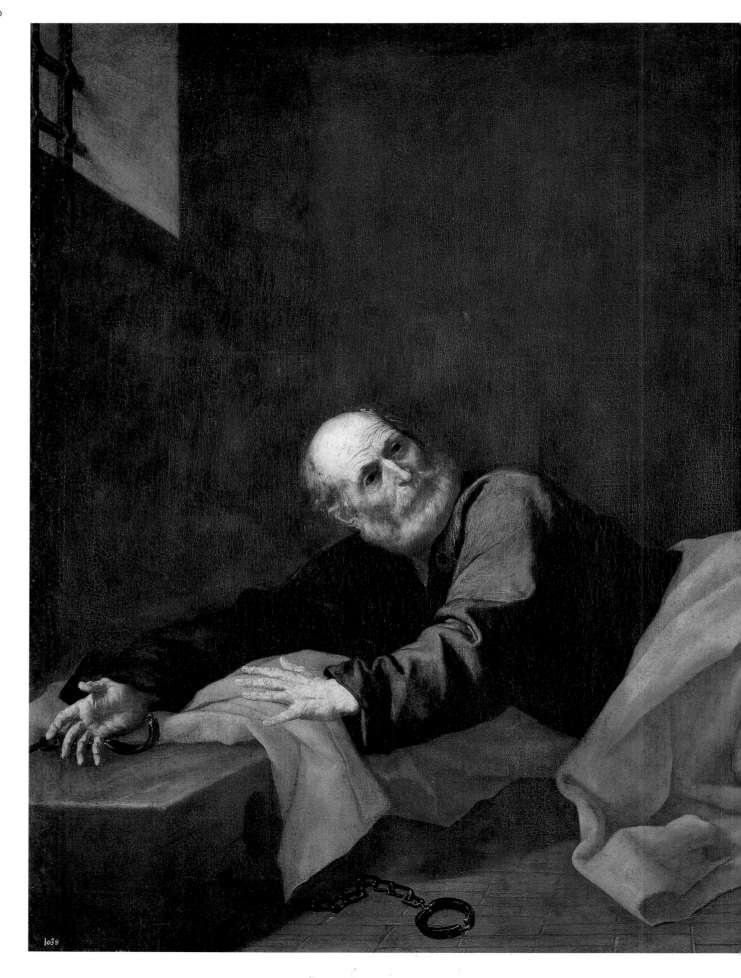

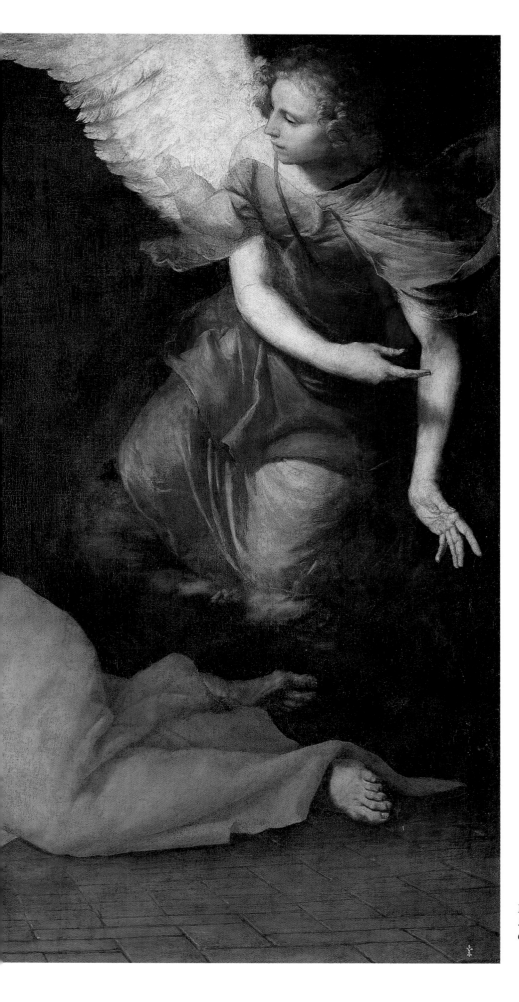

Jusepe de Ribera (1591–1652)
Saint Peter Freed by an Angel, 1639.
Oil on canvas, Museo del Prado, Madrid.

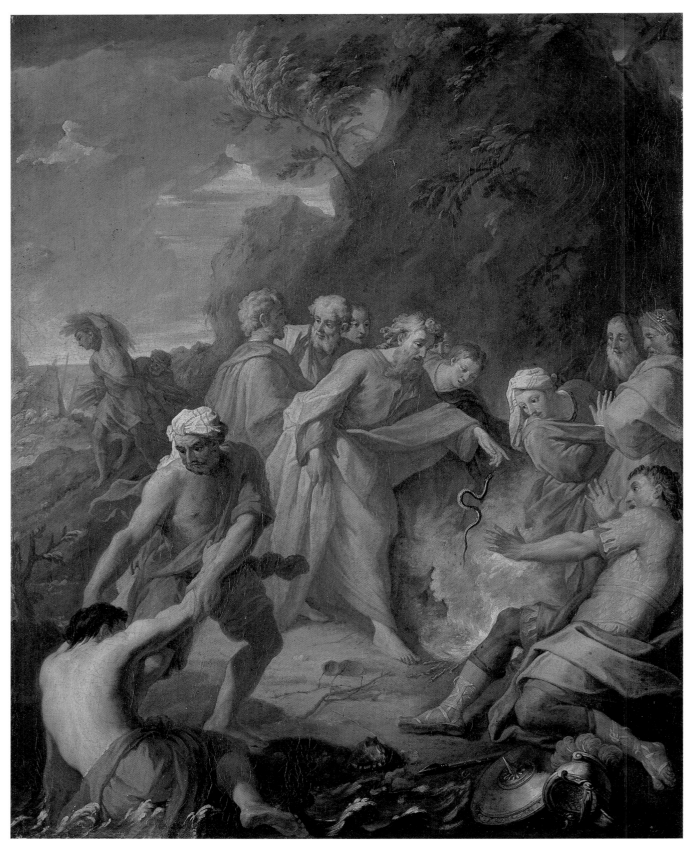

Claude Verdot (1667–1733), *Saint Paul of Malta Throwing a Serpent, Which Had Attached Itself to His Hand, Into the Fire.*
Oil on canvas, Louvre, Paris.

Paul and the Viper

 AUL WAS ARRESTED IN JERUSALEM. INVOKING HIS right as a Roman citizen to have his case brought before the Emperor's tribunal, he was sent by sea to the imperial city.

The story appears in Acts 28:1–6.

The ship set sail late in the season, when there was a great danger of storms. Soon after they left Crete, the winds grew fierce. Battered by high seas, the sailors began to jettison the cargo. They were driven off course and drifted for days without food. At last they sighted land, but as they headed towards the shore, the ship struck a reef and broke up. Those who could swim plunged into the sea. The rest held on to planks and debris, making their way to the beach as best they could. Amazingly, no one was lost.

On landing, they discovered that they had reached Malta. The natives came down to the shore and helped the survivors of the wreck. It was cold and raining, so they began to make a fire.

Paul, who had gathered some brushwood, approached the flames. Suddenly, a poisonous viper, alarmed by the fire, emerged from the wood. It bit Paul on the hand and clung to him. The natives saw this and said to each other, "This man must be a murderer; though he has escaped from the sea, justice has not allowed him to live."

Paul, however, shook the creature off and cast it into the fire. The natives looked on—surely his hand would begin to swell and he would die from the bite. But Paul showed no signs of harm. When they saw he was not hurt, they decided he was a god.

THE NATIVES' INTERPRETATION OF THE SNAKEBITE AS HOLY RETRIBUTION turns out to be false. Far from being a criminal, Paul is revealed to have special divine protection. The natives take this as a sign of Paul's divinity. The same mistake was made at Lystra, where Paul and Barnabas were mistaken for incarnations of Zeus and Hermes after healing a lame man. The pagan priests even prepared to offer a sacrifice to them, much to the missionaries' horror and dismay.

Paul's encounter with the snake evokes two Gospel passages. In Luke, Jesus gives his disciples the "authority to tread on snakes and scorpions, and over all the power of the enemy."

Claude Verdot paints a comprehensive rendering of the story. Every detail is included—the sinking of the ship, the saving of the sailors, the gathering of brushwood, and the making of a fire. As Paul throws off the viper, the crowd, including the centurion, pulls back in surprise.

Nothing will hurt them, he says. At the end of Mark, Jesus tells them they will be able to take up snakes in their hands and remain unharmed.

The snake is the ancient enemy, first encountered in the Garden of Eden. It is a symbol for all that rebels against God. These sayings reflect the power given to the faithful to overcome every barrier separating them from God.

James and Hermogenes

The story appears in
the *Golden Legend*.

THERE WAS A MAN NAMED HERMOGENES WHO
practiced magic and cast spells. He hated the apostle James and
the message that he preached. So one day he sent his disciple
Philetus to contend with James.

When Philetus appeared before the apostle, James performed
many miracles, which convinced him to convert to the faith. Philetus returned to
his erstwhile master, and reported that James preached the truth. Hermogenes was
furious, and cast a spell on Philetus that paralyzed him. Philetus' son went to James
for help, and the apostle gave the boy a small kerchief, with the promise that the
Lord could break even the most powerful spell. Philetus was immediately cured,
and went to join James.

Hermogenes was all the more enraged, and sent demons to bind and kidnap
James. When the demons approached the apostle, they cried out in agony and
begged for mercy. In his holy presence, they felt as if they were burning. James sent
them back to Hermogenes with orders to bind him and bring him back with them.

The demons did as they were bidden, and when they returned with
Hermogenes, they asked James' permission to torment the magician. Showing his
compassion, James banished the demons and unbound Hermogenes.

*This small panel comes from a predella that was originally part of a
major altarpiece in the Church of Santa Maria degli Angeli in
Florence, produced in the workshop of Agnolo Gaddi. This scene has
been attributed to Lorenzo Monaco, who trained in Gaddi's studio.
The altarpiece has been broken up: Other panels are in the Boden
Museum in Berlin and the National Gallery in London.*

Hermogenes was speechless—
how could the apostle not take his
revenge? But James told him he was
free to go. Hermogenes said to him,
"I know the wiles and malice of the
devils; if you do not protect me from
them, they will come back to kill
me." So James gave the magician his
staff as protection.

Hermogenes gathered all his books of spells and magical tools, and threw them
into the sea. Then he returned and, falling at the feet of James, asked to be received
into the faith. From that day on, he grew in conviction, virtue, and acts of charity.

JAMES AND JOHN, TWO BROTHERS FROM GALILEE, WERE AMONG
Jesus' twelve chosen apostles. Brash and fierce, they were nicknamed "sons of thunder"
by Christ.

In this apocryphal tale, James faces down a conjurer who uses his sinister arts to
control and enslave people. It is a story about magical power. But James, too, has

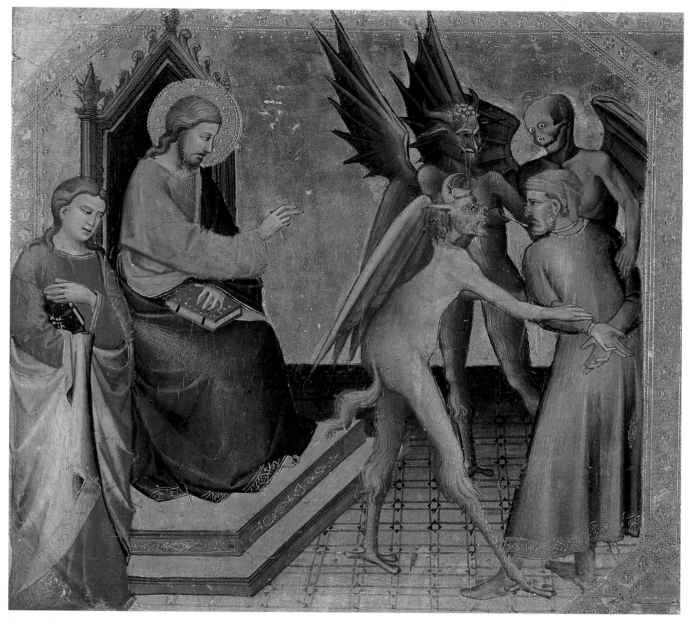

Lorenzo Monaco (c. 1370–1425), *Hermogenes Bound by the Devils He Sent Against Saint James the Elder*, 1388. Tempera on wood from an altarpiece, Louvre, Paris.

extraordinary abilities, which he uses to do good. His kerchief and staff are powerful weapons he employs to control demonic forces.

There is some humor in the story, as we watch Hermogenes grow increasingly frustrated in his attempts to defeat James. Hermogenes' own magic is used against him when James sends the demons back to fetch him. Who has the greater powers in the end? Not the magician who conjured the devils, but the apostle who does God's will. Forced to acknowledge defeat, Hermogenes is undone by James' kindness. His conversion is the inevitable end of the contest.

In the Bible, miracles are generally not seen as magical. They are signs which point to larger spiritual lessons, or they are incidences of God's mercy for the suffering. This distinction was clearly not recognized by the author of this story.

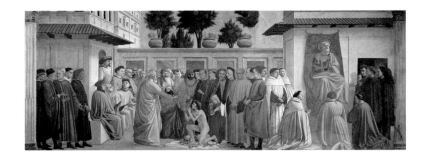

Masaccio (1401–28)
Resurrection of the Son of Teofilo and St. Peter Enthroned.
Brancacci Chapel, Santa Maria del Carmine, Florence.

Peter Raises the Son of Theophilus

The story appears in the *Golden Legend.*

WHEN PETER ARRIVED IN THE CITY OF ANTIOCH, THE authorities threw him into prison and shaved his head to shame him. But over time, his powerful preaching and miraculous healings convinced his captors that they had erred. When he was finally released from prison, he encountered a man named Theophilus, the prefect of the city. Fourteen years earlier, his son had died. Theophilus and the apostle went to the tomb, and Peter raised the boy from death.

With this and other miracles, he converted the people, and many joined the faith. The grateful Theophilus even turned his palace into a church. He had a great chair made and set on a high platform, so the apostle could be seen and heard when he preached to the people. Peter lived in Antioch as bishop for seven years, before finally setting off for Rome.

THE CHAIRING OF ST. PETER WAS A HOLY DAY IN THE LITURGICAL year, commemorating the apostle's enthronement as bishop. The bishop's chair, or *cathedra*, was an important symbol of his authority. In St. Peter's in Rome, a chair believed to have belonged to the apostle was preserved in a massive shrine created by Bernini in the apse of the basilica.

In this story, Theophilus prepared the chair for a practical purpose, so that Peter could be seen above the throngs in the church. It also exalted the apostle above the crowd.

The miracle in this story—the raising of one so long dead and buried—is unusual. Most stories involving revival of the dead follow the demise more immediately. The length of time that has elapsed makes the miracle all the more wondrous; after fourteen years, the body would be completely decayed, perhaps reduced to bones. Peter's action dramatically affirms his power to grant life in the name of Jesus.

In a fresco from the Brancacci Chapel, Masaccio sets the scene in a beautiful Italianate courtyard. The naked youth and his grateful father kneel before the saint.

On the right, a group of supplicants kneels before a painted image of the seated Peter, a reminder of the Church festival connected to the story. Apart from Peter and Theophilus, the crowd is dressed entirely in contemporary Florentine fashion. The crowd at right includes several monks. Many of the figures are believed to be portraits of noteworthy Florentines, including Brunelleschi, Alberti, and Masaccio himself.

Portions of the work were tampered with after the Brancacci family fell into political disgrace in 1436. Filippino Lippi was responsible for the repair and completion of the cycle.

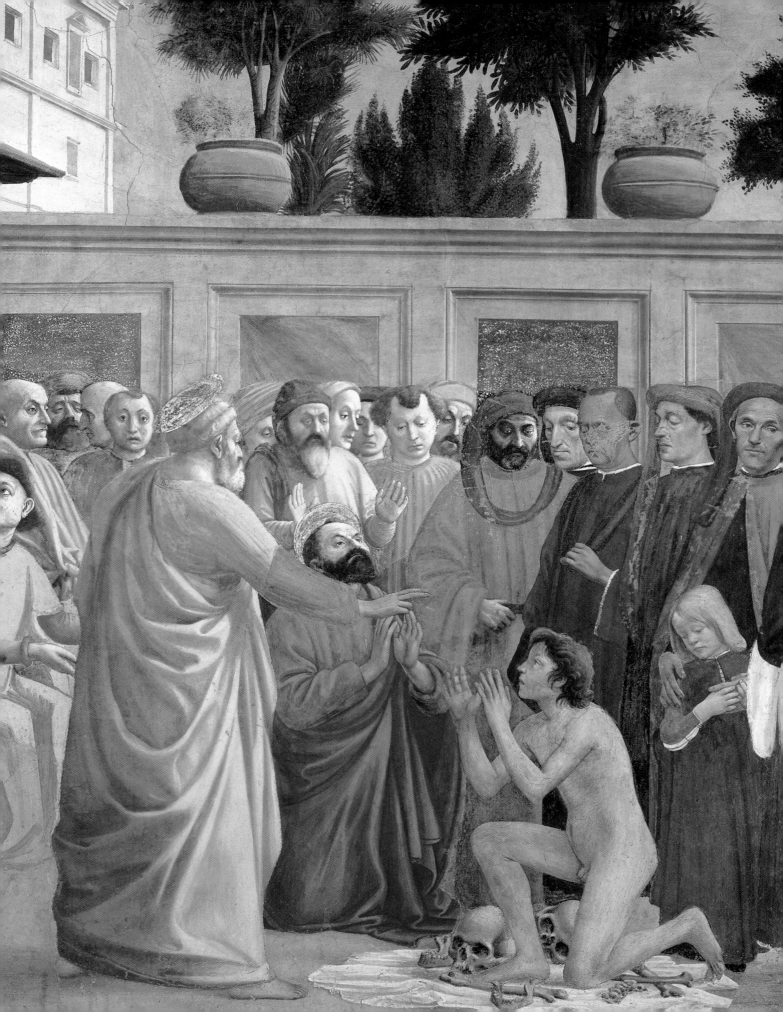

Peter, Paul, and Simon Magus

The story appears in the *Golden Legend*.

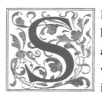

SIMON MAGUS WAS A CONJURER AND MAGICIAN WHO led many astray with his evil arts. He and Peter disputed one another many times: first in Jerusalem, and later in Rome. Simon was favored by the Emperor Nero, who even had a statue erected in his honor, which was inscribed: "To Simon the Holy God."

Peter and Simon met before the emperor in a final confrontation, which was also attended by Paul. The magician announced that he would ascend into heaven, providing final proof of his divinity. He had a wooden tower built on the Capitoline Hill. Crowned with laurel, he climbed to the top of the structure and leapt off. Demons carried him through the air, and he flew out above the astonished crowd.

Paul said to Peter, "I will pray; you give the command." And he knelt down to implore God's aid.

Nero pointed to the flying magician and said to the two apostles, "This man is truly God, and you are traitors."

Paul asked Peter, "Why are you waiting? God calls us to act."

So Peter addressed the demons: "I command you angels of Satan, in the name of Jesus Christ, to let go of Simon and let him fall to the earth."

Immediately the demons released their grip. Simon plummeted to the ground and died instantly of a broken neck.

SIMON MAGUS EXERCISED A POWERFUL HOLD ON THE IMAGINATION of the Church through the Middle Ages. In the eighth chapter of the Acts of the Apostles he is described as a magician who enthralled people with his tricks until he encountered the apostle Philip, and was converted and baptized. Thereafter, he would not leave Philip's side, and was astounded by the miracles the apostle performed in Jesus' name. When he saw that Peter and John were laying hands on the believers, giving them the gift of the Holy Spirit, Simon offered them money to grant him such power. Peter was offended and rebuked him. Simon repented and asked Peter to pray for him. The term "simony," meaning the sale of church offices, derives from this passage of the Acts.

Benozzo Gozzoli studied with Lorenzo Ghiberti and Fra Angelico in Florence. This panel, part of the predella of an altarpiece, was painted for the Florentine Alessandri family for the Church of San Pier Maggiore. Three companion panels depict a miracle of St. Zenobius, the conversion of Paul, and a miracle of St. Benedict.

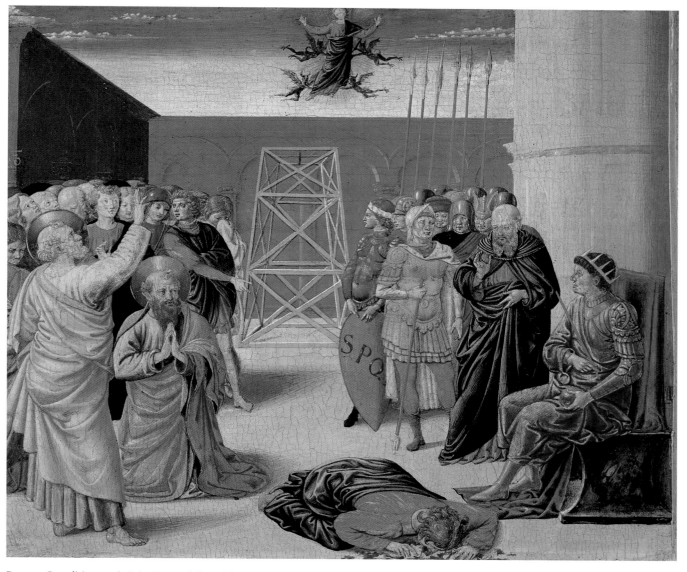

Benozzo Gozzoli (1420–97), *Saint Peter and Simon Magus.*
Tempera on wood from an altarpiece, Metropolitan Museum of Art, New York.

This is all we know of Simon from the canonical writings. Later texts elaborate Simon's story, describing him as a powerful heretical figure, fighting Peter at every turn. He is associated with the Gnostic heresy, and is credited with turning whole cities against the Christian faith. The *Golden Legend* collects many of these stories and presents Simon as an evil genius of egomaniacal power.

Ultimately, Simon cannot win his battle against Peter. In their encounter before the Emperor Nero, Simon overplays his hand. Although he can conjure the demons that carry him through the air, Peter proves to have the greater power. Invoking the name of Jesus, the apostle compels the demons to drop the magician, and Simon is cast to the ground.

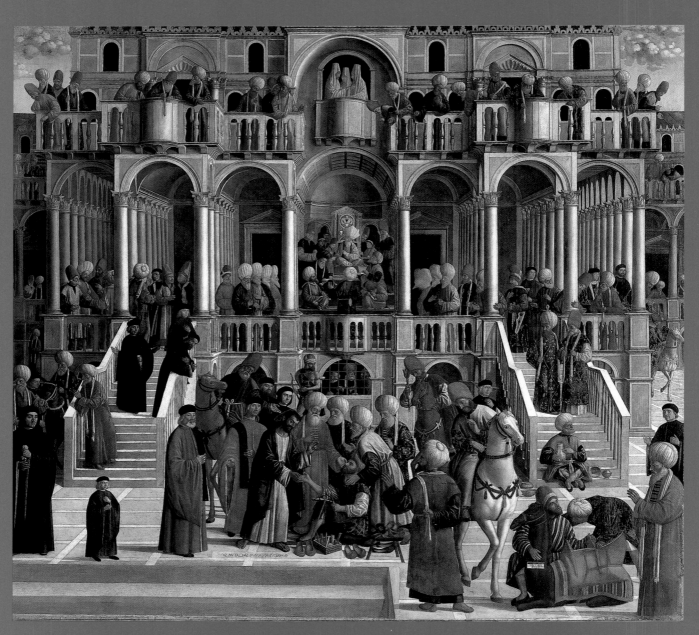

Giovanni Mansueti (1460–1526), *Saint Mark Healing Saint Anianus.*
Tempera on canvas, Gallerie dell' Accademia, Venice.

Mark Heals Anianus

HE EVANGELIST MARK WANDERED THROUGH THE city of Alexandria, and was disturbed by the luxury and vice that he saw. Finding his sandal worn out from so much walking, he visited a cobbler in the public square. As the shoemaker labored over the repair, his grip slipped and he pierced his hand with an awl. In pain, he cried out "O! The one God!"

When Mark heard this, he knew that God had made his journey successful. He took some earth from the ground, spat on it, and rubbed it into a paste, which he applied to the wound. The man was immediately healed.

The grateful shoemaker took Mark to his home and asked him many questions: Who was he? How had he come to Alexandria? Mark answered that he was a servant of Jesus Christ, and he preached the gospel to the shoemaker. The man, whose name was Anianus, was converted, and he and his family were baptized.

Later, as the Christian faith began to spread throughout the city, Mark was in danger. He named Anianus bishop, and left for two years. When he returned, he found Anianus had carried out his work faithfully: The town was full of Christians.

The story appears in the *Golden Legend.*

EARLY ON, THE SECOND GOSPEL WAS ATTRIBUTED TO MARK, THE companion of Saint Paul, who is mentioned in the Acts of the Apostles. In this story, Mark's career continues on from the biblical account.

When the cobbler cries out, "O! The one God!" he reveals a latent monotheistic faith, which surprises the evangelist—it is unusual for a pagan, a polytheist, to say such a thing. Mark uses the spontaneous exclamation as an opportunity to bring the Christian faith to the cobbler and his family.

Anianus' humble origins do not prevent him from being raised to an important position as bishop of the city. The egalitarian openness of the early Christian movement was striking. A man with a trade, presumably without sophisticated education, proved a reliable and successful leader of the nascent Christian community in Alexandria.

The body of Mark was brought to Venice in the year 466, and he became the patron saint of the city. The stories of his life and miracles were popular subjects for Venetian painters. Mansueti was a pupil of Gentile Bellini. His elegant and precise work has an air of exoticism about it. Turbaned Alexandrians fill the bustling square. A small group has gathered around Mark and Anianus in the center foreground; otherwise, the crowds are oblivious to the miracle taking place in their midst.

The panel was painted for the Scuola Grande di San Marco, a confraternity in Venice founded in the year 1260.

The Body of James
Is Brought to Spain

The story appears in
the *Golden Legend*.

FTER THE APOSTLE JAMES WAS BEHEADED IN Jerusalem, his followers carried his body down to the sea and put it aboard a ship. Trusting in God, they set off without sail or rudder. An angel guided the ship to Galicia in Spain, which was ruled over by a cunning and cruel queen, aptly named Lupa, which means "she-wolf."

The disciples of James laid his body on a stone, which immediately turned as soft and malleable as wax. It molded itself around the body, forming a perfect sarcophogus.

They went to the queen and told her how the angel had led them to her kingdom and asked her for a place to lay James to rest. She sent them to the lord of a neighboring city, a man as cruel as she was, who immediately threw them into prison. An angel, however, released them from captivity. When the lord learned of their escape, he sent soldiers to arrest the disciples. But in their pursuit, as the soldiers were crossing a bridge, it gave way, sending them to their deaths in the river below. The lord, recognizing that he had defied the will of God, repented, and begged the disciples to return to his city. They did, and preached so effectively to the citizens that they all became converts.

The Master of Raigern has condensed the story into a single unified scene—the body, the boat, the queen, the palace, and the wild bulls are all present. The dialogue between Lupa and the disciples is indicated by the scrolls of text flowing from the main characters.

The anonymous painter to whom this panel is attributed, active in southern Bohemia in the early 1400s, takes his name from an altarpiece in the Benedictine abbey at Raigern (present day Rajhrad).

Lupa heard of these events and grew angry. When James' followers approached her again, she had a pair of wild bulls brought in and told them that they were tame oxen. These, she said, could be yoked to their cart, and would convey the body of James wherever they wished.

Unaware of the queen's treachery, the disciples made the sign of the cross over the bulls and yoked them to the cart. Acting as tame as oxen, the bulls voluntarily set off to find a resting place for the apostle. The disciples walked alongside the cart as the bulls led them straight into the courtyard of the queen's palace.

When Lupa saw them all standing there and realized that her schemes had failed, she grew ashamed. She immediately converted to the faith, and was baptized. She turned her palace into a shrine to James and endowed it with great riches. And thenceforth she lived her life committed to charity and good works.

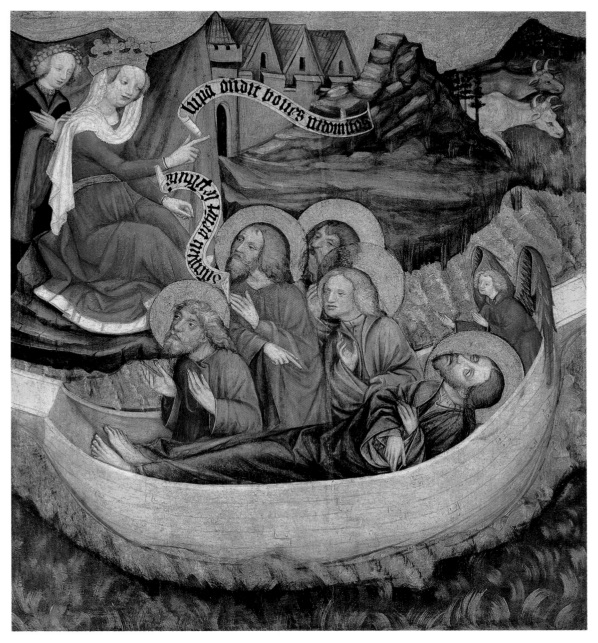

Master of Raigern, *The Remains of Saint James the Elder Are Shipped to Spain*, c. 1425.
Tempera on wood, Kunsthistorisches Museum, Vienna.

THE SHRINE OF SAINT JAMES AT COMPOSTELA WAS ONE OF THE MOST
important pilgrimage sites of the Middle Ages. The pilgrim routes through France and
northern Spain are dotted with churches that served the pilgrims on their march
toward the apostle's grave.

This story, with its several miracles, explains how the body of James made its way
from the Holy Land to Spain. Neither the boat nor the wild bulls are under the
control of James' disciples. Directed by God at every stage, they are saved from each
disaster that befalls them. The resting place of the apostle is chosen by God himself.

Their final arrival at Lupa's palace turns the Queen's treachery back on her,
convincing her of the error of her ways.

Philip Exorcises the Temple of Mars

The story appears in the *Golden Legend*.

THE APOSTLE PHILIP SPENT TWENTY YEARS PREACHING the gospel in Scythia. The pagan authorities at last arrested him and brought him to the temple of Mars, where they tried to force him to sacrifice to their god. Suddenly, a terrible dragon emerged from under the plinth that held the statue of Mars. It spewed forth its poisonous breath, slaying the son of the high priest, who was preparing the fire for the sacrifice. The two soldiers who held the bound apostle also dropped dead. Others standing nearby inhaled the acrid fumes and began to grow ill.

Philip shouted, "Believe me! If you take down your idol and replace it with the cross of Christ, the dead shall be raised and the ill shall be healed!"

The crowd called back to him, "If you can cure us, we will happily do as you say."

Philip turned to the dragon and commanded him in the name of Christ to depart to the furthest desert, harming no one on his way. Immediately, the dragon left them, and was never seen again. And Philip laid his hands on the sick, and cured them. The three dead men were also revived, as whole and sound as before.

They were all baptized, and Philip stayed there for a full year, preaching the Gospel.

SCYTHIA LAY ON THE FRONTIERS OF THE ROMAN WORLD. IN THIS distant setting, Philip overcomes the resistance of the followers of the old gods with a spectacular act of deliverance.

The legend uses the figure of the dragon to critique the pagan religion. It suggests that underneath the beauty of ancient worship, there lies something deeply sinister. The old gods are no more than a facade for demons. The beautiful house of worship hides a dragon's lair. When Philip is brought in to the temple, his presence alone is enough to expose the dragon that lives there. Unharmed himself, he is able to banish the beast and revive those who have been slain and sickened.

Unabashedly partisan, this tale glories in reversals. Philip, the prisoner, is the only one with power to confront the demon. The high priest is impotent before the creature that emerges from under the statue of his

Filippino Lippi displays his fascination with classical art in this fresco from the Strozzi Chapel in Santa Maria Novella in Florence. The statue of Mars stands in an elaborately rendered outdoor temple covered with sculpture. Three votive lamps hang from the lintel above. The exquisite clothing and armor of the Scythians lend an air of exoticism to the scene. Philip gestures past the statue towards a shimmering figure of Christ with the cross, high in the sky above, while the dragon slithers at his feet. Ironically, the story commemorates the destruction of the statue and shrine Lippi takes such obvious pleasure in painting.

god. He is a supplicant in the temple he once ruled, as he begs for his dead son to be raised. In the end, the pagans are transformed into Christians. The medieval Christian audience for whom this story was composed would have delighted in the onward march of their faith.

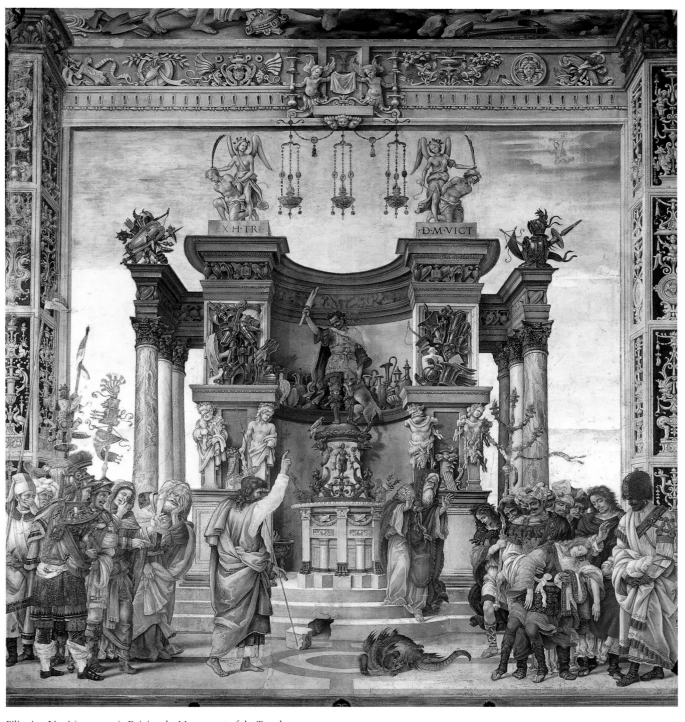

Filippino Lippi (1457–1504), *Driving the Monster out of the Temple*, 1502.
Fresco, Strozzi Chapel, Santa Maria Novella, Florence.

John the Evangelist Drinks from the Poisoned Chalice

The story appears in the *Acts of the Holy Apostle and Evangelist John the Theologian.*

OHN WAS BROUGHT AS A PRISONER BEFORE THE Emperor Domitian, who asked him, "Are you John, and have you said that my kingdom would be overthrown, and that another king, Jesus, would reign in my place?"

John answered him, "You will reign for the many years God has granted you, and others will succeed you in their turn. But at the end of time, when all earthly things will come to an end, the true and eternal king will come from heaven. He will judge the living and the dead, and every tribe and nation will confess his name. He is the Lord and King of all, Jesus Christ."

Domitian said, "These are fine words, but what proof can you give me that what you say is true?"

John asked for poison to be brought to him. When the emperor's servants presented him with the deadly toxin, he mixed it in a cup with wine and water, and prayed, "In your name, Jesus Christ, Son of God, I drink this cup which you will sweeten. Mingle the poison with your Holy Spirit, so that it becomes a drink of life and salvation, a cup of thanksgiving." And he drank deeply from the cup.

Taddeo Gaddi's small panel is from the predella of a large altarpiece. As part of a larger composition, this panel would have been just one of many scenes from the life of John. Here John drinks from the chalice, while in the foreground we see the dead criminal.

Everyone watched, waiting for John to collapse and die, but instead he continued to stand there calmly talking to the emperor. Domitian became enraged with his servants, suspecting that they had not given John real poison.

"Do not be angry with your servants," John said. "Let a trial be made, and you shall see the power of the poison. Bring a condemned man from the prison."

They retrieved a murderer from his cell and John added some water into the remaining mixture in his cup, which he gave to the criminal. When the man drank, he fell down immediately and died. All who saw it were astounded. The emperor commanded that the body be thrown away. John approached the body, and invoked the name of Jesus. He took the dead man's hand, and raised him back to life.

Domitian said to him, "I have decreed death to the Christians, but I see from you that this religion is rather beneficial. Instead of death, I banish you to an island."

And so John was taken to the island of Patmos, where he remained until the emperor's death.

THIS APOCRYPHAL TALE BEARS ALL THE HALLMARKS OF MEDIEVAL hagiography. The stock characters—the foolish ruler, the stalwart saint, the servants— play their roles exactly as expected. The story is structured as a contest in which John can repeat the truths of the Christian faith before the dull and unbelieving emperor.

Taddeo Gaddi (c. 1300–66), *Saint John the Evangelist Drinks from the Poisoned Chalice.*
Tempera on wood from an altarpiece, Fondazione Cini, Venice.

We are meant to laugh at the thick-headedness of the ruler and marvel at the miraculous power of the saint. The only deviation from the traditional telling is the ending of this story. Usually, the saint is subjected to a series of ingeniously cruel tortures, throughout which he continues to praise God and defy the ruler. In this case, John escapes with exile.

John's immunity to the poison enacts a saying of Christ from the Gospel of Mark: "And these signs will accompany those who believe: By using my name they will cast out demons; they will speak in new tongues; they will pick up snakes in their hands; and if they drink any deadly thing, it will not hurt them." Mark 16:17–18.

The story has a happy ending for the imprisoned man as well. As he is dismissed into exile, John pleads with the emperor to release the criminal. The emperor grants the request, and John turns to the man and tells him to praise Christ who has set him free.

Filippino Lippi (1457–1504), *Saint John the Evangelist Resurrects Drusiana*, 1502.
Fresco, Strozzi Chapel, Santa Maria Novella, Florence.

John the Evangelist Raises Drusiana from the Dead

HE EMPEROR DOMITIAN SENT JOHN INTO EXILE ON the island of Patmos. When Domitian died, the Senate reversed all his decrees, and John was able to return to Ephesus. He was greeted by throngs of people in the streets who cried out, "Blessed is he who comes in the name of the Lord!"

The story appears in the Golden Legend.

As he made his procession through the town, a group of people emerged from the crowd, carrying a dead body on a funeral bier. They called out to John, "Look! Here is Drusiana, who loved you and kept all your commands. She is dead. She longed for your return, and hoped she would see you again before she died. But now you are here, and she can see you no more."

John had pity on the faithful Drusiana. He told them to lay down the bier and unbind her shroud. Then he spoke in a loud voice: "Drusiana! The Lord Jesus Christ raises you. Drusiana, get up and go into your house, and make my supper."

Immediately she rose up to do his bidding. And the people shouted and praised God for three hours, shouting, "There is only one God: the God preached by Saint John!"

The fresco by Filippino Lippi comes from a sequence painted in the Strozzi Chapel of Santa Maria Novella in Florence. The Strozzis were one of the great families of Florence, and Filippo Strozzi was an important advisor to Lorenzo the Magnificent.

The chapel was dedicated to Saints Philip and John, and contained large scenes of their lives. Filippino displays his complete control of illusionist perspective. He renders the scene in a manner reminiscent of the theater. Through an architectural proscenium, we see the cityscape recede into space. His figures are not confined within, but spill out onto the stage, which projects beyond the frame.

THE HEALING OF DRUSIANA PUNCTUATES THE TRIUMPHAL ENTRY of John into Ephesus, and spurs the crowd to even greater euphoria.

Although cooking supper might seem an odd priority for one just raised from death, it ties Drusiana to a Gospel story. When Jesus went to the house of Peter and Andrew in Capernaum, he found Peter's mother-in-law ill with a fever. He cured her, and immediately she began to serve them.

The cooking motif is also consonant with the description the story gives of her life. As one who loved John and followed all his commands, she is restored to the life she knew. She rises from her funeral bier to take up a familiar task. Having attained her deepest desire, to see John's return from exile with her own eyes, she now takes her place once again as one of his loyal followers.

John the Evangelist Causes a Pagan Temple to Collapse

The story appears in the *Golden Legend*.

JOHN PREACHED THROUGHOUT THE PROVINCE OF Asia and converted many to the faith of Christ. Dismayed by his success, the worshippers of the pagan gods seized John and carried him to the temple of Diana. There they tried to force him to make a sacrifice to the image of the goddess.

John challenged them to a contest. "Since you believe your goddess Diana to be so powerful, pray to her to overthrow the Church of Christ. If she does so, I will sacrifice to her. But if she does not, I will then pray to my Lord Jesus Christ to overthrow Diana's temple. If he answers my prayer, then you must follow him."

The people consented to the test. The priests of Diana prayed and implored the goddess to overthrow the Church, but their prayers were met with deathly silence. John then set himself to prayer, and forthwith, the temple of Diana collapsed. The people were astounded and many more were thus converted to Christianity.

THIS APOCRYPHAL TALE RECALLS SEVERAL OLD TESTAMENT STORIES. The religious contest between John and the priests of Diana is similar to Elijah's struggle with the prophets of Baal. In both narratives, a lone faithful man faces down a crowd of pagan leaders. The prayers of each are offered to their respective gods, and the true God answers the plea of the faithful man in spectacular fashion.

This panel formed part of a large altarpiece illustrating scenes from the legend of Saint John the Evangelist. The individual panels were mounted in tiers surrounding a central Crucifixion. The painting is reduced to the simplest forms. The strong silhouette of the figures against the gold background allows the stories to be read from a distance. The pagan leaders are relegated to a subordinate position, standing in front of their dark and crumbling temple.

This legend was composed long after Christianity had supplanted the old gods. It portrays a completely uneven struggle between the forces of good—the Christians—and the forces of evil—the pagans. The old gods, when they were not portrayed as simple fictions, were transmuted in the popular mind into deceiving demons, powerless against the name of Christ.

The actual history of Christian ascendancy was rather more complex. It involved a slow process of conversion punctuated by persecutions. When Constantine legalized the faith in AD 313, the Church rapidly moved to the center of the political stage. Within several generations, Christians had closed the pagan temples and outlawed the old forms of worship. The story of John's challenge represents a triumphal Christian retelling of this history.

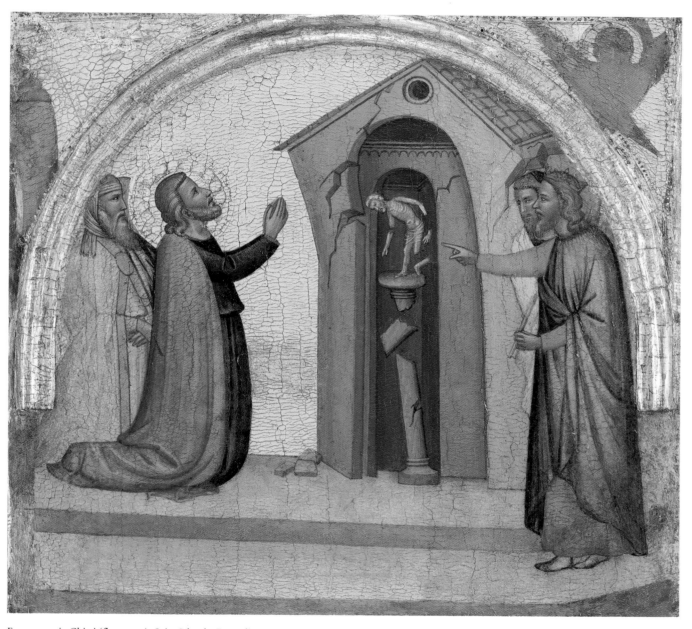

Francescuccio Ghissi (fl. 1359–74), *Saint John the Evangelist Causes a Pagan Temple to Collapse*, c. 1370.
Tempera on wood with gold ground from an altarpiece, Metropolitan Museum of Art, New York.

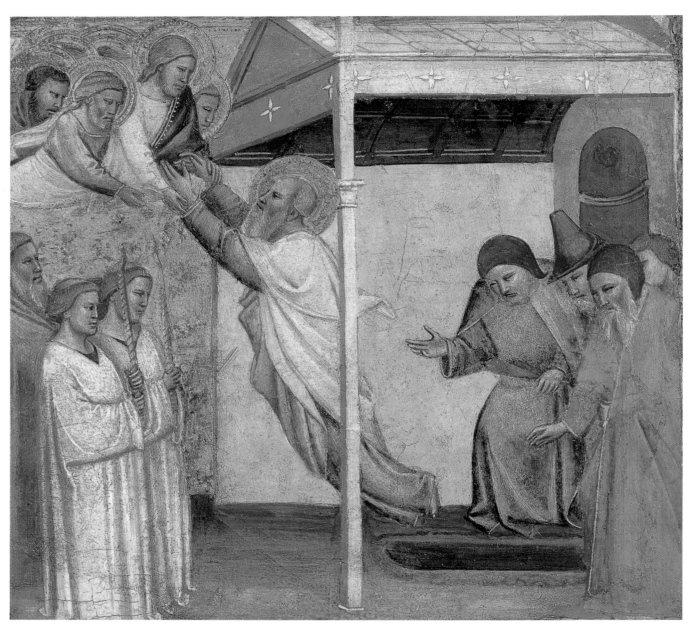

Taddeo Gaddi (c. 1300–66), *Ascension of Saint John the Evangelist.*
Tempera on wood from an altarpiece, Fondazione Cini, Venice.

The Ascension of John the Evangelist

HEN JOHN WAS NINETY-NINE YEARS OLD, JESUS appeared to him and said, "Come, my friend, to me, for it is time that you come. Eat and be fed at my table with your brothers." Jesus told him he would enter heaven on the following Sunday.

On the Lord's Day, John went to the church he had founded in Ephesus and preached a farewell sermon to the gathered worshippers. After he said the Mass, he ordered a pit to be dug in the floor before the altar. He took leave of the congregation and went down into the grave. Standing in the pit, he called on Christ to take him. Suddenly, God's glory shone all about him and he ascended to heaven on a beam of light. When he had gone, the people looked down into the pit and saw nothing but a fine dusting of manna rising out of the earth.

The story appears in the Golden Legend.

CHRISTIAN TRADITION HAS TENDED TO CONFLATE A NUMBER OF figures named John in the New Testament. The apostle John, brother of James and son of Zebedee, is generally portrayed as the youngest of the disciples. He is identified as the beloved disciple who reclined next to Jesus at the last supper and stood at the base of the cross with Jesus' mother. To him are attributed a Gospel, three letters, and the Book of Revelation. Pulling together all these strands, a biography emerges. Modern textual criticism has questioned this fusion of different characters, but in the Middle Ages, the unified portrait of John the Apostle was fully accepted.

By tradition, John did not suffer martyrdom as the other apostles did: He lived to a ripe old age in Ephesus. The miracle of his ascension into heaven is a reunion story. Jesus beckons him at last to join the rest of his brothers, the apostles, in heaven. The feast is prepared, and he is invited to lay down his burden and take his place with the Twelve.

This panel from an altarpiece was painted by Taddeo Gaddi, the most prominent pupil of Giotto, with whom he worked for almost a quarter century. After Giotto's death, Gaddi remained an important painter in his own right, continuing his master's work on the campanile of Florence's cathedral, and enjoying many public commissions for frescoes and altarpieces.

Christ, surrounded by the apostles, takes John by the hand to carry him to heaven, leaving the astounded worshippers to stare into the empty grave. Gaddi abbreviates the architecture, opening up the side wall of the church so that we can see the grave and the people within.

He leaves behind him a tangible sign of his saintliness. The manna in the bottom of the grave remains, to be used for the healing of disease and infirmity. Although his body is gone, the site of his ascension becomes holy ground.

Mark Saves the Life of a Saracen

The story appears in
the *Golden Legend*.

 GROUP OF VENETIAN MERCHANTS SET SAIL FOR
Alexandria in a Saracen ship. Far out at sea, a storm arose and the
ship began to break apart. One by one, the Saracens fell into the
wild waters and drowned. But one of them, as he sank beneath
the waves, called out to Saint Mark and promised that if he
survived, he would be baptized.

Suddenly, a man surrounded by a halo of light appeared. He plucked the Saracen
from the sea and placed him in the damaged boat. The storm ceased immediately.

When the survivors arrived in Alexandria, the Saracen neglected his vow.
Saint Mark appeared to him in a vision and reminded him that he had been saved
from death because of his promise to be baptized. The Saracen, moved by his
conscience, was baptized and took the name of Mark. From that day forward, he
grew in faith and good works, and died a devout Christian.

THE REPUBLIC OF VENICE CLAIMED THE BODY OF SAINT MARK THE
Evangelist and built the huge basilica that bears his name next to the Doge's palace. A
city-state of seafaring merchants, Venice stood at a confluence of cultures, dominating
trade with the East until the Spanish and Portuguese opened new sea routes in the
fifteenth century. This posthumous miracle of Mark reflects the tensions and rivalries of a
Christian city in constant contact with the non-Christian East.

*The enormously prolific Jacopo Robusti worked in Venice in the late
sixteenth century. Known as Tintoretto, or "little dyer," after his father's
profession, he studied with Titian. His dramatic Mannerist style looks
forward to the theatricality of Baroque painting. The still, upright
figure of the Saracen contrasts with the chaos surrounding him.*

*In Tintoretto's time, with the expansion of the Ottoman Empire,
this miracle was a reassuring assertion of divine protection. The story
was already several hundred years old, but Tintoretto modernizes it—
the sinking ship is as familiar as the ships that lined Venice's harbor.
His painting stood as a sign of hope that the encroaching Ottomans
would not prevail.*

Against the backdrop of a trading voyage, the Saracen experiences the
power of the sainted evangelist who plucks him from the waves. Although
he first neglects to fulfill the terms of his vow, a reminder from Mark sets
him on the path to conversion. The story is more than a simple account of a man saved from death; it is a triumph for
Christianity and for the authority of Venice's patron saint.

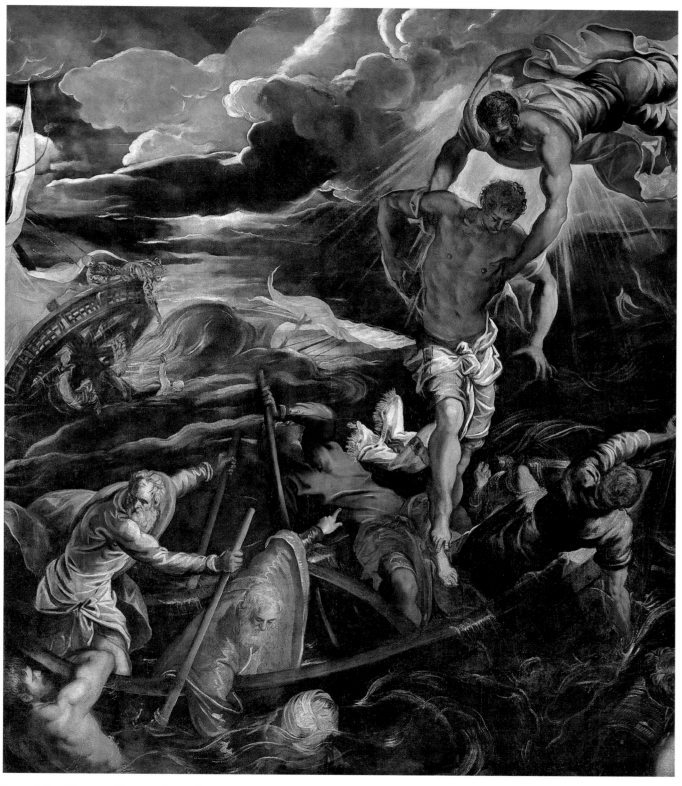

Jacopo Robusti, known as Tintoretto (1518–94), *Saint Mark Saving the Life of a Saracen.*
Oil on canvas, Accademia, Venice.

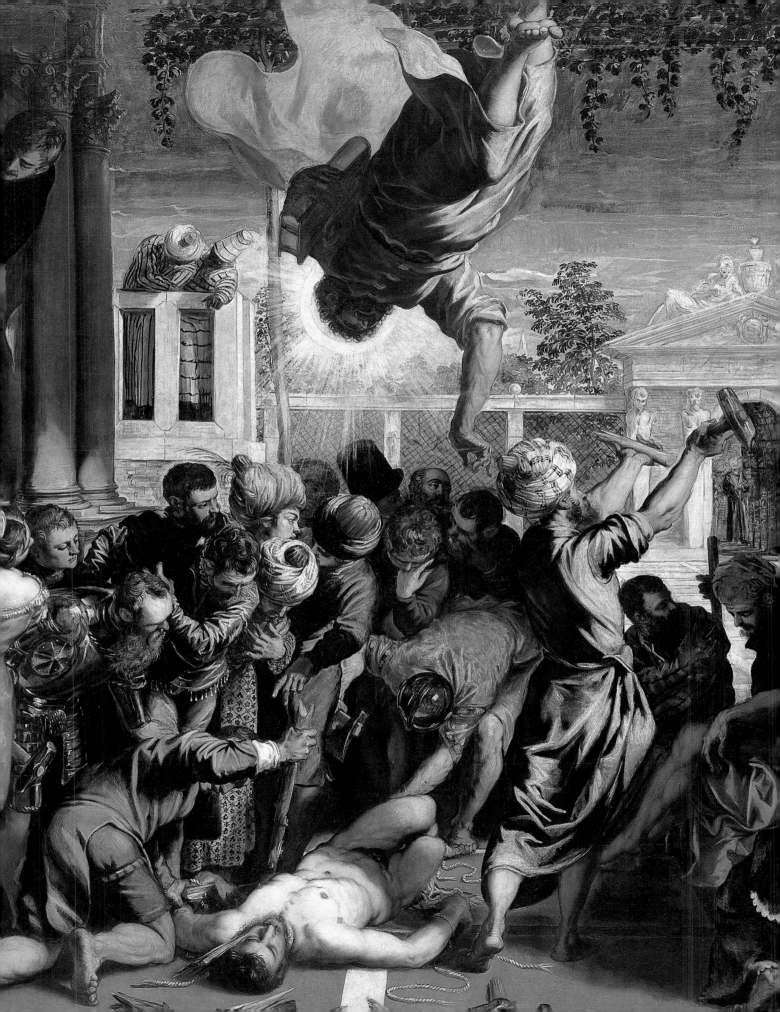

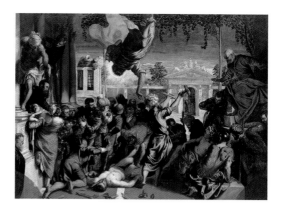

Jacopo Robusti, known as Tintoretto (1518–94)
Saint Mark Freeing the Slave from Torture, 1548.
Oil on canvas, Accademia, Venice.

Mark Saves the Slave

HERE WAS A SLAVE WHO SERVED A NOBLEMAN IN Provence. He was devout, and fervently desired to make a pilgrimage to the shrine of Saint Mark in Venice. But his master, a hard man, would not allow it. At last, the slave determined to go without his master's permission. As he set out on his journey, he was caught and brought before his master.

The story appears in the *Golden Legend*.

The nobleman was enraged and commanded that the slave be tortured. He told his other servants to bind the unfortunate slave and put out his eyes. They took up sharp implements of iron, but as they approached the slave to carry out their orders, their tools wilted in their hands. So the master ordered them to cut off the man's legs. They grabbed axes, but the axe heads grew soft as molten lead, and had no effect. Finally the master instructed them to knock out the man's teeth, but their iron hammers became so soft that they could do him no harm.

The master, seeing the miracles wrought by the saint, repented of his cruelty and begged the man's pardon. Then the slave and master set off together on a pilgrimage to Venice, to render their thanks to God at the shrine of Saint Mark.

This large painting is part of a series painted by Tintoretto in 1548 for the Scuola Grande di San Marco. Contrasts of dark and light, so integral in Tintoretto's work, help him tell the story. Under the shade of an arbor, the body of the slave is bathed in light, while the saint's halo bursts with energy. As the nobleman leans forward, the light catches his bald head.

The poses of the slave and of the saint are carefully arranged across the central space of the scene to draw our attention. Their bodies are dramatically foreshortened, visually relating them to one another and setting them apart from the surrounding crowd.

THE PRACTICE OF PILGRIMAGE WAS CENTRAL TO THE RELIGIOUS life of the Middle Ages. Those who wished favors of the saints traveled long distances to visit their shrines and leave offerings. Stories like this one evoke the power of these sanctuaries and underscore the effectiveness of the saints' intercessions on behalf of those who are loyal to them.

In this story, Saint Mark intervenes from heaven to protect the devout slave. We are not told why the man wished to visit the saint's shrine, only that his desire was intense enough to make him defy his master and endanger his own life. Although the slave is disobedient, the saint saves him from punishment; the authority of the nobleman is nothing compared to that of the saint. By the end of the story, social distinctions vanish as the master and slave set off together on their pilgrimage.

Blaise and the Widow

This story appears in
the *Golden Legend*.

SAINT BLAISE WAS A MAN OF HOLY LIFE WHO WAS chosen by the people of Sebaste in Cappadocia to be their bishop. He remained outside the town, living in the countryside to avoid its pagan lord and the danger of persecution.

There was a very poor woman in the town who was a widow. One day a wolf came and carried away the single pig that she kept. She went to Blaise and gave him a tearful account of her misfortune. He looked at her and, with a kind smile, said, "Do not be angry; your pig will be returned to you." And the wolf brought the pig back to the woman.

When Blaise later went in to town, he was immediately thrown in prison. When he was brought before the pagan lord, they argued about the faith. Blaise told the lord that the gods that he worshipped were nothing but demons. The lord threatened the saint with death if he would not fall down and worship the pagan gods. The saint refused, and was sent back to prison.

The woman, hearing of Blaise's confinement, slaughtered her pig, cooked its head and feet, and brought it to him in prison, with a loaf of bread and a candle. The grateful Blaise blessed the woman. He told her that every year she should light a candle in his church; he would bless her and anyone else who did so. And she carried out the saint's command, and enjoyed great prosperity from then on.

Sano di Pietro was one of the most prominent Sienese painters of the mid-fifteenth century. His workshop produced a steady stream of devotional images, and he was commissioned to paint major frescoes in the Palazzo Pubblico of the city.

This painting is part of a multi-panel altarpiece now in the Piancoteca Nazionale. In a two-part scene, the widow implores the saint's aid, and greets the penitent wolf carrying a surprisingly small pig. Blaise's magnificent bishops' robes are, like the detail of the candles in the story, complete anachronisms.

IN THE *GOLDEN LEGEND*, BLAISE IS PRESENTED AS A HOLY MAN CLOSE to nature. His country hermitage is a place of refuge for animals of all kinds. Birds flock to bring him food and wait for his blessing to depart. Knights from the town,

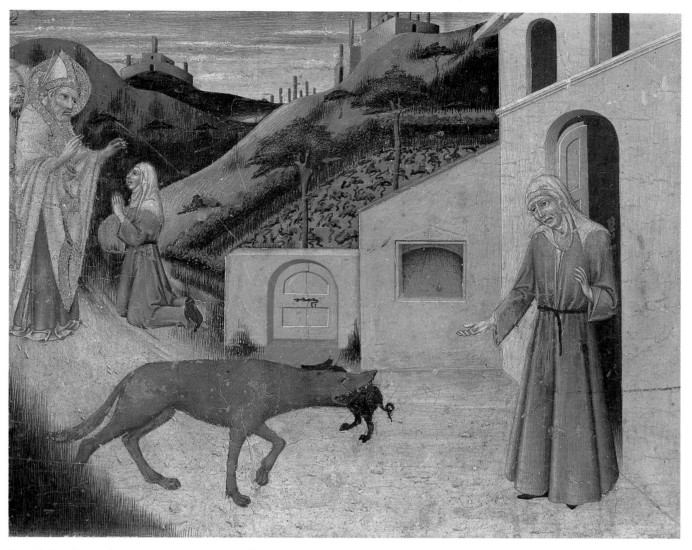

Sano di Pietro (1406–81), *Saint Blaise Commands the Wolf to Give the Pig Back to the Poor Widow*.
Tempera on wood, detail from the Scrofiano polyptych, Pinacoteca Nazionale, Siena.

finding no game in the countryside, are amazed to discover great throngs of animals around the saint's simple home. The tale of the stolen pig is told in the same vein. When the poor widow loses her only valuable piece of livestock, Blaise is able to compel the wolf to return it.

Her act of generosity, offering her pork stew to Blaise in prison, is all the more striking because we know the pig was so precious to her. The widow recalls the woman in Luke's Gospel who throws two small coins into the treasury. When Jesus sees this, he announces she has given more than all the rich who spill heavy gold coins into the treasury, for "she has put in all that she had to live on." The widow in this story has done the same.

Her generosity to the saint is repaid. The saint knows—anachronistically—that a church will be built in his memory and that supplicants will come to implore his aid. His command to light a candle each year in his honor reflects the pious practices of pilgrims of a later age.

Columba of Sens Is Saved by a Bear

OLUMBA WAS A YOUNG VIRGIN FROM A NOBLE FAMILY in Spain. When the Emperor Aurelian began to persecute the Christians there, she and some of her companions fled to Gaul, hoping to find safety. They arrived in the town where they planned to take refuge, but were immediately discovered and thrown into prison.

When one of her jailers tried to enter her cell and violate her, God sent a bear, which attacked and killed the guard, protecting the virgin saint. She did not, however, escape martyrdom. She and her companions were executed outside the town, and her body was left unburied.

At that time, there was a blind man named Aubertus who prayed to Columba for his sight to be restored, and his wish was granted. He went straight to the execution ground and picked up the saint's broken body. He prepared a final resting place for the young woman, and gave Columba a proper burial.

COLUMBA OF SENS, LIKE MANY EARLY CHRISTIAN MARTYRS, IS LITTLE more than a name to us now. The details of her life, elaborated over time, are almost entirely legendary.

The theme of virginity is a recurring motif in the lives of many of the early female martyrs. One of the aspects of Christianity that most upset the ancient world order was its encouragement of young women not to wed. This refusal of marriage struck at the very heart of late-Roman social norms. Unwed daughters defied their fathers, and had no place within society. Expressing their Christianity by adopting perpetual virginity was an act of complete rebellion, a declaration of freedom. Columba is just one of such virgin martyrs, joining the ranks of Agatha, Lucy, and Barbara. In this miracle, the bear protects Columba from attack, declaring God's protection over her chastity.

The reputed site of her martyrdom, near the Fontaine d'Azon at Sens in northern France, became a site of pilgrimage. The Abbey of Sens was later built over her grave. There are only a few churches dedicated to her, scattered across France and northern Italy.

The Riminese painter Giovanni Baronzio has placed the scene in a tightly constricted space. The tiny buildings, with their simple perspective, stand clearly within Byzantine and early Venetian traditions, and form a dense network within which the figures move. The soldiers are too large to maneuver through the space convincingly; the door from which they stumble in fear is distinctly smaller than they are. The original cathedral of Rimini was dedicated to Columba of Sens; this panel is thus a subject of local significance.

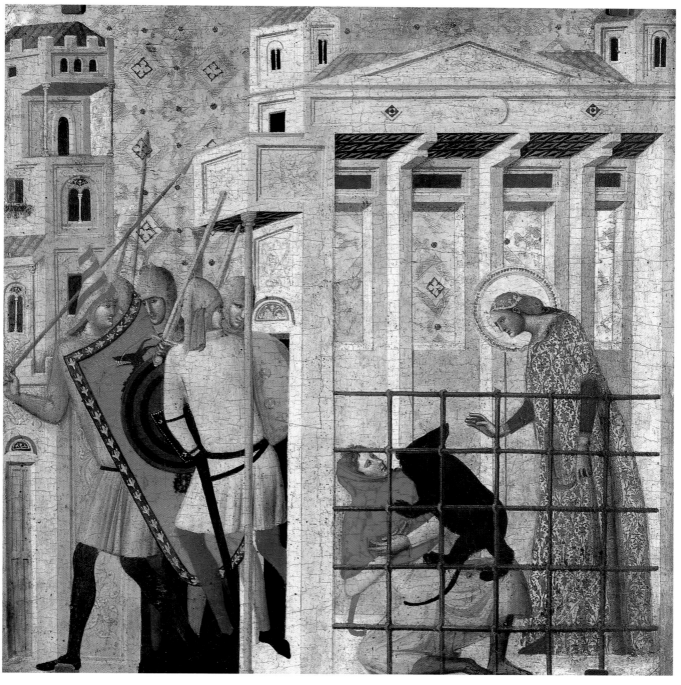

Giovanni Baronzio (d. 1362), *Saint Columba of Sens Saved by a Bear*, c. 1350.
Tempera on wood, Pinacoteca di Brera, Milan.

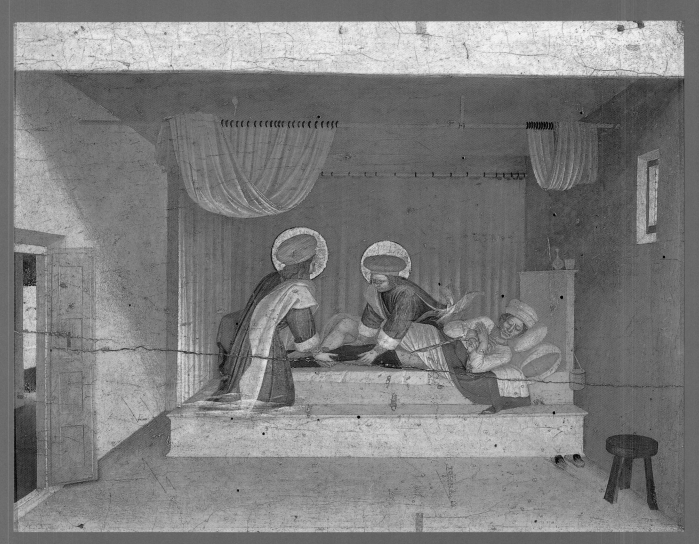

Fra Angelico (1387–1455), *The Healing of Deacon Justinianus by Saints Cosmas and Damian*, 1438.
Tempera on wood from an altarpiece, Museo di San Marco, Florence.

Cosmas and Damian
Heal the Deacon's Leg

A CHURCH WAS BUILT IN ROME IN HONOR OF THE saintly brothers Cosmas and Damian, two martyrs who were physicians before they died under orders from the Emperor Diocletian. During their lives, they accepted no money or reward for their healing work, but used their medical arts to help the sick and to glorify their Lord.

The story appears in the *Golden Legend.*

It happened that a deacon who served their church had an ulcerated leg. He suffered greatly, and prayed to them for healing. One night, the two saints appeared to him in a dream, holding surgeon's knives and jars of healing ointments. Standing over his bed, they discussed the case.

"We can remove the putrifying flesh," one saint said to the other, "but where will we find new flesh to replace what we have cut away?"

His brother replied, "Today they have buried a Moor in the graveyard of Saint Peter at Vincula nearby. His flesh is fresh and undecayed. Let us go and fetch a leg from the Moor to replace what we must remove from this man."

They hurried to the graveyard and removed the leg of the corpse. Returning to the man's bedside, they transplanted the dead man's leg onto the body of the ailing deacon. Then they disappeared.

In the morning, the deacon awoke. His pain was gone. He ran his hand down the leg—the ulcers had vanished. Quickly, he lit a candle and saw that the leg was not his. Remembering his dream, he jumped from his bed and ran to recount to all his good fortune. Hurrying to the graveyard, the townspeople examined the body of the dead man. There in the tomb was the deacon's leg, exchanged for the sound limb of the corpse.

The small predella panel comes from an altarpiece painted by Fra Angelico for the chapel of Cosmas and Damian in the church of the Convent of San Marco in Florence. The altarpiece was broken up in the seventeenth century, and the panels have been dispersed. The simple room in which the deacon sleeps is not unlike the cells of the monastery for which the panel was painted.

GRUESOME AND COMICAL BY TURNS, THIS STORY DESCRIBES A LIMB transplant long before any such surgery was possible. The two medical saints resort to grave robbery to accomplish their cure. The entire miracle takes place as the deacon sleeps. It is only on waking that he sees his new leg and understands that his vision has become a physical reality.

The most disturbing aspect of the tale to a modern audience is that the dead man is African. For a European audience, this may have softened the impact of the grave robbery—the dead man could be seen as entirely foreign. Certainly the different hues of skin made it perfectly clear that the new leg did not belong to the deacon. Nonetheless, to a modern audience, there is an uncomfortably colonialist ring to the story.

The Martyrdom of Denis

The story appears in the *Golden Legend.*

DENIS WAS A BISHOP WHO WAS SENT TO THE REGION of Gaul to preach the gospel. In Paris, he converted many to the faith, established churches, and ordained clergy to serve the people.

In the time of the Emperor Domitian, there was a great persecution. Denis was arrested with his companions Rusticus and Eleutherius. The emperor's provost questioned him, and finding him stubborn in the faith, sentenced Denis to be tortured. The saint was tied naked to a gridiron and suspended over fire. As the flames grew hotter, he continued to sing out praises to God, and was not harmed. He was taken from the gridiron and placed in a den of wild beasts, but he made the sign of the cross over them, and they became gentle and tame. And so he was flung into a fiery furnace, but the fire was quenched and he emerged unscathed. Finally, they hung him on a cross, and he suffered much.

They took him down from the cross and threw him into prison with his companions. The dank prison was filled with Christians. One night, while they awaited their execution, they celebrated the Eucharist together. As Denis began to distribute communion to the people, the Lord appeared in a flash of light. He offered Denis bread and said, "Take this, my dear friend, for your reward is great with me."

Soon the three men were led out to a place near the temple of Mercury where their heads were chopped off with axes. The body of Denis stood up and, taking his head in his arms, walked from the execution ground to the place where he would be buried. He was led by two angels, and from above, the songs of the heavenly choir could be heard.

Henri Bellechose, court painter to Jean Sans Peur, Duke of Burgundy, painted this altarpiece for the Charterhouse of Champmol, near Dijon. The Charterhouse was dedicated to the Holy Trinity.

God the Father presides over the scene, descending from heaven and surrounded by circles of angels. He stretches out his hands over his crucified Son. The Holy Spirit flits between the two in the form of a tiny dove, completing the Trinitarian image. On the right, Denis receives communion from Christ. The cape Christ wears matches the garments of the martyred saints on the right, making the identification of saint and savior explicit.

Henri Bellechose (1380–1440), *Communion and Martyrdom of Saint Denis*, 1416.
Oil on canvas transferred from wood, Louvre, Paris.

THE MEDIEVAL LEGEND OF SAINT DENIS CONFLATES THE LIVES AND
writings of several individuals. It identifies a first-century Gaulish martyr with
Dionysius the Areopagite, mentioned in the Acts of the Apostles (17:34). The Acts
recount that Paul debated with the Epicurian and Stoic philosophers at Athens.
Dionysius was converted and joined the Christian movement. The medieval legend
says that Paul made Dionysius bishop of Athens, and attributes several mystical texts
of the sixth century to him. The Denis of legend—philosopher, theologian, and
martyr—was honored at the Abbey dedicated to his memory.

In keeping with the conventions of medieval hagiography, Denis suffers many
abuses before he is finally beheaded. The provost can only look on with growing
irritation as the saint frustrates his tormenters and remains firmly in control. Even in
death, Denis chooses his final resting place, upon which his church will be built. The
Abbey of St. Denis, north of Paris, became the burial site of the French kings.

The Conversion of Eustachius

The story appears in
the *Golden Legend*.

THERE WAS A GENERAL IN THE COURT OF THE EMPEROR Trajan named Placidus. He and his wife worshiped the Roman gods. They busied themselves with acts of mercy and gave generously to the poor.

One day Placidus went out to hunt with a company of horsemen. They came upon a large herd of deer and gave chase. One of the animals was larger and fairer than all the rest, and it sprang into the dense woods. The other horsemen followed the herd, while Placidus tore off in pursuit of the lone deer. The animal leapt onto a high rock in the forest and turned to face Placidus. Suddenly, he saw a great light shining from between the deer's antlers—it was the figure of a man on a cross. The deer spoke to him, just as Balaam's donkey had once spoken.

In the twelfth and thirteenth centuries, the churches of northern Europe were transformed by the flowering of the Gothic. The dark churches of the preceding Romanesque period, with their frescoed walls punctured by narrow windows, gave way to large structures with vast expanses of stained glass. To enter these magnificent churches is to walk into a jeweled casket of light, evoking the heavenly Jerusalem as it is described in the last chapter of Revelation.

Chartres cathedral, one of the most spectacular examples of the emerging Gothic style, preserves a huge proportion of its medieval glass. The scene shown here is a detail of a window depicting the life of Saint Eustachius.

"Placidus, why have you followed me here? I have appeared to you through this animal for your benefit. I am Jesus Christ, whom you honor in ignorance. Your acts of charity have risen up to me. Therefore I have come here so that by the deer that you hunt, I may hunt you."

Placidus dismounted and fell to the ground, full of awe. He lay stunned for an hour. Coming to, he said, "Tell me again what you have just said." The Lord spoke to him again, instructing him in the Christian faith.

"I believe," said Placidus.

"If you believe," the Lord replied, "go to the bishop and be baptized."

Placidus rushed home and told his wife what he had seen. She, too, had received a vision that night. And so at midnight, they hurried to the bishop of Rome, and were baptized into the faith. The bishop gave Placidus the new name Eustachius. His wife was renamed Theospis.

IN THE *GOLDEN LEGEND*, THE STORY OF EUSTACHIUS TAKES ON THE character of a chivalric romance. Placidus is portrayed as a medieval knight, taking part in the noble pastime of hunting. The magnificent deer that he chases lures him into a secluded place, only to turn the game around; when the vision shines forth

Anonymous (13th c.), *Hunting Scene with Placidus*, 1215.
Stained glass, Cathedral, Chartres.

between the animal's antlers, Placidus is awestruck. The hunter has become the hunted.
Christ, speaking through the mouth of the animal, calls on the knight to convert.

The motif of a talking animal recalls the story of Balaam's donkey, yet the
differences are notable. In the Balaam story, God gives the donkey the power of speech,
but the animal expresses his own thoughts. The force of the story emerges from the
irony that a lowly animal sees more clearly than his master, a prophet. In Eustachius'
vision, the deer is the noblest of creatures, and speaks the words of Christ. The deer
becomes a symbol for Christ himself, in all his glory. In some versions of the story, it
is the crucifix, and not the animal, which speaks.

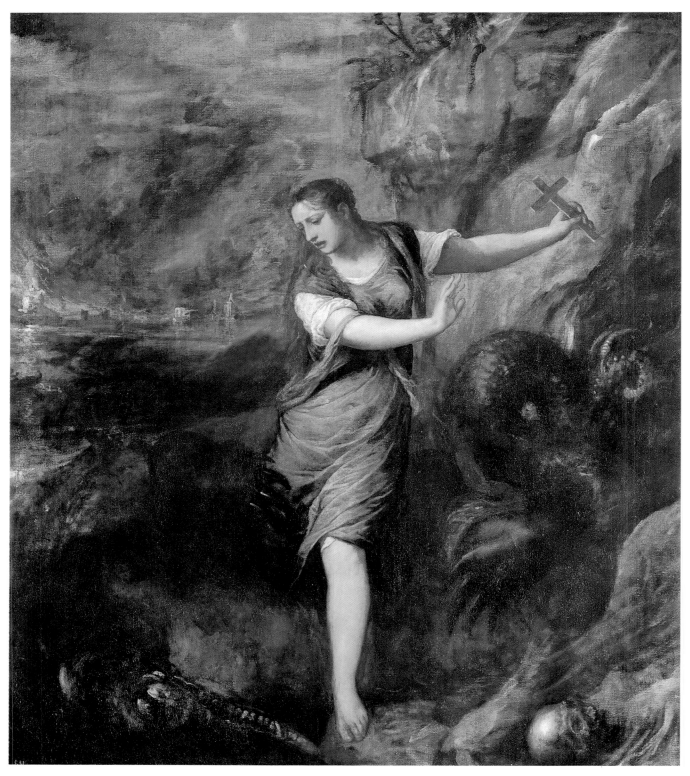

Tiziano Vecelli, known as Titian (c. 1488–1576), *Saint Margaret and the Dragon*, c. 1560.
Oil on canvas, Museo del Prado, Madrid.

Margaret and the Dragon

ARGARET WAS A YOUNG GIRL FROM ANTIOCH WHO cleaved to the Christian faith. Though her father, a priest of the pagan gods, was furious with her, she was determined to follow Christ.

The story appears in the *Golden Legend*.

One day, when she was fifteen years old, she was tending sheep in a meadow. The provost Olybrius rode by on his horse. Seeing her beauty, he determined to have her, either as a wife or as a concubine. When she refused him, he ordered her to be severely beaten and cast into prison.

Margaret was convinced that her suffering was due to the evil machinations of a demon, and she prayed that the devil would be revealed to her. Immediately he appeared in her cell in the form of a terrible, vicious dragon. He rose up and swallowed her whole. In the belly of the dragon, Margaret made the sign of the cross, and the beast burst open. She emerged unscathed.

MARGARET'S ENCOUNTER WITH THE DRAGON TAPS INTO A RICH VEIN of Christian imagery. In ancient Hebrew and Christian mythology, the dragon was seen as a symbol of the forces of chaos and death. In medieval iconography, the gates of hell were depicted as the open mouth of a sharp-fanged beast.

Jesus uses a similar image as a figure for his death and resurrection. "An evil and adulterous generation looks for a sign," he said, "but no sign will be given to it except the sign of the prophet Jonah. For just as Jonah was three days and three nights in the belly of the sea monster, so for three days and three nights the Son of Man will be in the heart of the earth." By making this comparison, Jesus expresses his own victory over death and sin.

Matthew 12:39–40.

Margaret's story resonates deeply with this theme. Her struggle over the devil is depicted as a mortal combat between saint and dragon. Her victory is both a triumph over the forces of death and chaos, and an imitation of Christ's death and resurrection. Although Margaret eventually dies a martyr's death, her miraculous deliverance from the dragon confirms that she is numbered among the saints, gaining the final victory.

The *Golden Legend*, usually quite accepting of extraordinary, even outlandish, events in the lives of the saints, is surprisingly doubtful about the historicity of this event. It points out that some commentators felt (even in the Middle Ages) that the account was apocryphal. Margaret's story is the stuff of legend, not history. It expresses its religious message in the rich and allusive language of myth.

The story of Margaret and the dragon is imaginative, mythic, and symbolic. This poses a tremendous challenge for Titian, whose style relies on a carefully rendered realism. He wreaths the scene in shadow, showing the saint stepping lightly away from the slain dragon. This allows him to avoid the direct representation of the saint bursting from the dragon's belly, using suggestion where literalism would be simply grotesque.

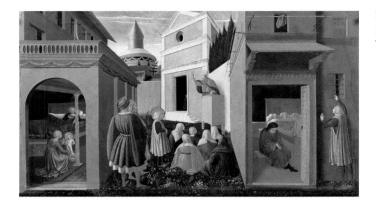

Fra Angelico (1387–1455)
Birth of Saint Nicholas and the Charity of Saint Nicholas (detail).
Tempera on wood, Pinacoteca, Vatican Museums.

The Childhood of Nicholas

The story appears in the *Golden Legend*.

NICHOLAS WAS BORN IN PATRAS, THE ONLY SON OF a couple named Epiphanes and Johane, who were as devout as they were wealthy. From the moment of his birth, Nicholas was an exceptional child. When the nurse took the newborn to bathe him, she placed him in a basin of water and he stood straight up before her. Breast-fed by his mother, on most days he ate contentedly. But on Wednesdays and Fridays, which were fasting days, he would refuse to nurse. Try as she might, she could not induce him to feed on these days more than once. As he grew older, he neglected the games and pranks of the other children, instead spending his free time in church, learning to put the lessons of the scriptures to good use.

NICHOLAS, THE FOURTH-CENTURY BISHOP OF MYRA, WAS ONE OF the most popular saints of the Middle Ages. Subsequent centuries have obscured the historical Nicholas, transforming him into the familiar figure of Santa Claus. The earlier accounts of his life are no less fabulous.

Fra Angelico presents three scenes of Nicholas' childhood and youth. In the first scene, his nursemaid tries to wash him as he stands up in the basin and raises his hand in blessing. The second scene (enlarged, opposite) shows Nicholas as a boy in the middle foreground, listening to a sermon. The third scene depicts him as a young man performing an act of charity: Three daughters of a poor man could not wed because their father lacked a dowry. Nicholas came by stealth on three consecutive nights and threw into their window small bars of gold, providing the bridal gifts they needed to marry.

Of his actual life, little is known. He is said to have attended the Council of Nicea, which stabilized Church doctrine after the legalization of Christianity. Much of the rest is the stuff of fable.

This story attributes amazing abilities to the baby Nicholas. His capacity to stand immediately after birth is not explained, but it is clearly an impossible act for a normal newborn. His refusal of the breast on Wednesdays and Fridays indicates his piety: Before he can even speak, he is observing the ritual requirements of the faith. This is a child destined for a holy life.

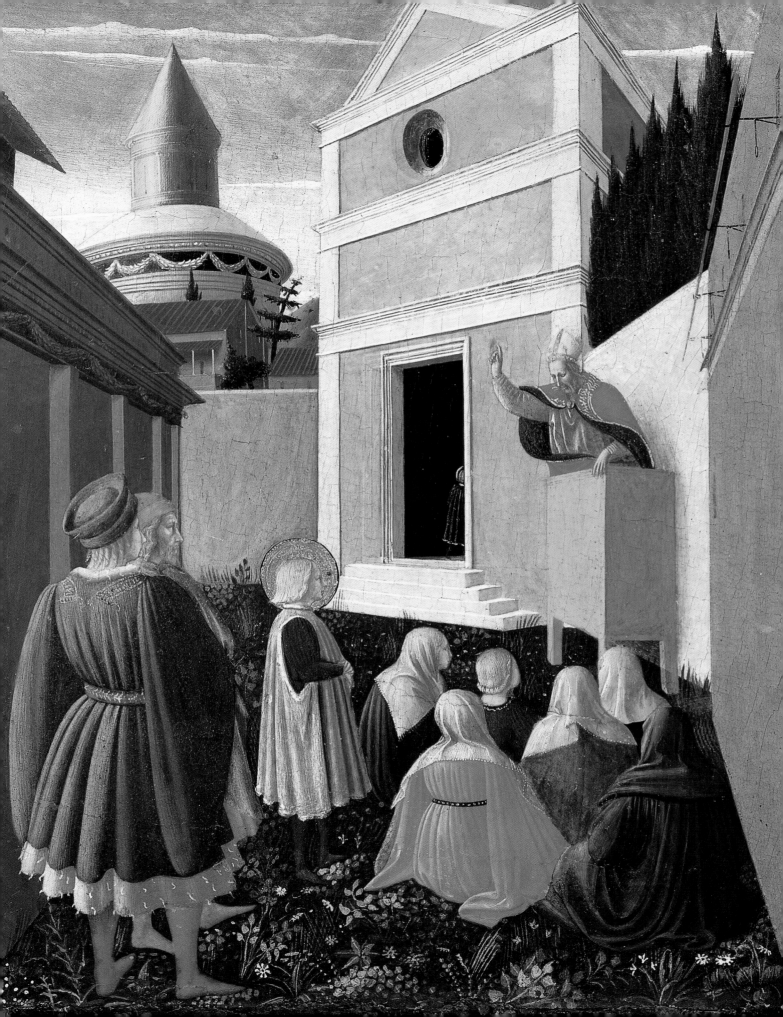

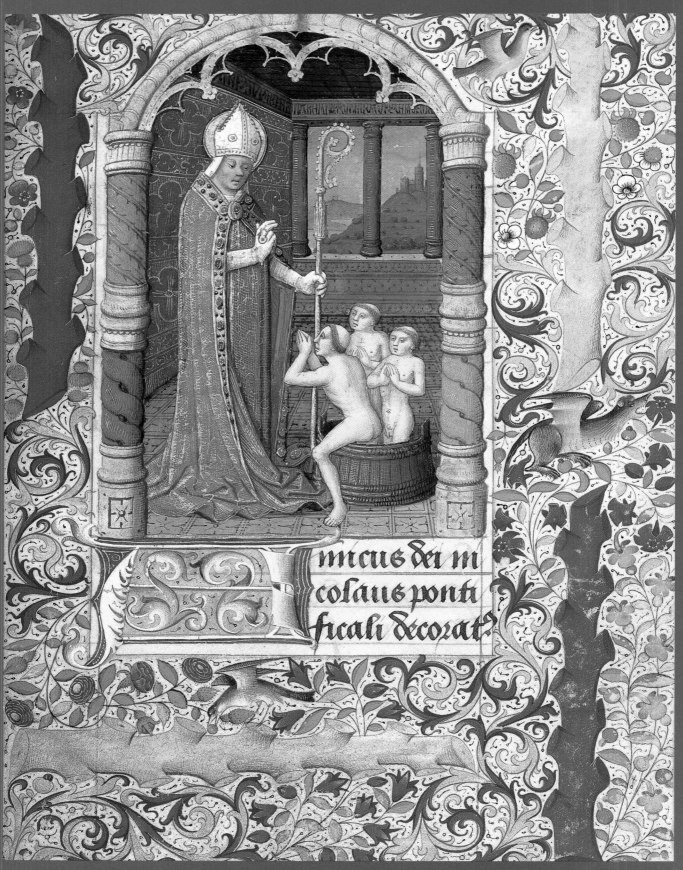

Anonymous (15th c.), *St. Nicholas Resuscitating the Three Youths*, c. 1485–90.
Illuminated miniature from a prayer book, The Pierpont Morgan Library, New York.

Nicholas Revives Three Youths

 HREE STUDENTS WERE LODGING AT AN INN. A TERRIBLE famine began, and the innkeeper, who also kept a butcher shop, devised a sinister plan. He murdered the three students and cut their bodies into small pieces. He pickled the body parts in a large barrel of brine and planned to sell the pieces of human flesh as preserved pork.

An angel appeared to Nicholas as he slept, revealing to him the crime of the innkeeper, and showing him where the pickled remains had been hidden. Nicholas raced to the inn and, making the sign of the cross over the barrel, revived the students. They emerged naked and whole.

IT IS BECAUSE OF THIS STORY THAT NICHOLAS BECOMES THE patron saint of children. His miraculous defeat of the evil innkeeper is remembered by those who seek his intercession on behalf of the young.

In the Middle Ages, his feast day on the sixth of December became associated with bawdy revels. In towns throughout Western Europe, "boy bishops" were elected to parade in mock ecclesiastic processions through the streets. Children dressed as priests performed satirical masses and preached comic sermons from church pulpits. The customs were impious and sometimes unruly, but they were tolerated, even encouraged, by the Church. The medieval mind was able to hold great reverence

This miniature appears in a luxurious late-Gothic book of hours. These prayer books contained sequences of prayer to be observed throughout the day by pious members of the laity, inspired by the monastic hours of prayer. Most books contained a selection of suffrages, prayers invoking the help of particular saints. The suffrage on this page calls Nicholas a "friend of God" and asks him to pray on our behalf.

for the ritual life of the Church, while simultaneously allowing space for inversion and parody. This playful mockery of Church order was largely stamped out during the more sober age of the Reformation. What did survive, however, was the tradition that Nicholas would bring presents and sweets to good children on his feast day. This custom has migrated from the sixth of December to Christmas.

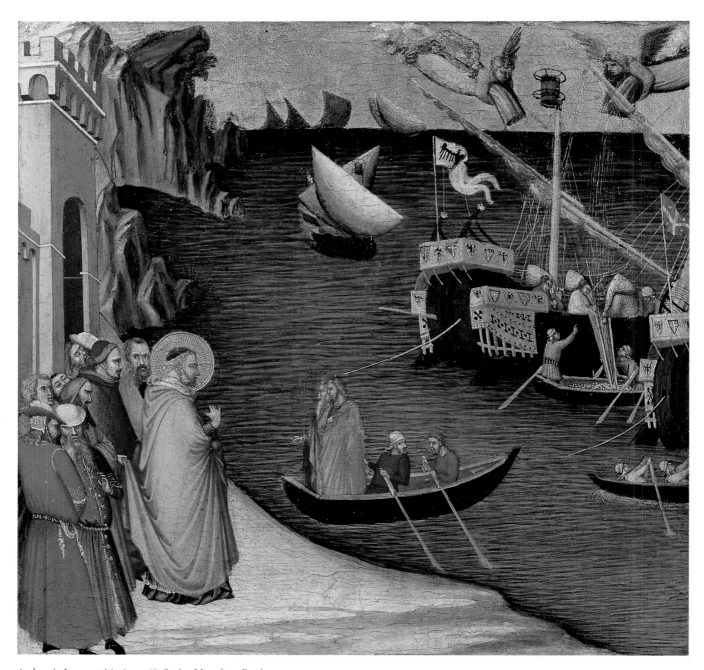

Ambrogio Lorenzetti (1285–1348), *Saving Myra from Famine*, 1332.
Tempera on wood from an altarpiece, Uffizi, Florence.

Nicholas Saves Myra from Famine

HERE WAS A TERRIBLE FAMINE IN THE REGION OF Myra. Supplies of food were running out, and the people were growing desperate. Word reached Nicholas that a convoy of ships bearing grain had moored in the port. He begged the sailors to donate food to the starving population. They could not give up any grain, they explained: The cargo had been weighed in the port where they had loaded it, and if they did not deliver the entire amount to Imperial garners in Alexandria, they would be in serious trouble. Nicholas prevailed on them, promising that the cargo would not be diminished if they offloaded a portion. They did as he asked, and deposited a two years' supply of grain in Myra—enough to sow as well as to eat. The ships departed, and when they came to Alexandria the cargo was measured out. They had delivered the full quantity required. When they told the Imperial officers of the miracle which had taken place, they all praised God and his servant Nicholas.

The story appears in the *Golden Legend*.

THE MIRACULOUS REPLENISHMENT OF THE GRAIN EVOKES THE familiar motif of divine intervention in times of hunger. In the miracle of Elijah and the widow of Zarephath (1 Kings 17:8–16), an inexhaustible jar of grain provides food for a household throughout a protracted drought. The tale also recalls the story of Christ's feeding of the five thousand, in which Jesus multiplies five loaves and two fish to satisfy the hunger of the great crowd. As Elijah and Christ have done, so does Nicholas. Carefully measured stores of grain are tapped to feed the hungry people, yet are never diminished. Nicholas' action reveals God's power to save the starving.

Although this is a work of hagiography rather than history, it does reflect the important secular role bishops began to play in the waning days of the Empire. With the legalization of Christianity under Constantine, the Church hierarchy became increasingly involved in administrative functions within the broader society. In this legend, the fact that the people turn to Nicholas, rather than to the civil governor, reflects his importance in the life of the city. Nicholas is concerned with the secular well-being of his people, just as he attends to their spiritual needs.

Lorenzetti's panel was painted for the Church of San Procolo in Florence. Now in the Uffizi, it once formed part of a larger altarpiece portraying the life of Saint Nicholas. The two side wings have survived, while the central image has not. Lorenzetti is best known for his monumental frescoes illustrating "Good Government" and "Bad Government" in the Palazzo Pubblico of Siena, the town of his birth. The clarity of his storytelling and his full-bodied figures are indebted to the work of Giotto, and represent a shift in Sienese art away from the Byzantine-influenced paintings of his predecessors.

In this panel, angels pour grain from heaven on the ships as the master of the convoy takes leave of Saint Nicholas.

Nicholas Revives the Strangled Boy

The story appears in
the *Golden Legend*.

THERE WAS A FATHER WHO LOVED HIS SON DEARLY.
Every year he celebrated the feast of Saint Nicholas with great
solemnity, praying to the saint to protect and bless his child.
One day he prepared a great dinner and invited many guests. A
pilgrim appeared at the door, begging alms for his journey. The
man sent his son out to the courtyard to give the man a donation. But the pilgrim
was actually a demon in disguise. The fiend snatched the boy and strangled him to
death. The father went out and beheld his son's corpse. Wailing, he brought the
boy's body into the house. "My bright, sweet son!" he cried, "How can this have
happened to you? Saint Nicholas, is this the reward you give me for my years of
devotion to you?" As he mourned, the boy suddenly opened his eyes, as though
waking from a deep slumber. He was restored to life and his family rejoiced.

THE FAITHFUL FREQUENTED THE SHRINES OF THE SAINTS IN ORDER
to obtain favors and protection from danger. Famine, disease, and violence were
constant realities of ordinary life, and the offering of candles and prayers was the only
assurance people had of safety.
Nicholas was particularly invoked for
the protection of children.

*The painting here comes from the same altarpiece as the preceding
miracle story. Ambrogio Lorenzetti has condensed the entire tale into
a tightly woven composition. Upstairs, we see the people gathered for
the feast. At the top of the stairs, the boy approaches the demon. In the
courtyard below, the strangling takes place. In the lower room, the
dead boy is mourned by his mother, and revives from death as his
mother is shown again, rejoicing. The praying father faces the saint,
who appears in the upper left with a beam of healing light which
enters the window and touches the boy. The architectural setting
becomes a framework in which all the key scenes happen simultane-
ously. Lorenzetti guides our eye around the panel, finally arriving at
Nicholas, who presides over the whole drama.*

In this posthumous miracle,
Nicholas saves the life of a boy. The
father's reaction to his son's death is
one of outrage. As he laments the
demon's crime, he cries out to
Nicholas. After the careful homage he
had paid the saint, why should he be
punished in return? The saint
answers the father's prayer, making
good on the faith he has shown.

Although this might seem a
rather crass bargain, buying the
favors of the saint through acts of devotion, it reflects the intensity and intimacy of the
father's relationship with Nicholas. The saint is as real to him as the demons that stalk
his doorstep. When disaster strikes, he is able to approach the saint in prayer and
express all his sorrow and indignation. Nicholas' intervention rewards the man's fideli-
ty, and confirms his care and concern for him and his son.

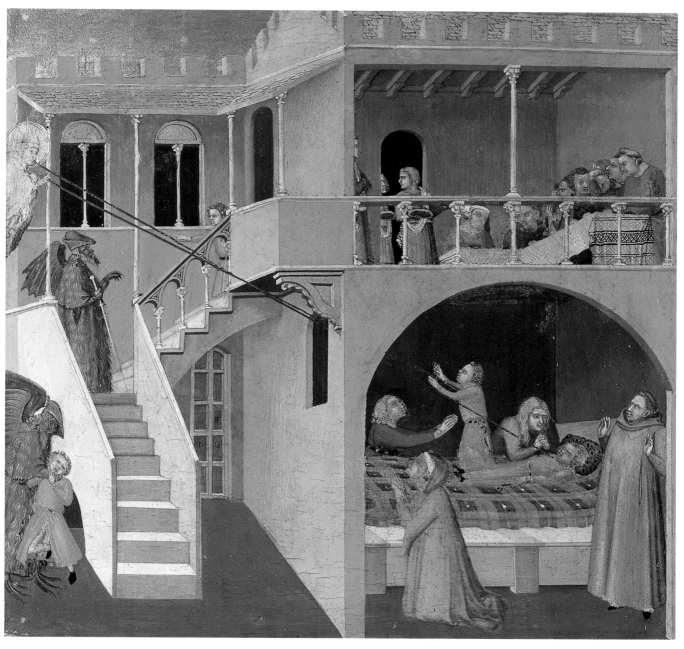

Ambrogio Lorenzetti (1285–1348), *Resurrection of the Boy*, 1332.
Tempera on wood from an altarpiece, Uffizi, Florence.

Jerome and the Lion

This story appears in
the *Golden Legend*.

NE EVENING, AS JEROME AND THE MONKS GATHERED
for prayers, a lion wandered into the courtyard of the monastery.
The monks, in a panic, scattered in every direction. Jerome,
however, walked right up to the beast and greeted him as a guest.
The lion reached out his paw; there, stuck in his tender pad, was
a thorn. Jerome ordered the monks to wash the animal's feet, and he gently pulled
the thorn from his paw. From that moment on, the lion became gentle and tame,
and lived among the monks.

When Jerome saw that the lion intended to remain, he set the beast a task. The
lion was made the herdsman of an ass that gathered firewood every day from
the surrounding countryside. The lion made sure that the ass worked diligently,
coming and going from pasture to monastery. Each day, at the appointed time, the
pair would come in for their daily meal.

All went well until one day, as the lion dozed near the pasture, a group of
merchants happened by and stole the ass. When the lion woke, he became frantic,
scouring the fields and hills for the missing animal. When at last he came to the
monastery, he stood outside the gate and would not enter, his shame was so great.

*Colantonio was a Neapolitan painter of the late fifteenth century and
one of the early proponents of the use of oil paints. In this intricately
detailed panel, Jerome sits in his study with all the accoutrements of a
fifteenth-century scholar. It is not tidy; this is a working space. Well-
worn books lie scattered across the shelves in a dazzling array of styles
and formats; little bookmarks jut out from between their pages; scraps
of vellum are tucked into corners and fall under the desk. Jerome has
jabbed his penknife casually into the wooden surface. On the small
chest in the lower left lies his red cardinal's hat with its many tassels.*

*Jerome interrupts his work to attend to the lion's paw. With quiet
concentration, he uses a small tool to pry out the thorn. The lion, as
calm as a housepet, sits patiently at his feet.*

The monks were angry, and
refused him his daily ration. Jerome
decided that the lion, in penance,
should do the work in place of the
ass. So the lion meekly set to carry-
ing firewood.

One day, as the lion toiled in the
fields, he saw the traders' caravan
far off in the distance. There, lead-
ing the camels, was the ass! The lion
charged towards them and fright-
ened the merchants off with his
loud roars. He then herded the ass
and the camels, fully laden with
goods, to the monastery.

The relieved lion ran happily through the monastery, kneeling in front of
each brother, and stroking the monks with his tail. At length, when the merchants
straggled in, ashamed to have been discovered with the stolen ass, it was agreed that
they would pay a yearly portion of fine oil to the monks as restitution.

TO HISTORIANS, JEROME IS KNOWN AS A MAN OF VAST ERUDITION
and fearsome asceticism. He used his knowledge of Hebrew and Greek to produce the
Vulgate, a Latin translation of the Bible, which was authoritative in Western Europe
for more than a thousand years. In the popular mind of the Middle Ages, however, he
is best known through this endearing folk tale.

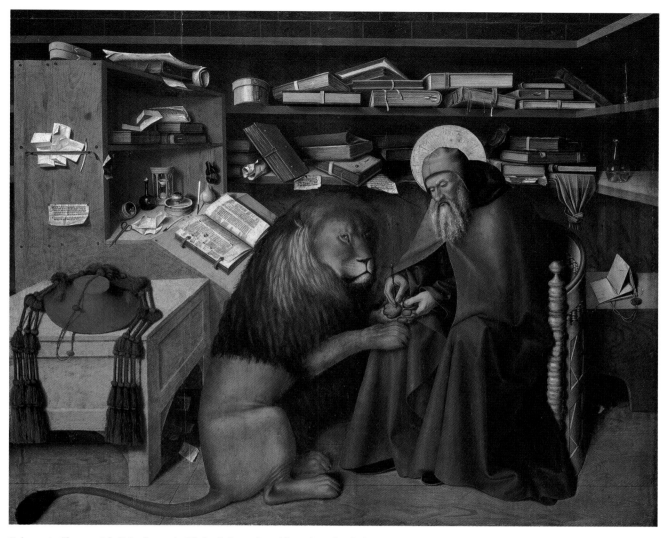

Colantonio (fl. 1420–60), *Saint Jerome in His Study Removing a Thorn from the Lion's Paw*, c. 1445.
Oil on wood, Museo Nazionale di Capodimonte, Naples.

[OVERLEAF]
Vittore Carpaccio (1450–1525), *Saint Jerome Leads the Lion Into the Monastery*, 1502.
Tempera on canvas, San Giorgio degli Schiavoni, Venice.

The miracle of the tame lion portrays human beings and nature in harmony. The grateful lion works with the monks, taking his place in an orderly and caring community. In a poetic passage from Isaiah, the prophet imagines just such a time of peace. "The wolf shall live with the lamb," it reads. "The lion shall eat straw like the ox." Human beings will return to a time of innocence, re-creating the original harmony of the Garden of Eden.

Isaiah 11:9.

Jerome's holy life and deep compassion allow him to realize the prophecy in his monastery. Without fear, he attends to the lion's need, and the lion responds in kind. When the lion seems to have betrayed the monks' trust, Jerome does not punish him, but lets him make up for the loss of the ass.

The story can also be read as an allegory for the taming of the passions. The lion's violent nature is transformed by an act of charity. The law of love reins him in. And yet, when he needs to summon his powerful roar, he is able to use his fearsome abilities for the good, saving the stolen ass, and setting right his earlier wrong.

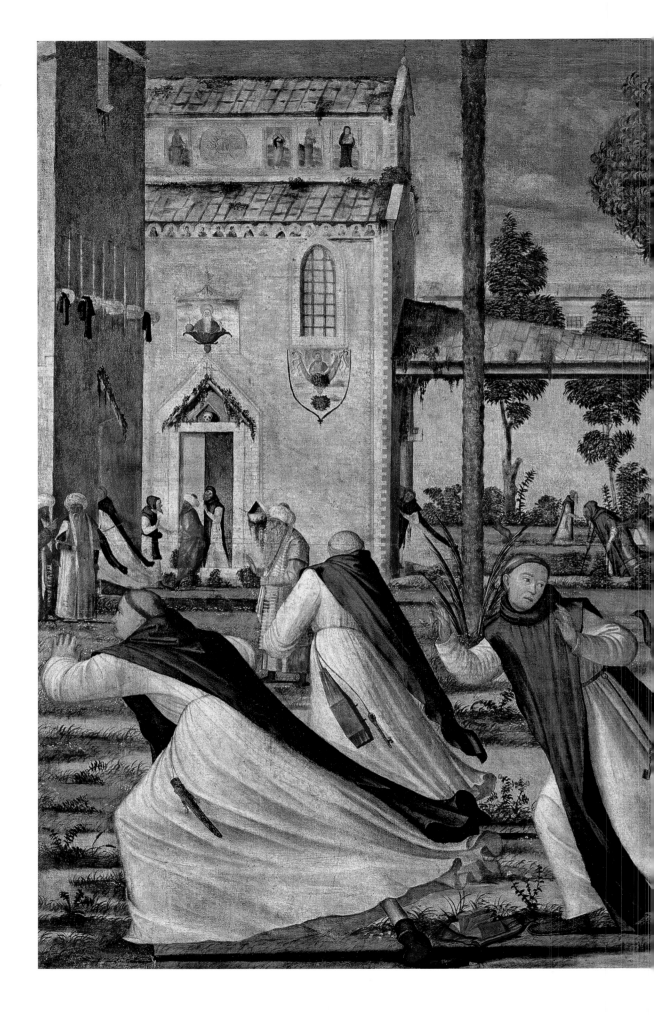

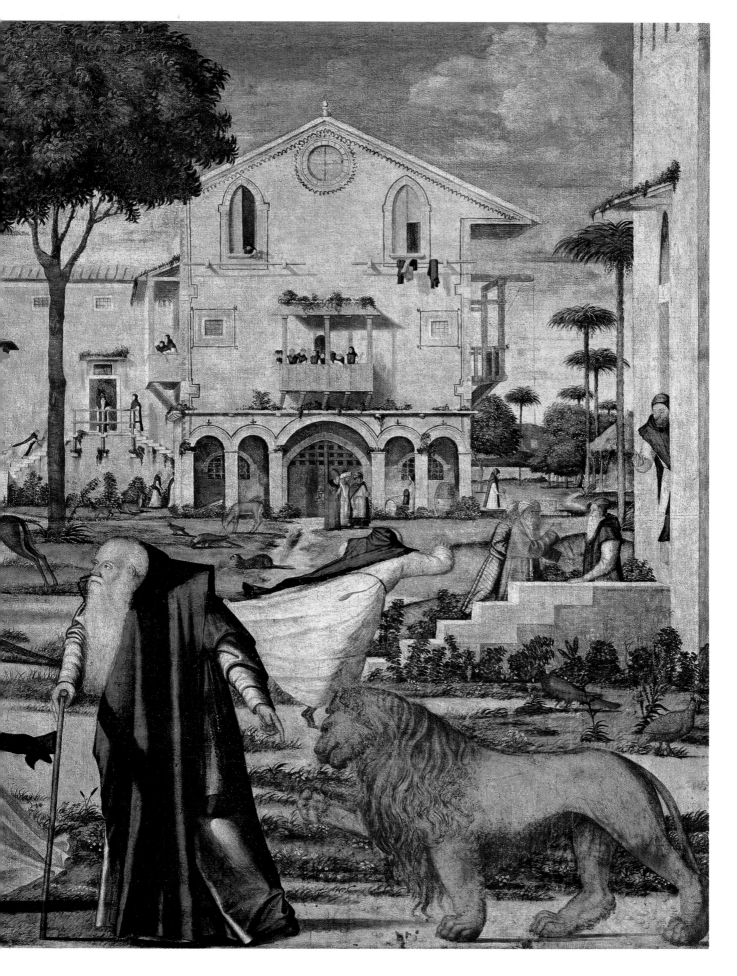

Pope Sylvester Seals the Dragon's Mouth

The story appears in the *Golden Legend*.

 FIERCE DRAGON APPEARED IN A PIT IN THE CITY OF Rome. With its poisonous breath, it killed more than three hundred people every day. The pagan priests went to the Emperor Constantine and complained: Ever since the emperor had converted to Christianity, this dragon had been killing his subjects. Constantine summoned Sylvester, the bishop of Rome, to ask his advice.

Sylvester left the emperor and prayed for guidance. Peter appeared to him in a vision and told him what to do. Invoking the name of Christ, he should seal the dragon in his pit, binding him until the time when Christ should come again.

The bishop did as he was commanded. Taking two priests with him, he went to the dragon's lair. Carrying lanterns to light their way, they descended one hundred fifty steps into the depths of the pit. There they found the cruel beast. Sylvester pronounced the divine sentence on the dragon. Then he took a cord, tied the mouth of the dragon shut, and secured it with his seal, which bore the mark of the cross.

As he climbed up out of the pit, he came upon two enchanters, who

Maso di Banco, a pupil of Giotto, was commissioned in the 1340s to decorate the Bardi family chapel in Santa Croce in Florence. His simple, monumental style owes much to his master. In this fresco, the ruins of the Roman Forum provide the backdrop to the drama. A column neatly separates two scenes. On the left, Sylvester ties and seals the dragon's mouth. On the right, he revives the two enchanters, while the emperor and his retinue look on.

were half dead from inhaling the dragon's stench. Sylvester made the sign of the cross over them and they were revived. Immediately they converted and were baptized. The people of Rome were awestruck and many in the crowds who witnessed this marvel were also converted to the faith.

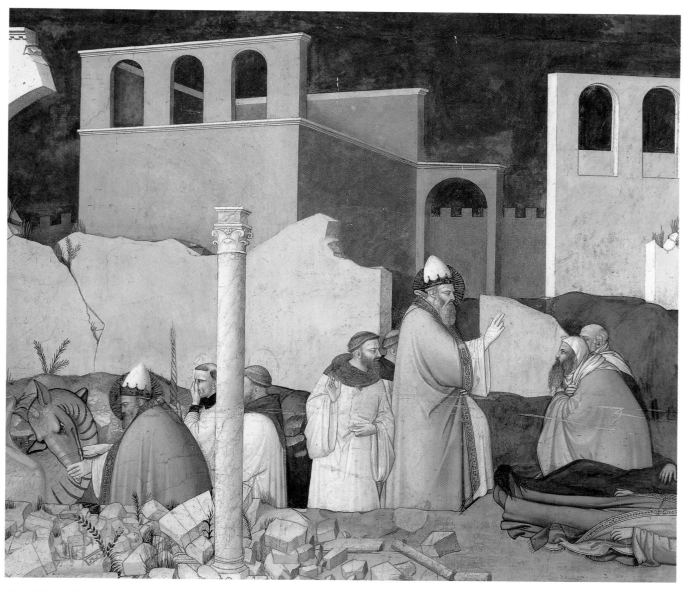

Maso di Banco (fl. 1320–50), *Saint Sylvester Sealing the Dragon's Mouth and Resuscitating Two Pagan Magicians.*
Fresco, Bardi di Vernio Chapel, S. Croce, Florence.

SYLVESTER WAS BISHOP OF ROME DURING THE REIGN OF CONSTANTINE.
Here he is presented in a mythic setting, battling with the forces of evil in the form of
a great dragon. His triumph over the demon is limited: He does not kill the beast, but
only seals his mouth until the Christ will come again to achieve the final victory.

The story contrasts the powerlessness of the pagan priests—referred to as the
"bishops of the idols"—with the authority of the Christian bishop. When the priests
see the dragon overcome and the raising of the enchanters, they join the Christian
ranks. The *Golden Legend* contends that Rome was thus saved twice over: The people
were delivered from both a deadly scourge, and from the false worship of idols.

Benedict and the Poisoned Chalice

The story appears in
the *Golden Legend*.

WHEN BENEDICT WAS LIVING IN HIS WILDERNESS retreat, it happened that the abbot of a nearby monastery died. The monks gathered to choose a new leader and, having heard of Benedict's sanctity of life, elected him to be their new Father in God.

A delegation of monks was sent to invite Benedict to take up the abbacy, but the saint declined their offer. Their manner of life, he believed, was too different from his own. The monks implored him, explaining their urgent need of guidance and leadership. Moved by their entreaties, Benedict finally accepted.

Finding them lax in their observance of monastic life, he began to admonish them. Such was his vigor in defending the pious life that he soon had made enemies of his monks.

Unwilling to change and knowing that they would chafe under his rule, the monks conspired to kill Benedict. They poisoned a glass of wine and offered it to the saint. Saying a blessing, Benedict made the sign of the cross over the glass, which shattered in his hands.

Benedict, realizing their treachery, got up and said to the monks, "God have mercy on you, fair brothers; I said to you rightly, at the beginning, that my way of life was not like yours; so now get yourselves another father, for I may no longer stay here." And he returned to the wilderness to make new monastic foundations of his own.

A MONASTERY IS MEANT TO BE A SCHOOL OF CHARITY WHERE MONKS learn through hard work, penance, and prayer, to love God with all their body, mind, and soul. It is a rigorous existence, requiring discipline and consistent self-denial. Because this way of life is so demanding, there is no guarantee that a monastery will live up to its high calling. Although Benedict was kind and comforting to monks who were faithful to their vows, he could be harsh and forthright with those who dishonored their profession. The poisoned cup is a potent symbol of the malice infecting the unnamed monastery. Once Benedict perceives the depth of their rage, he simply withdraws, reminding them of the misgivings he had from the outset.

Zurbarán's painting comes from a cycle of thirteen portraits of the founders of monastic orders. This somber portrait of the saint shows Benedict wearing the dark robe of the Benedictine Order. His hair is cut in the circular tonsure, a sign of his monastic profession. Holding in his hand a symbol of human treachery and malice, Benedict is lost in thought. His expression is resigned, not triumphant, showing his sorrow at the perfidy and unfaithfulness of the monastic community.

The monastic reformers—people like Benedict, Bernard of Clairvaux, and John of the Cross—have always encountered opposition. In the sixteenth century, John of the Cross was kidnapped by renegade monks who were resisting his plans for reform, and imprisoned in their monastery. As he languished in captivity, he began to compose his *Spiritual Canticle*, a poem of adoration. His reforms had to wait until he was able to escape and find shelter in a more dedicated religious house. In their struggles, the reformers revealed their own wisdom, patience, and forbearance.

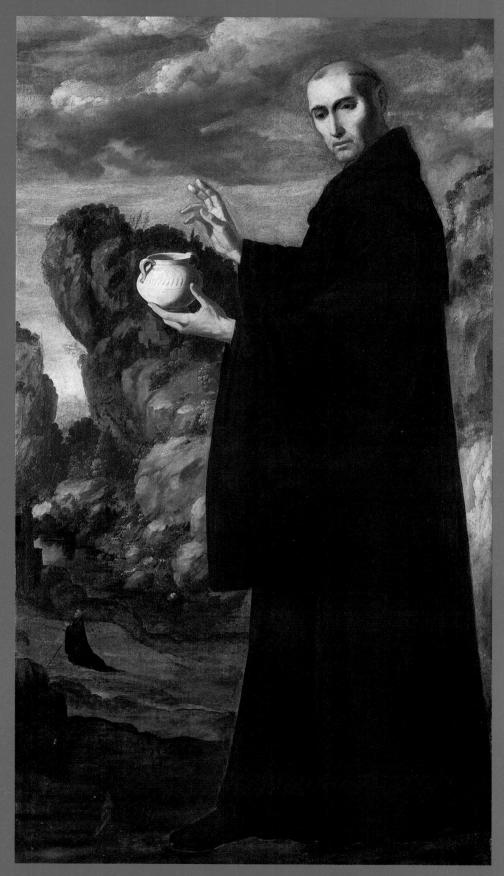

Francisco de Zurbarán (1598–1664), *Saint Benedict*.
Oil on canvas, Metropolitan Museum of Art, New York.

Benedict Causes Water to Flow from the Mountain

The story appears in the *Golden Legend.*

HREE OF THE MONASTERIES FOUNDED BY BENEDICT were perched high on mountains, far from any natural springs. The monks were obliged to climb down steep and dangerous slopes to fetch their daily water from a lake in the valley below.

A group of monks was sent from one of the abbeys to explain to Benedict the great difficulty they had in obtaining water. They asked that the site of their monastery be moved to a more convenient place.

Benedict heard their complaint and, with many kind words, sent them back to the monastery. That night, he climbed the mountain with Placidus, and gave himself to fervent prayer. As the morning broke, he laid three stones on the mountainside and returned to his own abbey.

When the monks returned the following day, Benedict told them to go to the place where he had laid the stones; God would bring forth water from the hillside, to save them the daily toil of climbing down to the lake.

Following Benedict's instructions, they found the rocks just as he had described. Already the water had begun to flow, as if the mountain were breaking into a sweat. With spades, they quickly dug a shallow pit, which filled straightaway, and the water gushed forth, spilling down to the valley below.

The fresco is one of 36 scenes from the life of Saint Benedict in the Great Cloister of the Abbey of Monte Oliveto Maggiore outside Siena. The abbey was founded in the mid-fourteenth century. The first nine of these frescos were painted by Luca Signorelli in 1497 and 1498. The cycle was completed by Giovanni Antonio Bazzi, usually known as "Il Sodoma," and was executed between 1505 and 1508.

JUST AS THE MONKS HAD REMOVED THEMSELVES FROM THE COMFORTS and distractions of ordinary life through their vows, so they removed themselves physically to monasteries built in the wilderness. These lonely places were not only practical—assuring the monks of solitude—but they were seen as a physical expression of spiritual cleansing and purification. In the Bible, the wilderness is a place of testing. Moses and the Israelites must traverse the desert to arrive at Sinai, where they encounter God on the mountain; Christ goes into the wilderness to be tempted, emerging victorious over Satan. In the wilderness, the unnecessary is pared away and the monk, unencumbered, faces God.

The monastic life revolved around two central practices: work and prayer. In his *Rule*, a collection of regulations for monastic life, Benedict set out the sequence of psalms to be recited through the hours of prayer. Monks recite the whole book of Psalms each week. In Benedict's time, many would have known the whole Psalter by heart.

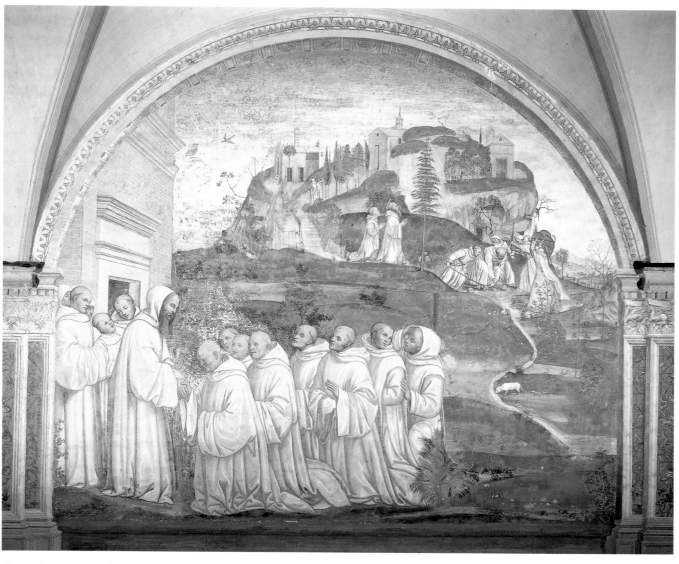

Giovanni Antonio Bazzi, known as Il Sodoma (1477–1549), *St. Benedict Causes the Water of the Mount to Flow*, 1508. Fresco, Abbey of Monte Oliveto Maggiore, Siena.

Biblical stories and the poetry of the Psalms infused the monastic life with rich, living metaphors. Thus the story of a monastery without water, perched high on a rock, is not simply about a practical matter to be resolved, but is a symbol of spiritual questing. Recalling the Exodus story of Moses striking the rock, the Psalms say:

> He split rocks open in the wilderness, Psalm 78:15–16.
> And gave them drink abundantly as from the deep.
> He made streams come out of the rock,
> And caused waters to flow down like rivers.

Benedict's miracle expresses a faith that God will provide, even in the harsh wilderness. The monks' physical need for water is satisfied in a way that recalls their spiritual thirst for the divine. In a barren waste, the water gushing forth is not simply sufficient, it is abundant.

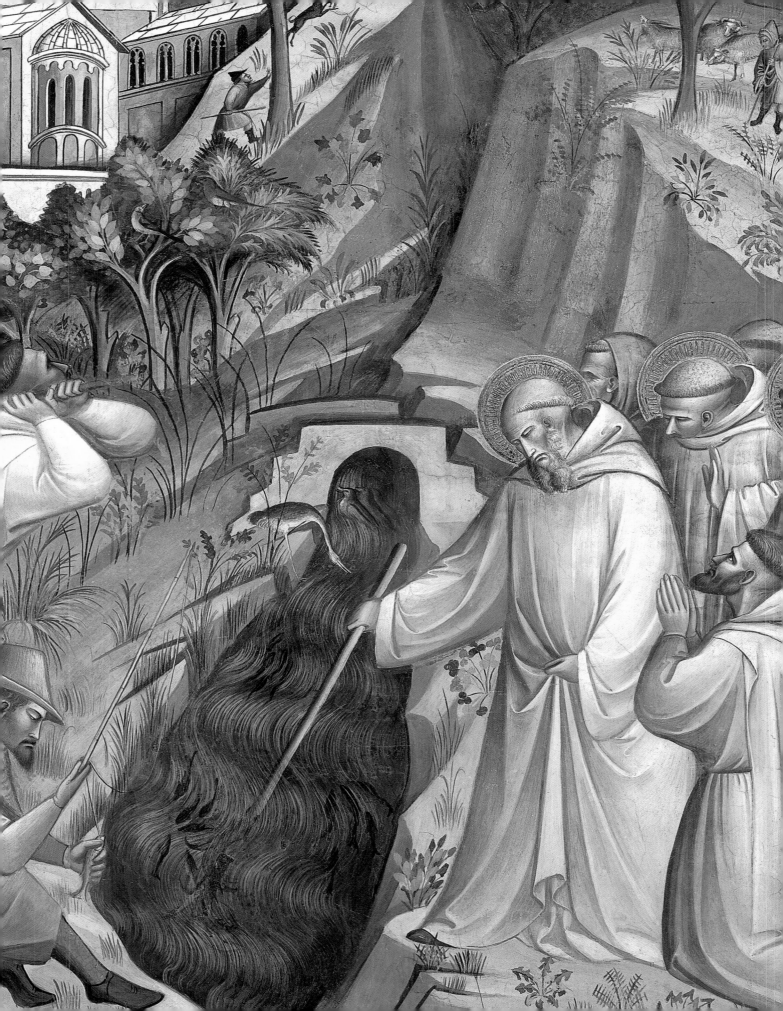

Spinello Aretino (c. 1345–1410)
Saint Benedict Makes the Billhook Fallen into the Water Return to Its Handle, 1387.
Fresco, San Miniato al Monte, Florence.

Benedict and the Axe

 AINT BENEDICT SET A MAN THE TASK OF CUTTING back thorns and shrubs near the monastery to clear a space for a garden. As he was working near a stream, his iron axe head fell from its shaft into deep water. The man was distraught. He ran to Maurus and confessed how careless he had been. When Benedict was told of it, he came and took the axe handle from the man. He threw it into the water. Immediately, the iron axe head rose to the surface and swam, reuniting itself to its handle. "Here is your axe head," Benedict said. "Do not be sad any more."

The story appears in the *Golden Legend* and in Gregory the Great's *Second Book of Dialogues, Containing the Life and Miracles of St. Benedict of Nursia.*

WHILE THEOLOGIANS DO THE IMPORTANT WORK OF DEBATING THE philosophical implications of the faith, most people experience the religious life in everyday difficulties and challenges. The miracles of the saints inspire people to hope for divine intervention and guidance in solving life's common problems.

In this simple anecdote, Benedict's kindness addresses the man's immediate need. The axe head is an expensive tool—to lose it is a serious dilemma. This is a very practical miracle. Many of the miracle stories of the Bible and from the lives of the saints are set in motion by this kind of basic human problem. The immediacy of these tales makes the faith tangible.

An identical tale appears in the Bible, concerning the prophet Elisha. In that story, the man who loses his axe is even more upset, for the axe was borrowed. Elisha also throws the handle into the water, bringing the axe head up from the deep. Benedict does Elisha one better: This axe head not only emerges from underwater, but it swims and reattaches itself to the wooden shaft.

Many monasteries supported themselves through their agricultural labor; the monastic buildings were the center of vast expanses of working land. This fresco by Spinello Aretino shows the monastery in the background; one monk peers over a retaining wall at the scene below. As Benedict throws the handle into the water, the distraught man kneels at his feet. All around them, the daily work of the monastery carries on.

The fresco is part of a series of scenes from Benedict's life decorating the sacristy of the hilltop church of San Miniato al Monte, a monastic foundation on the edge of Florence.

To the modern ear, this repetition of a story may seem to reflect a want of imagination, but to the medieval mind, the similarity between the tales was deeply appealing. If Benedict recreated a miracle of Elisha from the scriptures, this was convincing proof of the authenticity of his divine gifts.

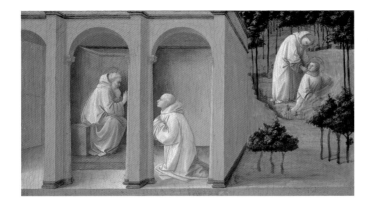

Filippo Lippi (c. 1406–69)
Saint Benedict Orders Saint Maurus to the Rescue of Saint Placidus, c. 1445.
Tempera on panel from an altarpiece,
National Gallery of Art, Washington D.C.

Benedict Orders Maurus to Save Placidus

The story appears in the *Golden Legend*.

HERE WAS A YOUNG MAN OF THE MONASTERY WHOSE name was Placidus. Benedict sent him out to draw water from a swift stream. As Placidus reached down with his bucket, his foot slipped on the muddy bank. The current caught him, and carried him rapidly downstream. Benedict, who was in his study, could see what had happened. He called Maurus, told him that there was a young monk who was about to drown and that he should go quickly to the lad's aid. Maurus hurried out of the monastery, and went straight out onto the river, running over the water as if it were dry land. Grabbing poor Placidus by the hair, he dragged him back to the safety of the riverbank.

When Maurus returned, Benedict told him it was not his virtue that had given him the power to walk on water; it was his obedience which had done so.

Filippo Lippi's intimate panel depicts the story in two parts. On the left, Maurus is sent by Benedict to save the drowning boy. On the right, Maurus pulls Placidus from the river. The image was originally painted as part of a larger altarpiece. Lippi was himself a monk, having entered the Carmelite order in Florence in 1421. His painting career spanned more than four decades, during the first flush of the Renaissance in Florence. His work came to the attention of the ruling Medici family, and a number of his prominent paintings were produced under their patronage. In his Lives of the Artists, Vasari portrays Lippi as a sensuous, amorous man. Vasari reports that Cosimo de Medici once locked him in a room to keep his mind on his painting; Lippi tied his bedsheets together to escape into the night. There is a certain irony that a monk so at odds with his own vows could paint a story of unquestioning obedience with such gentle piety.

MONKS VOW THEMSELVES TO A LIFE OF POVERTY, CHASTITY, AND obedience. With these three disciplines, they rein in their own desires and place themselves completely at God's disposal.

Benedict's words are harsh, but they are meant to instruct Maurus. The extraordinary feat of walking on water is a spiritual gift. And lest Maurus feel pride over what happened on the stream, Benedict reminds him that the miracle was wrought not out of any personal power, but through his unquestioning obedience.

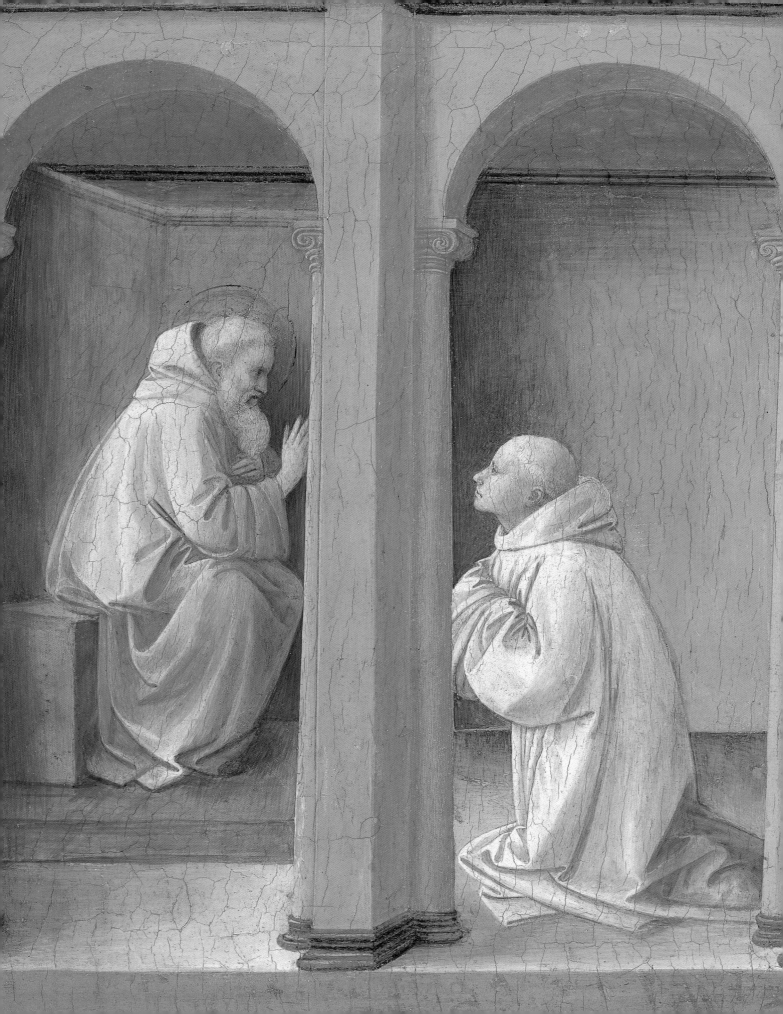

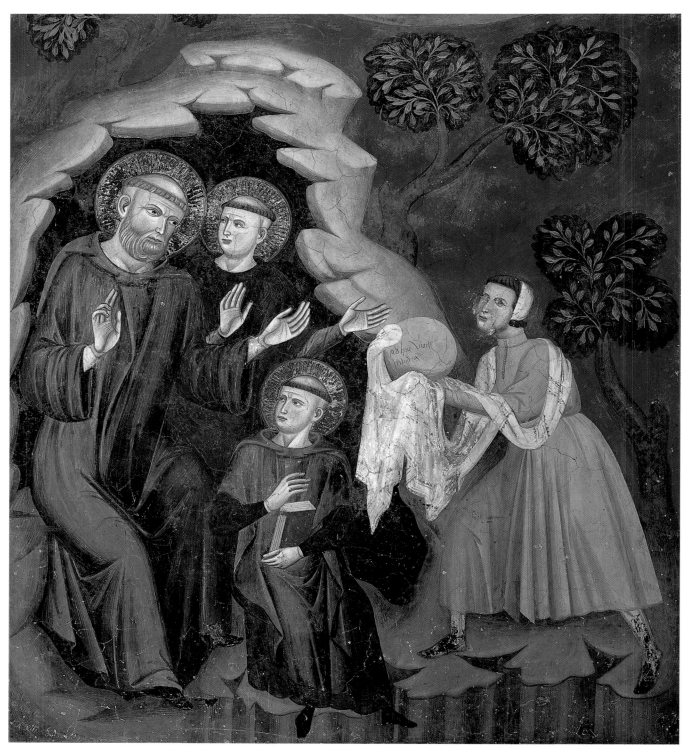

Anonymous (Umbrian), *A Woman Offers Poisoned Bread to Saint Benedict* (detail), 14th c.
Fresco, Sacro Speco, Subiaco, Italy.

Benedict and the Poisoned Bread

 ENEDICT'S FAME WAS SO GREAT THAT A PRIEST IN that region, Florentius, became jealous. He discouraged the curious from visiting the saint, and slandered him at every opportunity. His ill words had no effect—Benedict's fame continued to grow. Burning with envy, Florentius devised a plan: He sent a loaf of poisoned bread as a gift to Benedict. The saint received the bread graciously, knowing full well what was hidden within.

There was a crow from a nearby wood that used to come by Benedict's home every afternoon. He would feed it small morsels of bread, which the bird would nibble straight from his hand. That day, when the crow arrived, Benedict said to it, "In the name of Jesus Christ our Lord, take that loaf away and leave it in a place where no one will find it."

The crow, opening its mouth and flapping its wings, danced about the loaf cawing loudly, as if to say he would gladly do what the saint commanded, but could not.

Benedict told it, "Do not be afraid. Take the loaf and leave it where no one will find it."

At last, after much fuss and bitter complaining, the crow did as it was instructed. It took the poisoned bread and flew away. When it had disposed of the loaf, it returned, and received its daily feeding from the holy man.

THE STORIES SURROUNDING BENEDICT'S LIFE OFTEN DESCRIBE situations of conflict and jealousy. As he explored the spiritual life, he not only battled his own demons, but he had to contend with people who resented his way of life and his increasing fame. For the local priest, Florentius, envy flowers into murderous rage. Benedict's crow—an echo of the ravens that fed Elijah in the wilderness—is a peaceful companion to the hermit saint. In a nice reversal of the Elijah story, the saint feeds the bird from his own hand. When he asks the crow to carry away the poisoned bread, the bird resists: Both hermit and crow know that the bread has been poisoned.

Sadly for Florentius, his scheme is foiled by Benedict's prophetic ability to discern the poison. He later hatches a plot to send women to entice Benedict's monks to betray their vows of chastity. This scheme fails as well, and Florentius is eventually killed when a part of his house collapses on him.

When the young monk, Maurus, gleefully reports the scheming priest's death to Benedict, he earns a rebuke from the saint, and is commanded to do penance. Benedict grieves the death of his enemy, showing a charity that eludes the less spiritually developed Maurus.

The story appears in the *Golden Legend.*

The detail shown here is from a Romanesque fresco cycle in the church built at the Sacro Speco (Holy Cave) at Subiaco. Positioned to the left side of a window, it is accompanied by a second scene, which shows the crow carrying off the poisoned loaf. The church at Sacro Speco was built at the site of Benedict's wilderness hermitage, where the miracle is said to have taken place.

Benedict Exposes the False Attila

The story appears in the *Golden Legend* and in the *Second Book of the Dialogues Containing the Life and Miracles of St. Benedict of Nursia* by Gregory the Great.

ATTILA, THE KING OF GOTHS, RAVAGED ITALY WITH HIS armies. One day, his troops drew near to the monastery where Benedict lived. Attila, having heard that the supposed holy man had prophetic powers, determined to test him, hoping to expose him as a fraud.

He sent word to the monastery that he wanted to pay a visit to Benedict, and the saint replied that he could come whenever he wished. So Attila summoned a member of his guard, a man named Riggo, and dressed him in his own princely robes to impersonate the king. Three other advisors were commanded to go with Riggo, serving him just as if he were Attila himself.

As Riggo and his princely entourage rode in to the monastery, Benedict was sitting outside the abbey, watching the grand procession. The saint shouted out, "Take off those clothes, my good son, for the robes you wear are not yours at all!"

Riggo and his advisors fell to the ground in fear and shame for having tried to mock the wise and holy man. Once they had finished prostrating themselves, they returned straight to Attila and recounted with alarm how Benedict had exposed the imposter.

AS THE WESTERN ROMAN EMPIRE COLLAPSED UNDER THE WEIGHT of the barbarian invasions, the Church was one of the few institutions to survive. In this legend, Benedict faces down the ravaging Attila with enormous courage and prophetic power.

The ruse of sending an imposter to parlay with the saint is meant to taunt Benedict, making him seem foolish and testing his authority. Instead, Attila finds himself bested by the abbot, who recognizes the deceit before Riggo even reaches his door.

The two versions of this tale differ in some important details. While the *Golden Legend* identifies the barbarian invader as Attila, Gregory's *Dialogues* refer to him as Totila, a different chieftain. In the *Golden Legend*, Riggo (who is unnamed) drops dead at the feet of the abbot. In Gregory's *Dialogues*, the chieftain is humbled by the miracle, and comes to talk with Benedict. Dismounting some distance from the monastery, he approaches on foot, bowing as he nears. Benedict reproves him for his cruelty, and offers him a prophecy about the remaining ten years of his reign. The chieftain mends his ways and, though his course of conquest is unchanged, he reins in the savagery of his barbarian army.

Spinello Aretino painted this fresco as part of a large decorative program for the sacristy of the Church of San Miniato in Florence. Aretino brings the figures together at the gate of the monastery. As Benedict gestures with his hand, Riggo, the imposter, falls backwards. The carefully rendered armor and delicate architecture lend a richness of detail to a scene which takes place in a simplified, Giottoesque landscape.

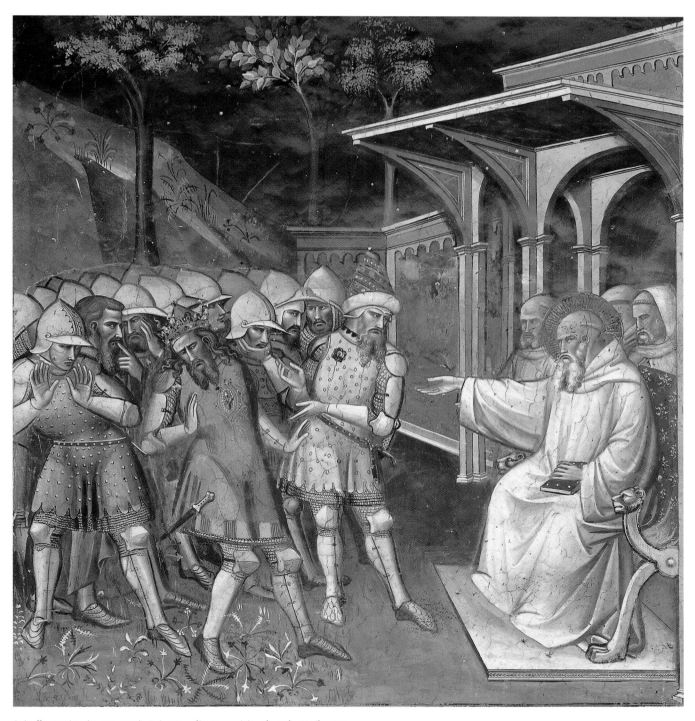

Spinello Aretino (c. 1345–1410), *Saint Benedict Recognizing the False Totila*, 1387.
Fresco, San Miniato al Monte, Florence.

Limbourg Brothers (15th c.), *The Procession of Pope Gregory the Great for the Cessation of the Plague in Rome*, 1416.
Illuminated miniature, Musée Condé, Chantilly, France.

Pope Gregory and the Plague

 TERRIBLE PLAGUE GRIPPED THE CITY OF ROME. When Pope Gregory saw that it did not abate, he commanded that a great procession should pass through the streets of the city. The people bore an image of the Virgin Mary, painted by Saint Luke himself, on their march through the streets. As they went, Gregory implored God to deliver the city from pestilence.

Suddenly, the plague ended. Angels could be heard singing near the sacred image of the Virgin, and Gregory joined their song with shouts of "Alleluia." Then he looked up to the castle by the Tiber's bank. There, atop the castle, stood an angel, who took his sword, wiped it clean of blood, and sheathed it. From that day on, the castle has been called Castel Sant' Angelo.

The story appears in the Golden Legend.

THE FILTHY CITIES OF THE ANCIENT AND MEDIEVAL WORLD WERE breeding grounds for disease. Raw sewage, rotting garbage, and tainted water made the outbreak of large epidemics inevitable. No medicines existed to combat the "foul air" which was blamed for the plagues that ravaged the towns. The only remedy was to retire to a country villa and wait (if one had the means), or to implore God to end the pestilence.

Widespread diseases were interpreted as divine chastisement for the sins of the people, a just punishment for human wickedness. The figure of the avenging angel, carrying out God's will with a bloody sword, cast fear into the minds of the people.

Gregory steps into office as the plague ravages Rome. He was an unwilling Pope. Born to a patrician Roman family, Gregory had entered government service as a young man. Soon he felt compelled to renounce his riches and power and enter the religious life, where he gained a different kind of authority, one based on the sanctity of life and the wisdom of teaching. When Pope Pelagius died, the people selected Gregory to be their new bishop, despite his resistance. They closed the city gates to prevent him from fleeing, but he managed to escape in an oxcart driven by merchants. According to legend, he hid in the countryside for three days, until a shaft of light burst from heaven like a spotlight, pinpointing his location. Unable to hide, he finally accepted the office of Pope. In response to the rampant plague, Gregory arranges for the procession carrying the miracle-working image of the Virgin Mary by Saint Luke, who was said to have been a painter as well as a physician. His prayers are heard, and the vision of the angel sheathing his sword confirms the city's deliverance from the pestilence.

The Tres Riches Heures of Jean, Duc de Berry *is one of the most exquisite Books of Hours of the late Middle Ages. Illuminated by the Limbourg brothers for their noble patron, it was never finished.*

The illustration wraps around a portion of the text from the Seven Penitential Psalms. Gregory's miracle is appropriate adjunct for these psalms—6, 31, 37, 50, 101, 129, and 142—which were used as prayers for forgiveness of sin. As Gregory raises his hands in prayer, people in the procession collapse behind him. A mother swoons as her helpless child reaches for her. Above the scene, the angel is seen, sheathing his sword.

The Mystic Mass of Pope Gregory

The story appears in
the *Golden Legend*.

HERE WAS A WIDOW IN ROME WHO USED TO BAKE the bread used for the Holy Eucharist. One Sunday, she brought her bread to the church, and Pope Gregory received it and began to celebrate the mass. Once the bread was consecrated at the altar, he turned to distribute communion to the people. He came to the widow and pronounced the accustomed words: "The body of our Lord Jesus Christ keep you in everlasting life." The woman smiled. Gregory was not pleased, and rather than give her communion, he returned the sacrament to the altar. Then he walked back to the woman and asked why she was smiling. "Because," she answered, "you tell me the bread I baked with my own hands is the body of our Lord Jesus Christ."

In response to the woman's impious words, Gregory called the people to prayer, asking God for greater faith. After they had prayed together for some time, he rose and went to the altar. There the bread was transformed—it became actual flesh. Gregory and the people were astounded. He then prayed again over the sacrament, which once again took the form of bread. He lifted the bread from the altar and gave communion to the widow, who never again scoffed or doubted.

FROM THE TIME OF THE EARLY CHURCH, THE BREAD AND WINE OF the Eucharist have been treated with great reverence. During the Middle Ages, theologians debated the nature of the transformation that took place at the moment of consecration. The doctrine of transubstantiation, which codified these ideas into a unified theory, holds that the substance of the bread and wine are changed into the very body and blood of Christ. Their "accidents," or external appearance, remain unchanged. This doctrine was a core tenet of medieval belief and informed popular piety.

This missal, exquisitely printed in two colors, is lavishly illustrated and contains initial capitals painted in by hand. It was made only one generation before the Protestant Reformation, which would challenge the Eucharistic piety expressed through the image on this page. Ironically, the advent of printing was one of the factors that ushered in the Reformation. The quick dissemination of theological tracts and Bibles in the vernacular broke down the medieval Church's control over the religious life of Europe. Just twenty-five years after this Missal was printed, Luther would nail his 95 Theses to a church door, and usher in a new age.

The story of Gregory's Mass presents the doctrine as a tangible reality. The smiling widow sees only the bread she baked herself. The miraculous transformation of the bread reveals its true essence, quashing unbelief. Once doubt has been vanquished, the bread is changed again, and the ceremony can continue.

The image of Gregory's Mystic Mass was very popular in late Middle Ages. Its iconography differs from the story as told in the *Golden Legend*. In this image, Christ appears in full bodily form atop the altar. The historian Eamon Duffy suggests that this representation conflates the story of the woman's doubt with an image from popular piety: the Image of Pity, representing the body of the dead Christ with bleeding wounds.

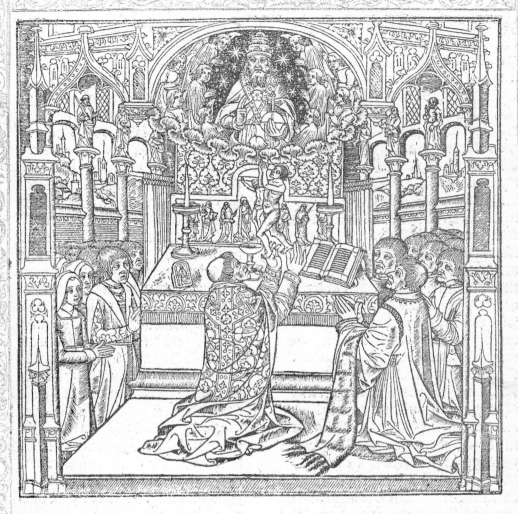

Missale scdm vsum ecclie Lingoneñ
Dñica prima aduētus dñi. Jntroitus

AD te leua
ui aĩam meã deus
meus in te confido
non erubescam:ne
q̃ irrideant me ini
mici mei eteniin vniuersi qui te ex
pectant non cōfundentur . ps. Dias

tuas dñe demonstra michi: et semitas tu
as edoce me.Glia pñ. Nō dicitur p totuz
aduentum.Glia i excelsis. Collecta.

Ercita quesumus dñe poten
tiam tuã et veni: vt ab imi
nētibus pctõrum nrõruz piculis te
mereamur protegente eripi:te libe
rante saluari . Qui viuis z regnas
cum deo patre in vnitate spiritus
 Si memoria euenerit facienda est

Anonymous (15th c.), *Mass of St. Gregory.*
Woodcut from a missal, The Pierpont Morgan Library, New York.

The Head of Edmund Is Guarded by a Wolf

The story appears in the *Golden Legend*.

DMUND, KING OF EAST ANGLIA, WAS A WISE AND virtuous Christian ruler. He reigned with humility and administered his realm with benevolence, restraining the cruel and giving charity to the poor.

During his reign, the pagan Danes invaded the land and harassed the people. One day, Edmund received a messenger from Hringar, a chieftain of the Danes, ordering him to surrender. Edmund had no troops with which to fight the invaders. He consulted his close friend, a bishop, who advised him either to accede to their demands, or to flee and save his own life. Edmund would do neither: He would face martyrdom gladly before submitting to pagan rule. "If I die, I live," he said.

Edmund waited inside his hall, throwing away his weapons, mindful of the example of Christ, who offered no resistance to his arrest. The Danes arrived and beat the king cruelly with rods. All the while, Edmund prayed aloud. Then they tied him to a tree and threw spears at him, until the painful shafts bristled from his body like the spines of a porcupine. All the while, his prayers continued unabated. Finally, enraged, Hringar ordered his head cut off.

The Danes hid Edmund's head in the thickets of the surrounding forest so that it could not be buried with the body. Returning to their boats, they sailed away.

The illumination comes from a manuscript of The Life, Passion, and Miracles of St. Edmund, King and Martyr. *Produced at the Monastery of Bury St. Edmund's in the mid-twelfth century, it is a classic hagiography, lavishly illuminated in a lively Romanesque style. On another page of the same manuscript, the king sits crowned and enthroned, while two monks kiss his feet.*

As soon as they had departed, the townspeople began to search for Edmund's head. As they looked, they called to one another, as wandering woodsmen are apt to do, "Where are you?" The head shouted out in reply, "Here! Here! Here!"

Following the sound of Edmund's voice, they came upon a wolf, guarding the head between its forepaws, lest any harm should come to it. The people took the head to reunite it with the body. The wolf accompanied them on their journey, to the very gates of the town. Once Edmund had been buried, the wolf returned to the wood, harming no one.

IN MANY WAYS, THE CHRISTIAN MENTALITY OF THE MIDDLE AGES was forged in the crucible of second- and third-century persecutions of the Church. The experience of brutal martyrdom under the pagan Roman Empire gave rise to a cult of saints who had died for their faith. Once the Church had been legalized and gained ascendancy in the fourth century, churches were raised over the martyrs' tombs, and miraculous cures and interventions were attributed to the dead heroes of the faith. The persecutions also shaped Christian attitudes toward the non-Christian world, proposing a model of a life-and-death struggle fought by the faithful against the pagans.

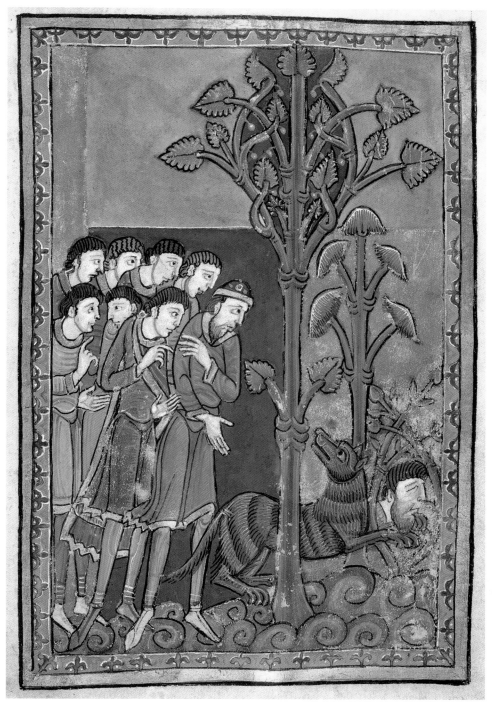

Anonymous (English), *The Finding of Edmund's Head Which Is Being Guarded by a Blue She-Wolf*, c. 1130. Manuscript illumination, The Pierpont Morgan Library, New York.

By the ninth century, England had been fully Christianized for only a few generations. The Viking invasions traumatized the Anglo-Saxon kingdoms. Trade was disrupted; towns and monasteries were destroyed. That the Vikings were pagan only confirmed the people's worst fears, and they cast their struggles against the invaders as a heroic defense of the faith against overwhelming pagan force. Edmund's death was seen as more than the simple result of a cruel invasion: It was a martyrdom of a holy man, a true Christian. As his severed head cries out, Edmund, literally, gets the last word.

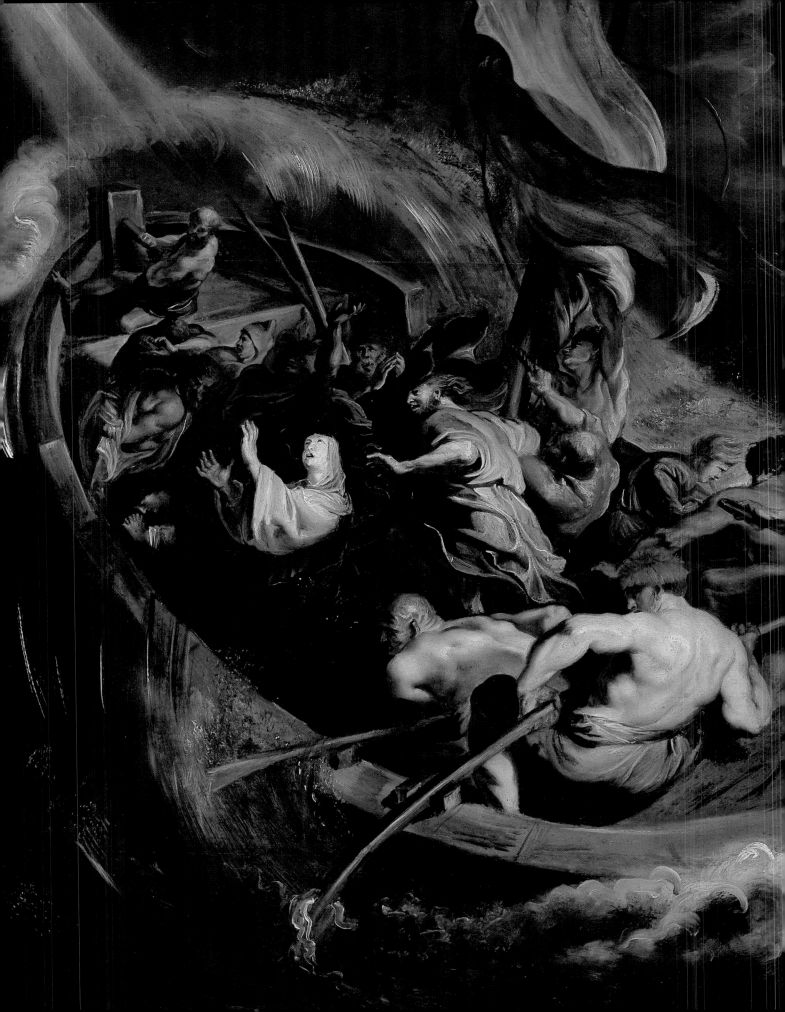

Peter Paul Rubens (1577–1640)
Saint Walburga and the Miracle of the Ship, 1611.
Oil on oakwood from an altarpiece, Museum der Bildenden Künste, Leipzig.

Walburga and the Storm

ALBURGA WAS AN ENGLISH PRINCESS. HER MATERNAL uncle, Saint Boniface, was a British missionary who evangelized the pagan Germans. Her brothers, Willibald and Winibald, were also missionaries.

At the age of eleven, her father, Richard, set off on a pilgrimage to the Holy Land. He entrusted Walburga to the care of the Abbess of Wimborne in Dorset. She studied with the nuns for twenty-six years, growing in wisdom and piety. In the year 748, her uncle Boniface summoned her to help with the evangelization of the Germans. She set off for the continent with a company of nuns. Embarking on a ship to cross the channel, they soon found themselves in the midst of a fierce and dangerous storm. The sailors were terrified, but Walburga knelt calmly on the deck and began to pray. Immediately the wind abated and the sea became calm. When they landed, the sailors spread word of the miracle far and wide. Walburga's journey became a triumphal procession, as people greeted her with joy and awe.

THE COLLAPSE OF THE ROMAN EMPIRE IN THE WEST AND THE barbarian invasions created a vast mission field for the Church. Evangelists from the British Isles poured in to these pagan lands and, under Boniface, created a network of monasteries as centers of Christian learning and piety. From these outposts, they slowly converted Germany to the faith.

Walburga came from a noble family of extraordinary devotion. She was a woman of deep learning, who wrote accounts of the lives of her sainted brothers Winibald and Willibald. She became abbess of the nunnery at Heidenheim, where Winibald was abbot of a neighboring monastery. When he died, she was given governance over both foundations.

Rubens painted Walburga's miracle for an altarpiece in a side chapel of the Cathedral of Antwerp. His rendering of the violent sea is carefully observed. At the heart of the scene, an almost ghostly Walburga raises her hands in prayer, while a beam of heavenly light descends on her.

Boniface purposely waited before inviting his niece to join the missionary project. She was already thirty-seven years old when she departed for the continent, a mature woman who could undertake serious responsibilities. The storm threatened to end the adventure almost before it had begun. Walburga's miracle protected the missionaries and paved the way for her successful arrival in pagan lands, as word of her powers preceded her.

Eligius and the Horse

LIGIUS WAS A CRAFTSMAN, SKILLED AS A GOLDSMITH and an ironworker. One day a horse was brought to him to be reshod. Possessed by a demon, the animal was completely wild and uncontrollable, kicking and struggling against its handlers. Eligius approached the raging horse, but he could not induce the animal to be still while he replaced its shoe. At last, he pulled the horse's leg off. He took the limb to the forge and nailed a new shoe to the hoof. When he came back to the stunned animal, he replaced the leg with the newly reshod foot. Making the sign of the cross, he healed the animal, restoring its body to wholeness. The demon vanished and the horse became perfectly tame.

THIS EXTRAORDINARY POPULAR STORY WAS TOO FARFETCHED TO make it into the official biographies of Saint Eligius. Even the credulous Jacopo da Voragine refuses to include it in his often fanciful *Golden Legend*. It survived as a folktale, and was depicted in art commissioned by guilds of metal workers.

The historical Eligius, also known as Saint Loy or Eloi, was indeed a goldsmith. He worked in the seventh-century courts of the Frankish kings Clotaire II and Dogobert I. His piety and honesty commended him to his royal patrons, who made him master of the royal mint and consulted him for advice on matters of state. As a courtier, he wore a hair shirt under his fine clothing, and gave generously to the needy.

Eventually, he retired from court life, devoting himself to prayer and fasting for a time. When the bishopric of Noyon became vacant, he accepted the office. He built churches and honored the remains of the saints, supervising the creation of lavish shrines to enclose their relics. In the seventh century, before Christianity was firmly established in the Frankish kingdom, Eligius worked tirelessly to convert the pagan population.

In a manuscript illumination from Italy, Eligius is depicted at his forge. A servant holds the bleeding stump of the horse, which stands patiently watching the saint at work. At the bottom, the arms of the Papacy are flanked by shields with ironworking implements. The ornamented gold background contrasts with the humble working scene.

Now largely neglected, the cult of Eligius was popular in the Middle Ages, especially in northern France and the Low Countries. He was invoked as patron of goldsmiths and iron workers, as well as of horses. The folk element of this miracle story demonstrates how the popular imagination often added its own details to the lives of historical figures. Here, Eligius confronts a very practical dilemma and solves it an extraordinary way. For an ironworker, the problem of a recalcitrant horse refusing to be shod was common. The story promises the saint's help with an ordinary problem of daily life.

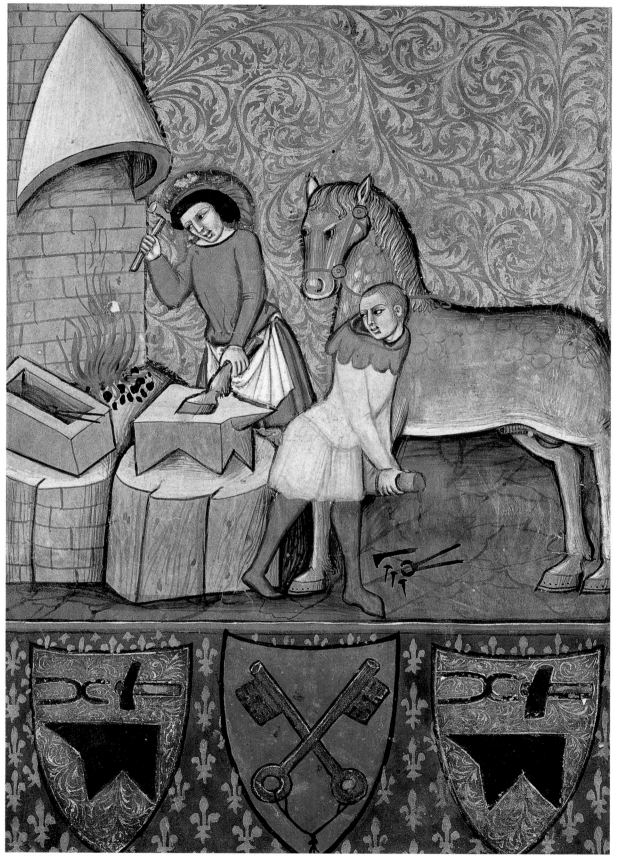

Anonymous, *The Miracle of St. Eligius.*
Manuscript illumination, Biblioteca Universitaria, Bologna.

Anonymous (Swiss), *Saint Remigius Replenishing the Barrel of Wine* and *Saint Remigius and the Burning Wheat*, 15th c.
Tempera and oil on wood from an altarpiece, Metropolitan Museum of Art, New York.

Remigius, the Wine, and the Wheat

REMIGIUS WAS A HERMIT FOR TWENTY-TWO YEARS before he was chosen to be archbishop of Rheims. He was so gentle that small birds would fly down to his table as he ate, and feed from his hand.

The story appears in the *Golden Legend*.

Once he was lodging in the house of a devout woman. She had a barrel of wine which was almost spent, so Remigius went down into the cellar and made the sign of the cross over it. He lingered there in prayer for some time. Suddenly, the barrel became so full that it tumbled over.

Another time, it was revealed to Remigius that there would be a terrible famine. He arranged for wheat to be stored so that the people would not starve. In one town, a group of drunken men scoffed at the prophecy, and to mock Remigius they set the garner on fire. Remigius found out and went to the town while the fire still burned. Elderly and easily chilled, he sat down and warmed himself by the flames, and said quietly, "The fire is always good."

The limbs of the vandals who had set the fire became wasted and twisted, while their women came down with gout. Their children, too, were sickly. And so they and their descendants suffered for their misdeed.

AS ARCHBISHOP OF RHEIMS IN THE FIFTH CENTURY, REMIGIUS PLAYED an important role in the Christianization of the Frankish lands. These two stories, however, illustrate a different aspect of his life.

Remigius' gentle spirit is evident in his kindness to the birds that nibble from his hand. His table is open to all. He sets an example, which some follow, and others do not.

The good woman's hospitality is rewarded. As she shares her home with the stranger, he repays her with an act of kindness. Like Jesus at Cana, he replenishes her dwindling supply of wine. Generosity begets prosperity.

An anonymous Swiss artist painted these two side panels for an altarpiece. The two panels contrast the fate of the good and the wicked. The surly townsmen on the right look on while Remigius warms his hands. Their sickly children fall to the ground beside them. On the left, the good woman is rewarded with wine as Remigius shares a meal with her.

The ungrateful townsmen also reap the rewards of their actions. Remigius does not scold or punish. Nor does he extinguish the flames. Instead, he sits quietly and enjoys the warmth, whatever its source. The people's punishment is a reflection of their own bad faith. The infirmities they suffer are diseases tied to poor nutrition. They destroyed their own supply of wheat, and they suffer the consequences.

Sebastian Saves Italy
from the Plague

The story appears in
the *Golden Legend*.

 TERRIBLE PLAGUE RAGED THROUGHOUT ITALY. THE number of dead was so high that the living could not bury them all. Two angels appeared in the streets, one good and one evil. The evil angel carried a staff. As he approached each house, he pounded on the door—with each stroke of his staff, he condemned one person to death in that house.

As the plague continued, a man had a vision. It was revealed to him that the pestilence would not cease until an altar was built to Saint Sebastian in Pavia. The work was accomplished in the Church of Saint Peter, and the plague immediately ended. In gratitude, relics of Saint Sebastian were dispatched from Rome, and enshrined at the new altar.

SEBASTIAN, AN EARLY CHRISTIAN MARTYR, ONLY BARELY MAKES AN appearance in this story. Next to nothing is known of the historical Sebastian. His legend recounts that he was a soldier under Diocletian who enjoyed the emperor's favor. Eventually, he was denounced as a Christian. Despite his loyalty, Diocletian ordered him executed. He was tied to a tree and shot through with arrows. A pious woman came secretly to take his body away for burial, and discovered he was still alive. She nursed him back to health, and he again appeared before the emperor, who then sentenced him to be beaten to death. The cult of Sebastian flourished in the Middle Ages and he was particularly invoked against plague.

In this miracle, the solution to the plague is a liturgical, cultic action. The two angels will go on battling—while people continue to die—until an altar is erected to honor Sebastian in Pavia.

Jules-Elie Delaunay creates a highly dramatic, almost operatic version of the scene. The two angels grapple at a door, as people lie about the gloomy streets in contorted poses of suffering.

Acquired under Napoleon III for the national art collections, the painting epitomizes the grandiose and highly sentimental taste of the Second Empire.

Once it is built, the saint rewards their efforts and halts the evil angel's progress through Italy. The final deposition of relics at the shrine is an act of thanksgiving.

God is an incredibly distant figure in this drama. The role of the two angels is unclear: Are both sent by the divine will? Or does the good angel seek to stop the evil one? The story offers no explanation. Even Sebastian remains far from the suffering people. It is simply reported that a man received a vision ordering the building of the altar in Sebastian's name. Once the saint is honored, he answers the prayers of his faithful supplicants.

Jules-Elie Delaunay (1828–91), *The Plague in Rome*, 1869.
Oil on canvas, Musée d'Orsay, Paris.

Master of Saint Giles (15th–16th c.), *Saint Giles and the Hind*, c. 1500.
Oil on wood, National Gallery, London.

Giles and the Hind

ORN OF WEALTHY PARENTS, GILES DISTRIBUTED HIS inheritance to the poor. Dedicating his life to God, he began to work miracles, and his fame soon spread.

Giles retreated to a cave in the region of Nîmes in southern France. Far from human habitation, his hermitage was encircled by thick brambles. There he lived in great poverty and spent his days in prayer. God sent a hind to be his companion. The gentle animal fed him with her milk.

One day, a group of the king's servants was hunting in the wilderness near Giles' cave. They spotted the hind and gave chase. She bounded across the landscape, closely followed by their baying hounds. The hind reached the bramble enclosure and darted to safety. Giles, seeing the hounds approaching, prayed to God to save the hind that had nourished him these many months. The dogs stopped dead in their tracks. They howled outside and refused to go near.

The servants reported this strange event to the king. Curious, he summoned the bishop of that region and, together with the servants and dogs, they went to the thicket. Again, the dogs refused to go near, kept at bay by Giles' prayer. One of the servants rashly fired an arrow into the bushes in hopes of flushing out the hind. The arrow pierced Giles, who continued to pray for the protection of the animal. The king and the bishop entered the brambles, where they encountered Giles and the hind. They asked the saint how he had come to be there and who he was. Giles patiently answered their every question. Realizing they had harmed a holy hermit, they begged his forgiveness. They offered him money, which he refused. Later, they sent doctors to look after his wounds, but he refused these as well, accepting his suffering as an opportunity to grow in patience and virtue.

The story appears in the *Golden Legend*.

SAINT GILES RUNS FROM FAME, BUT THE SANCTITY OF HIS LIFE cannot be hidden. In this tale, he finds the most remote place possible, and there he spends his time in prayer and self-denial. He has nothing but the cave in which he lives and a small well from which to drink. His utter poverty puts him in complete accord with nature, represented by the hind who feeds him.

The hunters intrude on this peaceful scene. Foolishly shooting an arrow into the thicket, they violently penetrate the harmonious world of the hermit. The arrow that pierces Giles' hand recalls the wounds Christ received on the cross. Like Christ, he bears his injury gladly, for he receives it in the act of protecting the innocent.

By an anonymous master, this detailed scene from an altarpiece is a studied contrast between the gentle saint and the two men who kneel in front of him. The bishop and the king, representatives of ecclesiastical and civil power, acknowledge the authority of the holy hermit. In a strictly hierarchical society, this inversion of power carried a forceful message: Even the greatest lords, both spiritual and temporal, stand under the ultimate power of God. Here, the manifestation of divine authority is a gentle hermit caressing a deer.

Giles was not destined to remain in his desert hermitage. The king eventually induced him to accept the gift of a monastic foundation, and Giles reentered public life.

The Mass of Giles

The story appears in the *Golden Legend.*

ING CHARLES, HEARING THAT GILES WAS A GOOD AND saintly man, went to see him. There was a grave sin that weighed so heavily on his mind that he would confess it to no one. In distress, he asked Giles to pray for his forgiveness.

The following Sunday at the mass, Giles prayed for the king, as he had been asked to do. An angel appeared and placed a list of the king's sins on the altar before the saint. The heavenly emissary promised that if the king were penitent, Giles' prayer for forgiveness would be answered and the king would be absolved. Giles handed the angel's list to the king, who immediately confessed his sins, and received pardon.

A RELUCTANTLY PENITENT KING CHARLES IS PRODDED TO MAKE his full confession by the miraculous intervention of an angel. The historic Christian understanding of sin and forgiveness requires that wrongdoing must be acknowledged by the guilty before pardon can take effect: Even kings are not above this principle. Though Charles seeks out Giles, he is unwilling to reveal the nature of his crimes. The angel's list proclaims openly to the saint what the king will not disclose. With his sins exposed, Charles completes his penance, confessing to the saint, and receives forgiveness.

Throughout the Middle Ages, there was significant debate about the relative powers of Church and State. This story has a political dimension, reminding kings that they, too, are under the authority of the Church, which alone has the power to forgive sin.

The story also speaks to ordinary individuals as an admonition that absolution comes only through a forthright admission of wrongdoing. Like Charles, they cannot evade that responsibility. The angel's list is a reminder, as well, that Charles' sins are already known in heaven; to hide them is pointless.

Although Giles lived in the eighth century, the painter has transposed the scene to his own time. With exquisite detail he has rendered the scene within a late medieval liturgy. Celebrating the mass, Giles is shown at the moment of the consecration, holding up the host as he reads the prayer from his missal. All the lush trappings of a wealthy abbey are on display. The golden altarpiece glistens with reflected light. The book, on its plush cushion, is bound into a fine cloth wrapping. Carpets, brocaded altar frontals, and carefully made vestments enhance the majesty of the scene.

The angel appears above the altar, carrying a small sheet with a text promising the forgiveness of Charles' sin.

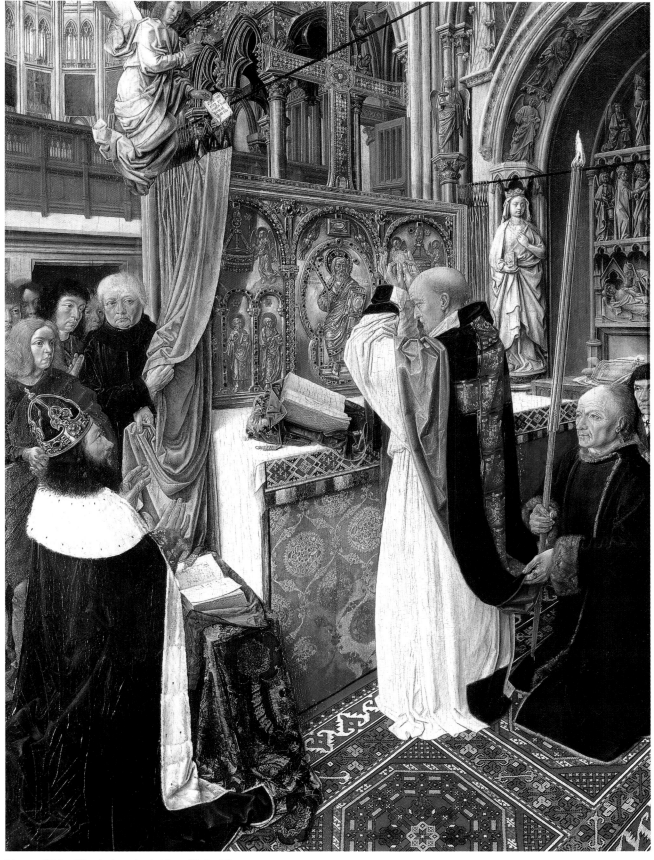

Master of Saint Giles (15th–16th c.), *Mass of Saint Giles*, c. 1500.
Oil on wood, National Gallery, London.

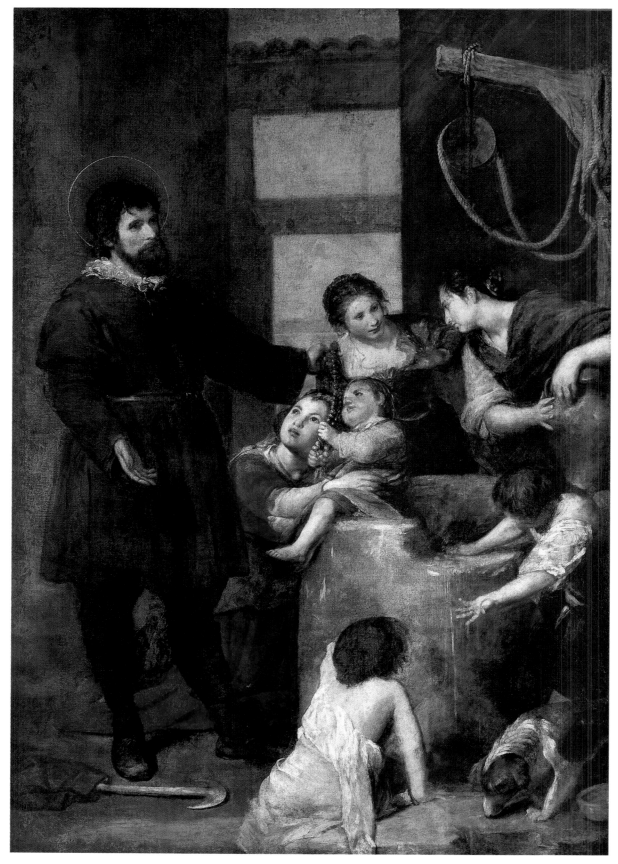

Alonso Cano (1601–67), *Saint Isidore and the Miracle at the Well*, 1648.
Oil on canvas, Museo del Prado, Madrid.

Isidore and the Well

 SIDORE WORKED THE FARM OF A LANDOWNER NAMED Juan de Vargas. Every morning, Isidore would attend mass at a nearby church. The other laborers complained to Juan that Isidore was always late to work. When his employer confronted him, Isidore replied that he would make good any shortfall. Suspicious, Juan went out one day to see how Isidore was accomplishing all his plowing despite arriving after everyone else. He watched him out in the field, pushing his plough. Near Isidore, another plough, pulled by white oxen, was plowing on its own, with no one to guide it. As Juan ran into the field to observe this strange sight, the second plough and its oxen disappeared. When he asked Isidore who had been helping him, the saint replied simply that he plowed alone and relied on God to help him meet his daily share of the work. Juan knew then that it must have been an angel that guided the second plough.

Isidore was married to a woman named Maria, who was as devout and faithful as he was. Although they were poor, they were generous to others in need. One day, their small son fell into a deep well. From its depths, Isidore and Maria could hear his plaintive cries. They knelt down in prayer, asking God to save their child from drowning. The water in the well began to rise, carrying the boy to the very top of the wellhead. They returned thanks to God for their son's deliverance.

CHRISTIANITY HAS STRONGLY EGALITARIAN ROOTS. MANY OF THE disciples who gathered around Jesus were drawn from the ranks of working people, and the early Christian movement was filled with slaves and the poor. Despite this, it is striking how many of the saints of the Church came from the wealthy and privileged classes. Isidore and his wife Maria stand out in this company of saints. They never entered a religious order, nor did they enjoy any rank or earthly prosperity. Their piety and devotion alone earned them a place in the Church's collective memory.

Isidore was canonized in 1622, along with four other Spanish saints— Ignatius Loyola, Francis Xavier, Philip Neri, and Teresa of Avila. This painting by Alonso Cano was made for the high altar of a church in Madrid. Isidore, rather well dressed for a day laborer, presides over the scene. The women and children around him bustle around the well, which overflows with water.

The miracle at the well takes place in the ordinary surroundings of agricultural life. The farmyard is a dangerous place, and in an unguarded moment, the couple's only child tumbles into the deep well. God intervenes in answer to their prayers. The tale is bittersweet, for the child later died of disease. Isidore and Maria thereafter took a vow to refrain from sexual relations and retired to separate houses in the village. They ended their days in prayer and works of charity.

Isidore and Maria were credited with many posthumous miracles, and their bodies were preserved and venerated. Kings and prelates received miraculous healing at their shrines. Maria is known as "Maria de la Cabeza" because her head was kept in a separate shrine and carried in processions during times of danger.

Francis Preaches to the Birds

The story appears
in the *Little Flowers
of St. Francis.*

HILE WALKING ONE DAY, FRANCIS CAME UPON A TREE full of birds. He asked his companions to wait for a moment, and went over to the tree. The birds fluttered down and gathered at his feet. He began to preach, telling them of the goodness of their creator, who provided them with streams of water for their drink and trees for their nests. He reminded the birds that God had given them beautiful cloaks of feathers to wear. Furthermore, God had given them the freedom to fly wherever they wished. He warned them against ingratitude, and encouraged them to give glory to their creator by their songs.

The birds flapped their wings and sang, bowing their heads with pleasure at his words. Francis rejoiced with them. Then he made the sign of the cross, blessing them and sending them on their way. They rose from the ground at once, and flew away in four groups: one to the east, one to the west, one to the south, and one to the north. As they disappeared from sight, their singing filled the skies with praise.

FRANCIS APPROACHED THE WORLD WITH A TOUCHING INNOCENCE. He had a simple wonder for the beauty of nature, and his actions were direct and unaffected.

This innocence was hard won. Francis knew the hunger, cold, and misery of the poverty he embraced. His spiritual discipline was fierce. He spent many long hours in prayer, and chastened his body with fasting and penitence. Through these disciplines, he eventually gained a simplicity of manner and an air of humble sanctity which was admired and emulated by his followers. Preaching to the birds, Francis evokes the innocence of Eden in which Adam, the first man, lived in harmony with animals. Unlike Adam, Francis achieves this innocence despite living in a fallen world.

From a fresco cycle illustrating the life of Francis, this detail shows the gentle saint towering over a diverse collection of birds. One of his companions stands behind him, gesturing in wonder. The full cycle fills the central apse of the conventual Church of St. Francis at Montefalco in Umbria.

The author of the *Little Flowers* presents the sermon to the birds as a lesson for Francis' brethren, the friars of his order. It is interpreted as a sign that his words would fill the four corners of the earth, just as the birds had set off in every direction with his blessing. And it reminded the friars to embrace the simplicity and freedom of the Franciscan way. Like the birds, they owned nothing in this world, relying entirely on God for their daily provisions.

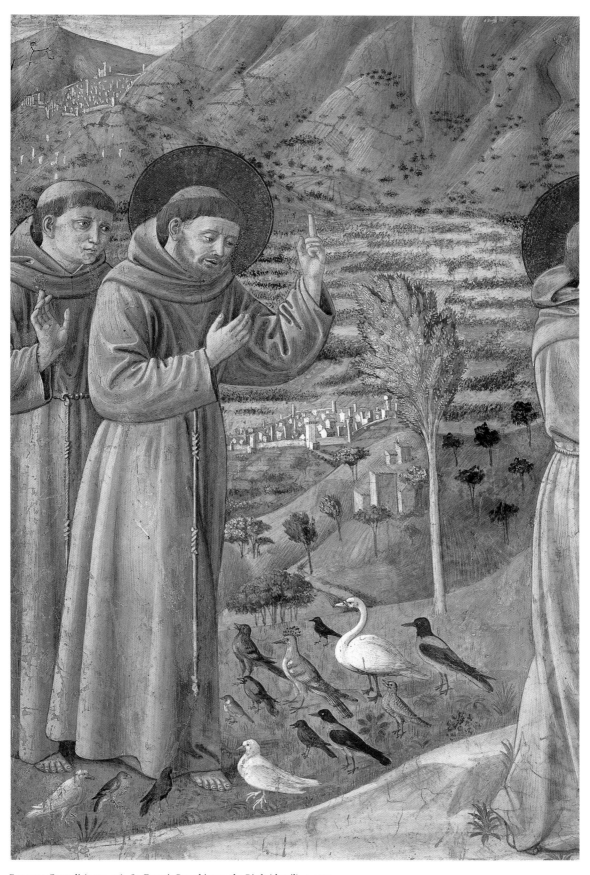

Benozzo Gozzoli (1420–97), *St. Francis Preaching to the Birds* (detail), c. 1452.
Fresco, San Francesco, Montefalco.

Luc-Olivier Merson (1846–1920), *The Wolf of Gubbio.*
Oil on canvas, Musée des Beaux-Arts, Lille.

Francis and the Wolf of Gubbio

The story appears
in the *Little Flowers
of St. Francis.*

FRANCIS WAS STAYING IN THE TOWN OF GUBBIO WHEN a wild and ravenous wolf began to terrorize the area. It snatched animals from their pens and even attacked and devoured people. The townsfolk were so afraid that they never ventured outside the walls without weapons, armed as if for war. Eventually, they dared not leave the town at all.

In compassion for the people of Gubbio, Francis determined to have a word with the wolf. He made the sign of the cross and went out to face the animal. When the wolf saw Francis, he rushed towards him with open jaws. Francis made the sign of the cross over the angry wolf and said, "Come here, brother wolf. I command you in the name of Christ not to harm me or any other human being."

The wolf approached Francis quietly and lay at his feet. Francis said to him, "Brother wolf, you have done much harm here. Not only have you killed animals, but you have attacked human beings made in the image of God. You are a thief and a murderer, and the people of the town are your enemies." Francis suggested a plan to make peace between the wolf and the townspeople. He promised the wolf that he would be fed by the people if, in return, the wolf agreed not to harm anyone, animal or human. "Give me a pledge that you will abide by these terms," Francis said. And the wolf stretched out his paw and placed it in Francis' open hand.

A nineteenth-century French painting shows the wolf receiving his ration from the town butcher. He is so tame that even the small child next to him can reach out and pet his back while his mother looks on happily. The painter saints the wolf, giving him a halo. In contrast to medieval and early Renaissance depictions of this story, Francis is nowhere to be seen. Instead, Merson takes the opportunity to create a genre scene, enjoying the details of the frozen fountain and romanticized, moldering buildings.

Francis led the wolf into Gubbio, to the amazement of the townspeople. He preached a sermon to the gathering, and laid out the terms of the arrangement. They agreed to their part of the bargain. Francis reached forth his hand again, and in the sight of all, shook the wolf's paw. The people shouted and praised God for their deliverance. And from that day forward, the wolf and the residents of Gubbio lived together in peace.

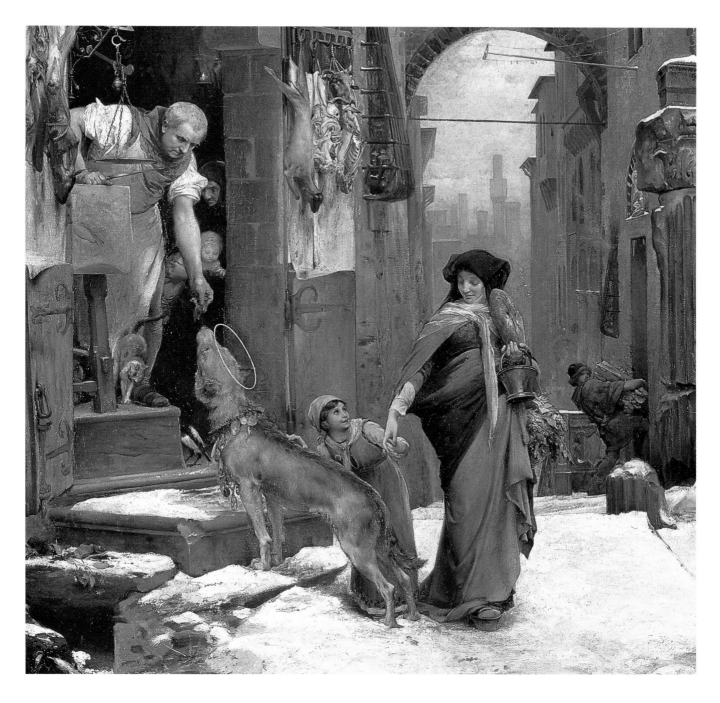

FRANCIS IS A MEDIATOR IN THIS STORY BETWEEN TWO EQUAL FACTIONS:
He preaches to wolf and townspeople alike. He calls the wolf his "brother," a term he
uses in his famous canticle to address all created things. Brother sun and sister moon,
brother wind and sister water join together in his hymn, taking their place in the
harmonious cycle of nature. Even sister death is a friend, guiding the faithful home to
their creator. His vision of nature does not deny suffering and loss, but raises up the
whole of creation as a song of praise for his "most high, omnipotent, good Lord."
When Francis makes peace between the wolf and the townspeople, his vision of
harmony is momentarily realized. The anger and violence are laid aside by both human
and beast. In place of rivalry, there is cooperation, and God is praised in action.

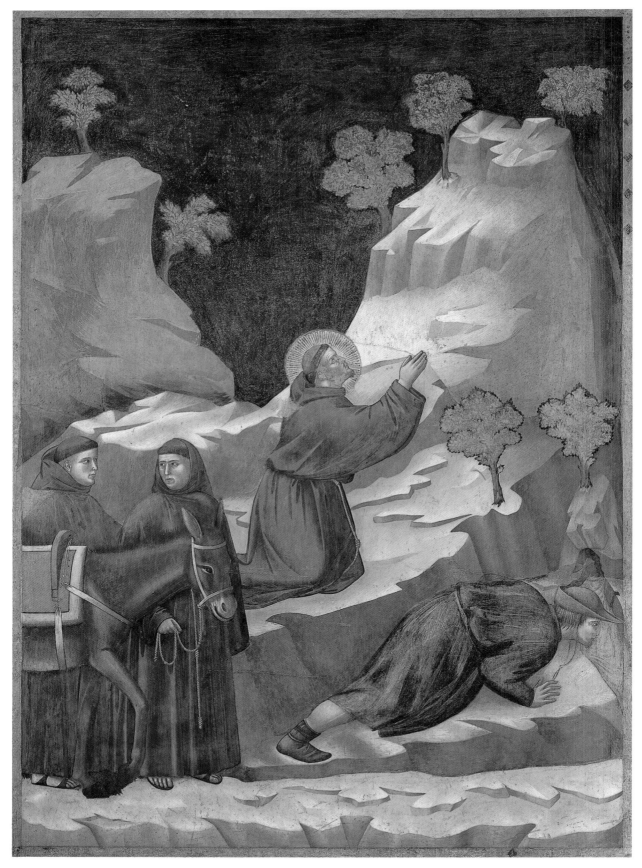

Giotto di Bondone (1267–1337), *Miracle of the Fountain.*
Fresco, Upper Church, San Francesco, Assisi.

Francis Causes Water to Flow on Mount Alverna

RANCIS HEARD THAT THE COMMUNITY OF FRIARS HE had founded on Mount Alverna was flourishing. They sent word to him that their monastery was a peaceful place, conducive to the work of prayer. So Francis determined to visit them.

One evening, as he journeyed with three companions toward the mountain, he stopped in a certain place and decided to spend the night in prayer. All through the night he was tormented by demons, as Saint Anthony had been in the desert. When morning arrived, he felt exhausted and ill.

His companions enlisted the aid of a local farmer to guide them and to provide a mount for the weakened Francis. As they ascended the steep mountain, the farmer turned to the saint and said, "Brother Francis, I have heard people say many good things about you. Strive always to be what they say you are, and do not change, so that the people who trust you will never be deceived. That is my advice to you."

Francis immediately dismounted and kissed the man's feet. He thanked him for giving him such good and straightforward advice.

A little later, as the day grew hot, the farmer said, "I'll die if I don't get something to drink." Francis leapt again from his horse, and, falling to his knees, raised his hands heavenward in prayer. After a time, he said to the farmer, "Go over to that rock, and you will find living water. Christ in his mercy has made it spring out of the stone so that you may drink."

The man ran to the place Francis had indicated, and there he found a fresh spring, and drank his fill. Never before or since has water been found at that spot.

The story appears in The Life and Legends of Saint Francis of Assisi.

Giotto's fresco is from the Upper Church of the Basilica of Saint Francis at Assisi. This scene is on the left side of the main portal; on the right side, Giotto has painted the scene of Francis preaching to the birds. Above the miracle of the spring is a scene of Pentecost, with the Holy Spirit dancing in fiery flames over the apostles, which emphasizes the spiritual significance of Francis' action below.

THE MOTIF OF WATER POURING FROM DRY ROCK IS A FAMILIAR ONE in Christian narrative. Francis, like Moses and Benedict before him, causes a miraculous spring to well up, quenching the farmer's thirst. The words Francis uses—"living water"—point beyond the mere physicality of the wonder, and evoke Jesus' promise of living waters welling up in the heart of the believer.

Francis embraced poverty and, with it, took the side of ordinary peasants like the farmer. He acknowledges the value of this common man's advice by kissing his feet, an act of tender homage. The miraculous spring is a reward for the man's honest advice, and points him to the highest wisdom: the gift of the Spirit which wells up like a spring in a desert.

Francis Receives the Stigmata

The story appears
in the *Little Flowers
of St. Francis*.

RANCIS IDENTIFIED HIMSELF COMPLETELY WITH Christ, both in body and soul, by modeling himself on Christ's poverty and compassion. When Francis was 43 years old, in the year 1224, he took two friars with him to the wilderness mountain retreat of La Verna.

For forty days and nights he fasted and kept vigil. While he was deep in prayer on the morning of Holy Cross Day, an angel appeared before him, a seraph with six flaming wings, descending swiftly from heaven. As the angel approached, he could see in its center the figure of a man crucified. The Crucified One looked at him with love. Francis was filled with joy at his tender, familiar gaze, and overwhelmed with compassion for his suffering.

Then the whole mountain was filled with light. Others are said to have seen it: Shepherds keeping their flocks wondered what shone so brightly. A team of muleteers, bound for Romagna, saw the light and, thinking the sun had risen, loaded their animals and set off on their journey.

In the light, Christ himself appeared to Francis, filling his heart with a burning love. The wounds—stigmata—Francis saw on the Crucified began to appear on his own body. His hands and feet were pierced through, as though by cruel nails. Between his ribs appeared the lance wound which had been inflicted on Christ on the cross. These were not visions: The wounds bled and hurt, and remained imprinted on his body until the day he died.

Giotto's altarpiece was described by Vasari when it was in the Church of Saint Francis at Pisa. It entered the Louvre collection in 1813. The scenes at its base—the predella—depict three other scenes from Francis' life: the dream of Innocent III, in which the Pope saw Francis upholding the tottering Church of St. John in the Lateran; the Pope approving the statutes of the Franciscan Order; and Francis preaching to the birds.

THE RELIGIOUS IMAGINATION OF THE LATE MIDDLE AGES WAS INSPIRED by this deeply emotive identification with Christ and his sufferings. Popular devotion was increasingly driven to explore the world of feeling, to dwell on the Passion of Christ, and the sorrow of his mother at his death. Francis lived that piety, in marks borne on his own body.

The *Little Flowers of St. Francis*, an early account of his life, tells us, "The fervor of devotion waxed so within him that through love and through compassion he was wholly changed into Jesus." His identification with Christ was complete.

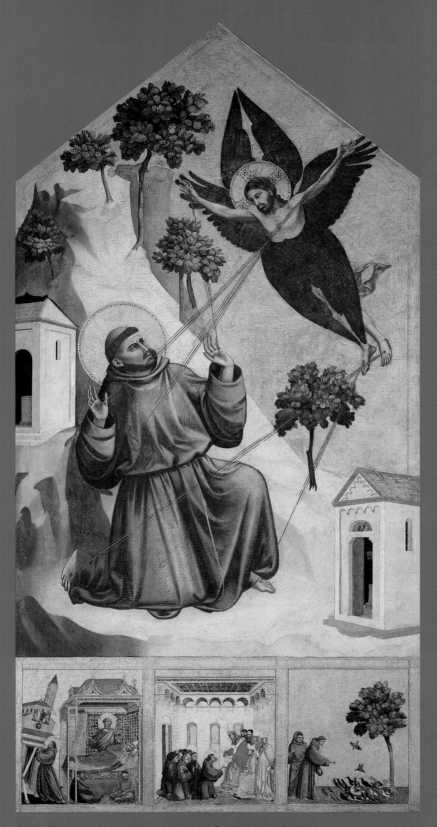

Giotto di Bondone (1267–1337), *Saint Francis of Assisi Receives the Stigmata*, c. 1300.
Gold leaf and wood, Louvre, Paris.

[OVERLEAF]
Domenico Ghirlandaio (1448–94), *The Stigmatization of St. Francis of Assisi*, c. 1480–85.
Fresco, Santa Trinita, Florence.

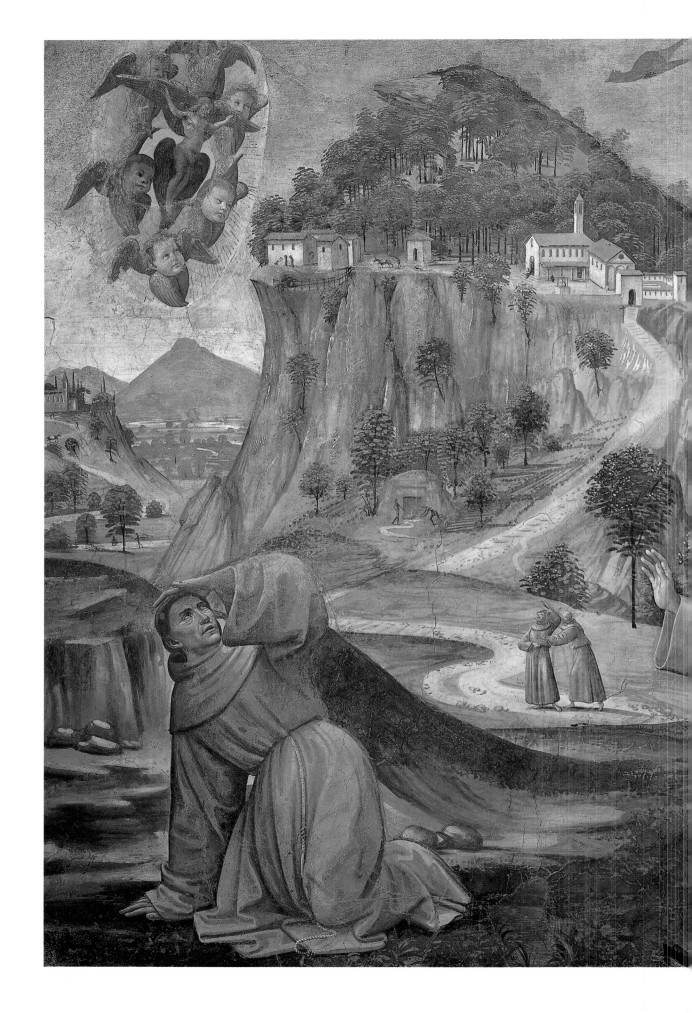

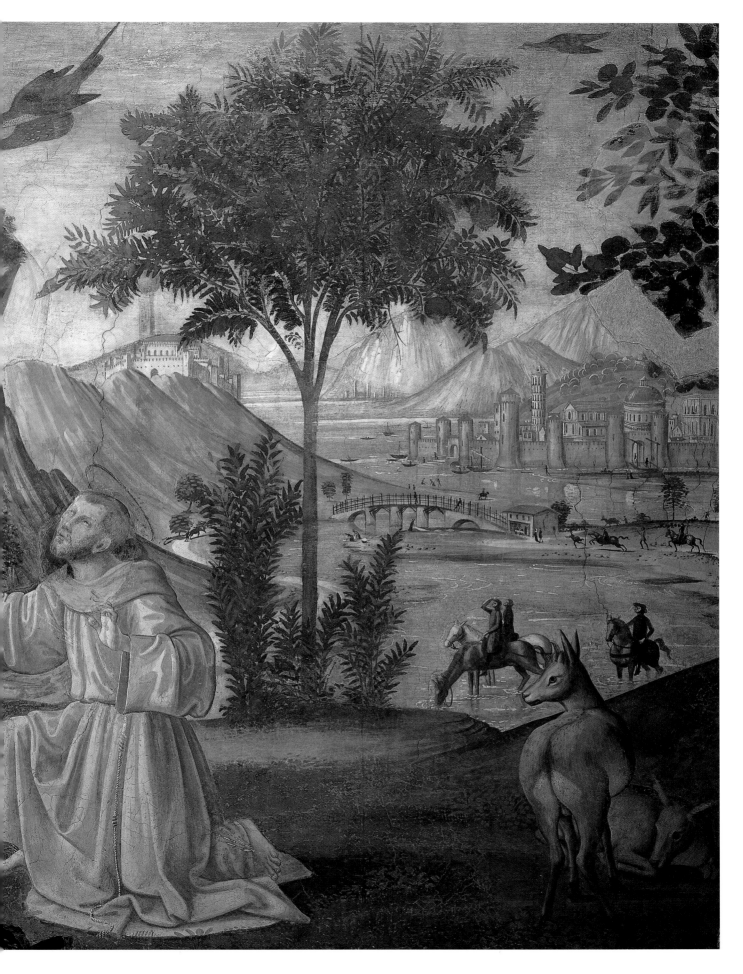

Clare Repels the Saracens

The story appears in the *Golden Legend*.

THE HOLY ROMAN EMPEROR FREDERICK WAS AT WAR with the Pope. His army, which included many Saracen troops, was ravaging the towns of central Italy. At last, they came to Assisi and laid siege to it. The convent attached to the church of Saint Damian was built against the walls surrounding the city, and the poor sisters who lived there were terrified. They ran to their holy mother Clare, who was ill in bed. With tears they told her that the Saracens were at the gates of the cloister.

Clare rose from her sickbed and fetched the consecrated Host from the church. She placed it in a golden pyx. Taking it to a high place overlooking the walls where she could be seen by the invaders, she knelt down in prayer.

"O dear Lord God," she prayed, "can it please you that your gentle, unarmed servants should fall into the hands of the pagans? Fair, sweet Lord, I implore you to protect your handmaidens, for I cannot protect them from this danger."

A small voice, like the voice of a little child, replied, "I will protect you always."

Clare continued to pray, "O sweet, fair Lord, protect this city, which has provided for us out of love for you."

"The city will have some trouble," the voice said, "but I will protect and defend it."

So Clare rose from her prayer and dried her eyes. She comforted her sisters and told them to have courage. The Saracens suddenly grew afraid. They fled the city and scattered into the countryside. Assisi and the poor sisters of Saint Clare were saved. Clare ordered those who heard the sweet voice never to speak of it, or to disclose the miracle to any living person.

This image is part of a large panel by a follower of Guido da Siena, showing eight scenes from Clare's life around a full-body portrait of the saint. In this early painting of the Sienese school, a hint of naturalism marks beginning of a departure from the more stylized manner of Byzantine-influenced work. The Saracens tumble from the roof and walls as Clare emerges from the convent, holding the golden pyx, or box, containing the reserved sacrament. Their tousled hair and falling pickaxes dramatize the confusion of their swift fall.

CLARE, MOVED BY THE PREACHING OF FRANCIS OF ASSISI, DECIDED to join his movement. She ran to the Portiuncula, where Francis lived with his companions. There Francis cut her hair and replaced her fine clothes with the same rough robe which the friars wore. Because there was no place for her to stay—and remaining with the male brethren was out of the question—Francis lodged her in a nearby Benedictine nunnery. Soon she attracted followers of her own, and a convent was established for them. The "Poor Clares," as they were known, were the women's branch of the Franciscan movement.

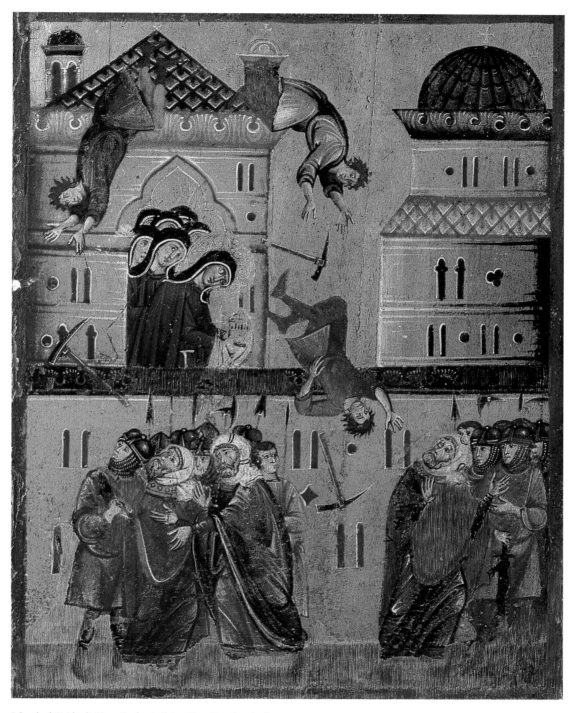

School of Guido da Siena (13th c.), *Saint Clare Repulses the Saracens*.
Pinacoteca Nazionale, Siena.

In this miracle, Clare delivers her sisters and the city of Assisi from a siege. The Saracen mercenaries in the Imperial army provoked absolute terror in the population of the Italian cities. Because they did not share the Christian faith, they were presumed to be mercilessly cruel. Clare shows her enormous courage and conviction by going up on the walls to pray in plain sight of the enemy. The divine intervention is assured through the delicate voice of a child, and the attackers flee in terror. Gentleness and faith triumph, and the Saracens are repelled without a single shot being fired.

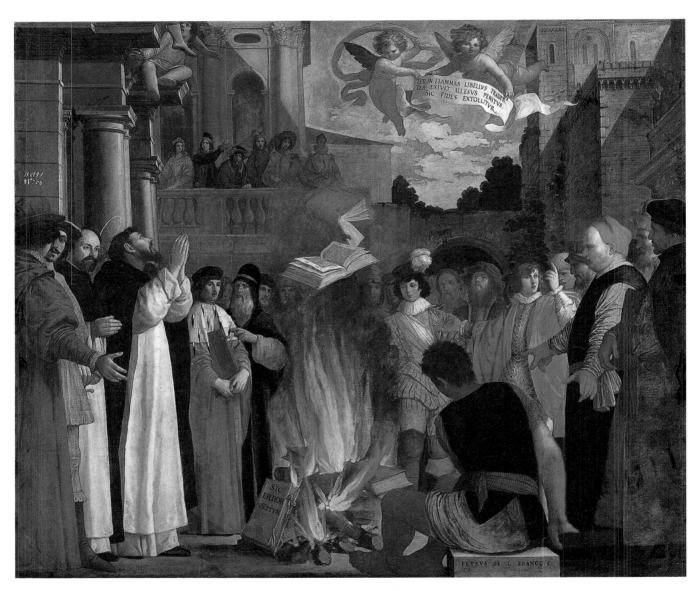

Pietro Damini (fl. 1592–1631), *Saint Dominic and the Books of the Heretics.*
Oil on canvas, Accademia, Venice.

Dominic and the Trial of the Books

THE ALBIGENSIAN HERESY RAGED IN THE SOUTH OF France. Dominic went to Toulouse, where he argued the case for the Church's doctrine against the heretics. After much heated discussion, it was decided that each side should write down its teachings in books and a definitive debate would be held. Dominic brought his volumes of theology and doctrine to the contest. The Albigensians, collecting their own texts, also arrived at the appointed time.

Dominic presented his arguments, and the leaders of the heretical party contended with him. At last, they agreed to a test. They kindled a great fire into which they agreed to throw their books. Those that burned would be proved false, while those that survived the flames would be accepted as containing the true faith.

Each party threw their books into the flames. Those of the Albigensians burned. Dominic's books, however, leapt out of the flames. When they were tossed back in, they flew out a second time, completely immune to the fire.

The story is found in the Golden Legend.

THE ALBIGENSIAN MOVEMENT CHALLENGED TRADITIONAL CHRISTIAN doctrine and the authority of the Church. Dominic, who came from the Catalan region of Spain, was one of the leading figures to oppose the new creed. His mendicant order, the Order of Preachers or, more commonly, the Dominicans, disputed with the separatist sectarians.

To a modern audience, the spectacle of the burning books provokes horror, conjuring an image of authoritarianism and small-mindedness. To the medieval mind, the story is one of truth triumphing over falsehood, order over chaos. There is no way to bridge the gap between these two perceptions; our worldview has shifted decisively.

At first, Dominic's challenge to the Albigensians takes the form of an academic debate. When this does not move either side from its stance, the dispute is handed over to a higher authority. Despite the fact that the Catholic books leap from the flames twice, the *Golden Legend* reports no change of heart on the part of the sectarians. The debate rages on. The Albigensians were eventually defeated by military crusade.

The image of Dominic confronting the heretics would have had a tremendous immediacy at the time Pietro Damini painted this picture. The Protestant Reformation had sliced through Europe, severing whole nations from the Catholic Church. In the aftermath of that disaster, the Council of Trent had embarked on its own course of reform, reasserting the central doctrines of the Church as Rome had received them. The image of Dominic's challenge to the Albigensians celebrated the triumph of the Church over heresy, and was a prayer in paint for a similar fate to befall the Protestants.

Damini's elegant, stately style suits the Counter-Reformation mood of his time. His canvas tries to recapture the simplicity of Venetian painting of the preceding century.

Bonaventure Is Healed by Saint Francis

 IOVANNI DI FIDANZA AND MARIA RITELLA HAD A son whom they named John at his baptism. The child soon became ill, and his mother feared he would not survive. She had heard of Francis and his saintly works, so she and her husband brought the feeble child to him. They promised he would enter the Franciscan order if he were made well. Francis looked at the child and exclaimed, "O buona ventura!" meaning, "O good fortune!" And the child regained his health. When he came of age, he took the Franciscan habit as his parents had promised, and was known to all as Bonaventure, after the prophetic words of Francis.

SAINT BONAVENTURE HAD A SPECTACULAR CAREER. HIS WIDE LEARNING and theological insight won him the posthumous title "Seraphic Doctor." He taught at the University of Paris until a controversy erupted between the secular instructors and those who belonged to the mendicant orders. A member of the secular faction wrote an angry polemic against the friars entitled *The Perils of the Last Times*. Bonaventure responded with a ringing defense of the mendicant life in his work, *Concerning the Poverty of Christ*. The Pope convened a commission that decided in favor of the mendicants, who were restored to their teaching posts at the university. Bonaventure and Thomas Aquinas received their doctorates in theology together in 1257. In the same year, he was elected Minister General of the Friars Minor. He used his administrative skill to guide the Franciscans through a period of controversy. His *Life of Saint Francis* was written at the request of the General Chapter of the order, and was declared the official biography of the saint. Offered the archbishopric of York by the Pope, he declined the office. In 1273, however,

This image is one of a series of four paintings which was commissioned in 1627 for the church of the Franciscan college of Saint Bonaventure in Seville. Herrera sets the scene outdoors; the beautiful, colorful clothes of Bonaventure's parents contrast with the humble brown habit worn by Francis.

he was made cardinal and bishop of Albano. The papal envoys found him washing dishes in the friary, and were compelled to wait for him to finish before he greeted them. He ended his career with a commission working for the reunification of the Catholic and Orthodox churches.

Bonaventure was too young to have known Saint Francis. His brilliant academic and ecclesiastical career starkly contrasts with the simplicity of Francis' own life, and reflects the growing authority of the Franciscan movement in the life of the Church. The actual origin of Bonaventure's name is unknown, and in his own writings he makes only the most passing reference to a healing taking place during his childhood. By attributing his naming to the founder of the Friars Minor, the story suggests that Francis foresaw the greatness of his successor and creates a mythic passing of authority from one generation to the next.

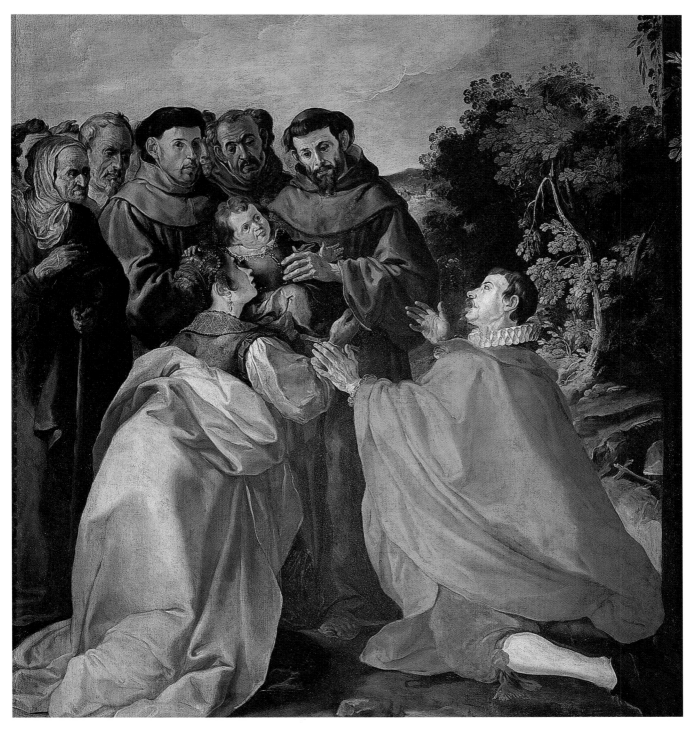

Francisco Herrera the Elder (c. 1576–1656), *The Child Bonaventura Healed by Saint Francis*, 1628.
Oil on canvas, Louvre, Paris.

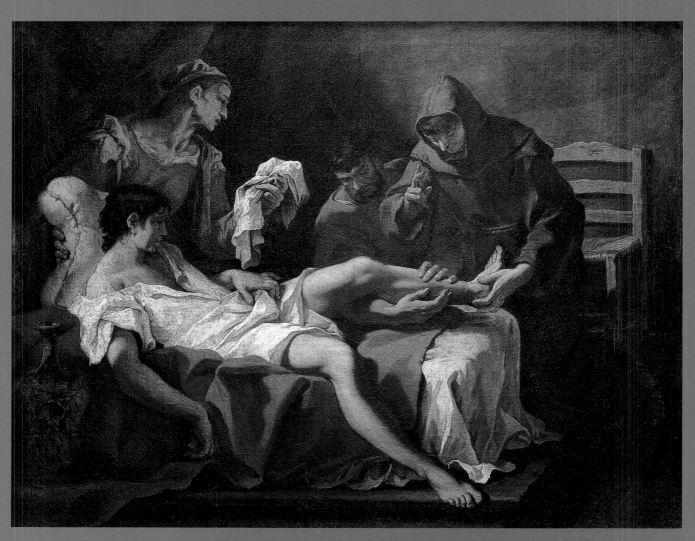

Sebastiano Ricci (1659–1734), *Saint Anthony of Padua Heals a Young Man*, c. 1690.
Oil on canvas, Louvre, Paris.

Anthony of Padua
Heals the Young Man's Leg

 HERE WAS A YOUNG MAN OF PADUA NAMED Leonardo, who grew so vexed with his mother that one day he kicked her. Later he was sorry for what he had done. He went to Anthony and confessed his fault. Anthony said to him, "The foot of one who kicks his mother or father deserves to be cut off."

Leonardo was so upset by what Anthony had said that he went away and lopped off his own foot. The news of his self-mutilation began to spread through the town. When Anthony heard it, he rushed to the young man's house. He knelt by his bedside and offered humble prayers. Then he picked up the foot and, putting it back in place, made the sign of the cross over it. Leonardo was immediately healed and leapt from his bed with joy. He praised God and thanked Anthony for being made whole again.

LEONARDO'S RASH ACT IS A WARNING AGAINST TAKING RELIGIOUS sayings literally. Anthony's reaction to the young man's confession evokes the words of Jesus: "If your hand or your foot causes you to sin, cut it off and throw it away; it is better for you to enter life maimed or lame than to have two hands or two feet and to be thrown into the eternal fire." It is a harsh saying, and Anthony, perhaps unwittingly, makes it into a sentence of punishment. When the young man takes his words at face value and carries out the amputation, Anthony rushes to his bedside to set things right.

Matthew 18:8.

Although some commentators portray Leonardo as a simpleton, laying the blame squarely on his shoulders, it is Anthony's rashness in condemning the young man that sets the story in motion. The miracle has a double purpose: It saves Anthony from the consequences of his words, just as it makes the young man whole.

Sebastiano Ricci traveled widely in his long career. Born in Belluno, he practiced his art in towns across central Italy before traveling to Vienna, where he worked on the Shönbrunn Palace. He continued to journey throughout France and England seeking commissions before finally settling in Venice.

The story is set in the dark room of a simple home. Ricci takes the opportunity to display his mastery of the figure as he portrays the young man splayed on the bed. His wronged mother holds a plump pillow under his head, as if to express her forgiveness.

This strange story is a counterpoint to Anthony's otherwise spectacular career. Renowned as a preacher and a fierce defender of the doctrines of the Church, Anthony was one of the great figures of the Franciscan order. He was canonized only a year after his death, and his shrine in Padua attracts throngs of pilgrims.

Anthony of Padua and the Mule

 HERE WAS A MAN WHO DOUBTED THE CATHOLIC FAITH. Although he had heard Saint Anthony preach many times, he could not bring himself to believe that the host, the bread of the Eucharist, was transformed in the mass, becoming the very body of Christ. Anthony and the man agreed to a public contest: If the man's mule would bow to the consecrated host, the man would become a believer.

Three days passed, during which the man's mule was given nothing to eat. Anthony spent the time in prayer and fasting. At the appointed hour, Anthony, the man, and the famished mule gathered in the main square. A bundle of fine hay and oats was laid before the animal. At the same moment, Anthony appeared, carrying the Blessed Sacrament. Calling to the mule, Anthony commanded him, in the name of his Creator, to kneel before God, present in the sacred bread.

Ignoring his hunger and the fine hay and oats that lay in front of him, the mule turned and, bending his knees, worshipped the Blessed Host. The man who had doubted was converted, as were many of the witnesses in the public square.

LATE MEDIEVAL DEVOTION WAS STRONGLY CENTERED ON THE ADORATION of the Blessed Sacrament. The mass was seen a daily miracle of transformation, in which Christ's True Presence was manifested in bread and wine at the altar. Anthony's miracle is a test of that belief. Though the unbeliever scoffs, his mule, unreasoning and stubborn, recognizes the presence of God in the host. Although he is ravenously hungry, he ignores the food he is offered and instead kneels in adoration.

Anthony, known as the "hammer of heretics," preached and taught throughout southern Europe. In a time of rising discontent in the Church, when the official doctrines were being brought into question by heretical groups, he stood as a vehement defender of the faith. With more than a touch of triumphalism, the doctrine of the Church is vindicated in a very public miracle.

This elaborately illuminated breviary was produced for Queen Eleanor of Portugal in the early sixteenth century by Flemish artists. In it, Franciscan saints are particularly prominent. The framed scene depicts the story of Anthony and the mule. The host floats in midair, haloed in gold, before the kneeling saint and the devout animal. The doubters point and gesture in wonderment. In the border, three other scenes from the saint's life are depicted. He takes leave of the Augustinian friars at Coimbra; he sets sail on an ill-fated trip to Morocco; and he retreats to the hermitage at Montepaolo.

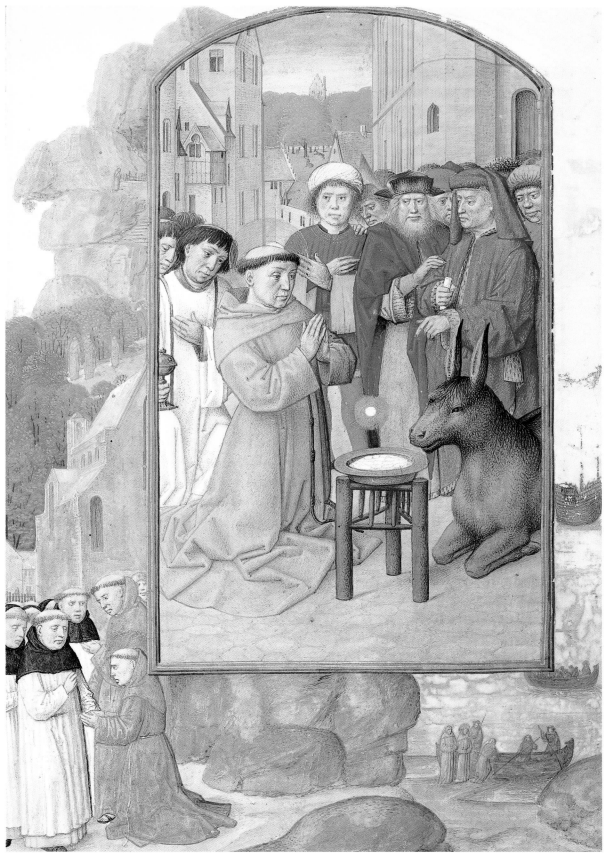

Anonymous (Flemish), *Saint Anthony of Padua and the Miracle of the Mule Adoring the Host*, c. 1500.
Manuscript illumination, The Pierpont Morgan Library, New York.

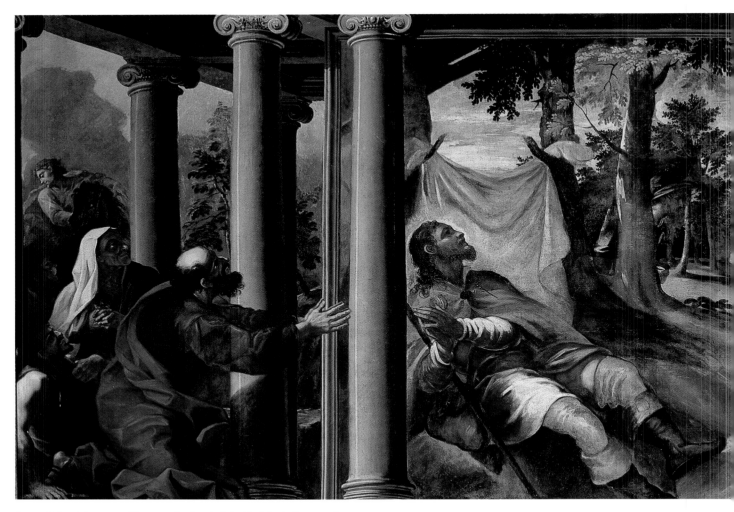

Jacopo Robusti, known as Tintoretto (1518–94), *Saint Roch in the Desert*, 1567.
Oil on canvas, San Rocco, Venice.

Roch Is Healed of the Plague

The story appears in
the *Golden Legend*.

A YOUNG MAN NAMED ROCH HAD A GIFT FOR HEALING. He travelled through France and Italy, curing the sick with the touch of his hands. When he came to the town of Piacenza, he healed many suffering in the hospital there. One night, an angel appeared to him in a dream and told Roch he himself would be smitten with the plague. Roch woke up and found himself afflicted. When the town's people saw that he was sick, they drove him away for fear of infection. Roch found a nearby wood and made himself a little shelter of boughs.

A local noble man, named Gotard, lived close by and kept hunting dogs. One day, his favorite hound brought the famished Roch a loaf of bread taken from his master's board. This went on for some time, until Gotard became suspicious and decided to follow the hound. Discovering the suffering saint, he began to bring Roch food every day, and together they sat and talked about how to live a holy life.

The plague grew worse in Piacenza, and Roch returned, still sick with fever. He laid hands on many and cured them. Finally, God revealed to Roch in a dream that he was released from the plague. He set off and continued his curative work, leaving behind the faithful Gotard.

ROCH'S JOURNEY THROUGH LIFE IS PORTRAYED AS A PILGRIMAGE. Although he is of noble birth, he leaves his wealth and family behind and sets off to serve the needy by healing their sickness. His devotion is tested when he, too, comes down with the plague. When he is driven out of Piacenza by its terrified citizens, he experiences both the pain of disease and the social ostracism that accompanies it. His identification with their suffering is made complete, and Roch survives this challenge with undiminished faith. Once Roch has been cured and continues on his journey, he leaves behind a band of faithful followers.

Tintoretto made this image for the Scuola di San Rocco (Saint Roch) in Venice. In it, he cleverly depicts a painting within a painting. In the central panel, Roch is shown in his hovel in the woods, swooning and feverish. The devotional image is surrounded by a colonnade. On the right, a woman gestures toward the painted image, directing a half-dressed, sick man to address his prayers to the saint.

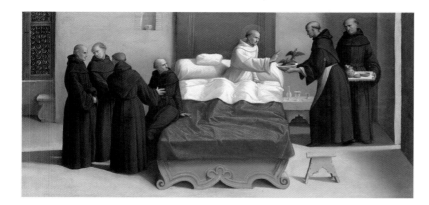

Benvenuto Tisi, known as Garofalo (1476–1559)
Saint Nicholas of Tolentino Reviving the Birds, c. 1530.
Oil on canvas transferred from wood,
Metropolitan Museum of Art, New York.

Nicholas of Tolentino Revives the Birds

EVOUT FROM CHILDHOOD, NICHOLAS BECAME AN Augustinian hermit at a tender age. He disciplined his body fiercely, maintaining his virginity until his death, fasting regularly, and never eating meat of any kind. The people of Tolentino recognized the holiness of his life, and heard him preach peace in the strife-ridden streets of the city.

As he grew old, his body began to weaken. Although he was increasingly frail, he refused to change his manner of life, and continued his arduous fasts. At last, his prior insisted that he take some hearty food. He ordered two pigeons to be roasted and brought to Nicholas. When the cooked birds were brought to his bedside, he made the sign of the cross over them. Immediately, they were restored to life, and flew away.

NICHOLAS OF TOLENTINO WAS BORN OF DEVOUT PARENTS IN THE thirteenth century. He was named after Nicholas of Myra, at whose shrine his parents had prayed for a child. The account of his birth, and his youthful predisposition to the religious life, recall the birth and childhood of his namesake. It also recalls Samuel in the Old Testament, whose mother, Hannah, prayed for a child after a long period of infertility. This motif of a son given by God in answer to prayer, who is devout even in childhood, sets the scene for an exceptional life of holiness and miraculous works.

Garofalo made this small panel as part of a larger altarpiece. A companion panel shows Nicholas of Tolentino reviving a dead child. Garofalo's style is simple and descriptive. In a plain room, the saint sits up in his bed, which is much more lavish than one he would have actually slept in.

In this charming story of two birds brought back to life, Nicholas displays an iron will. All his life he has trained and chastened his body; he is not going to allow illness to soften his fierce asceticism. When the prior arranges for him to be served a meal of meat, he faces a dilemma: obey his superior, or follow his discipline. His quandary is solved through a miracle—the birds are revived and set free. Not even the prior can argue with that.

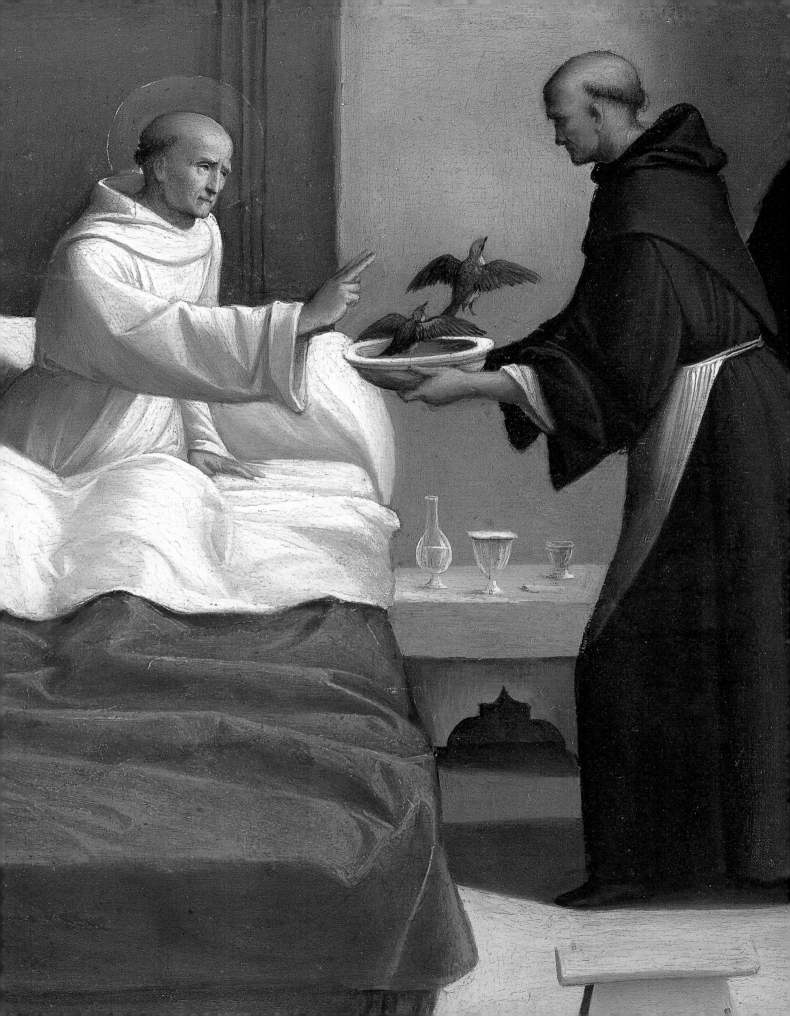

Niccolò di Pietro Gerini (1368–1414), *An Episode from the Life of Saint Giovanni Gualberto*. Tempera on wood with gold ground, Metropolitan Museum of Art, New York.

Giovanni Gualberto
and the Crucifix

IOVANNI GUALBERTO WAS BORN TO NOBLE PARENTS in the city of Florence. Trained as a soldier, he whiled away his time in pursuit of worldly pleasures.

When his brother Hugh was murdered, Giovanni vowed to avenge his death and restore honor to his family. On Good Friday, as he rode his horse to the Church of San Miniato, he encountered the murderer. The alley in which they met was narrow, and there was no means of escape. His moment had arrived.

The murderer threw himself to his knees and thrust out his arms, begging for mercy. Giovanni drew his sword. Suddenly, he was overwhelmed with a change of heart. The sight of the pitiful criminal reminded him of the sufferings of Christ before his tormentors. He dismounted and, embracing the man, forgave him.

Leaving the man, Giovanni went into the church. As he passed the crucifix, the head of Christ bowed to him. Giovanni decided at that moment to renounce his former life and enter the monastery.

TWO WORLDVIEWS CLASH IN THIS STORY. ON THE ONE HAND IS THE secular, noble ethos in which honor is the most important value. Giovanni seeks revenge in defense of his ancestral house. In the fractious Italian city-states, family feuds often spilled over into communal violence. Opposed to this worldview the gospel message of forgiveness promotes the active pursuit of peace. As Giovanni discovers, choosing the path of reconciliation requires him to completely sever ties with his old life.

This is a tale of conversion. Giovanni's conscience is awakened by the penitence of the murderer. He is moved to betray the ethos of his clan in order to achieve a higher good. He chooses to break the cycle of violence, and is reconciled with his enemy. In an act of the greatest courage, he forswears retaliation, exposing himself to the anger and ridicule of his own family.

His choice is affirmed when he enters the church and the miracle occurs. The nodding head of Christ completes Giovanni's conversion, and he decides to enter the monastery. Hearing of this, his father is furious, and threatens to remove him by force. But Giovanni is undaunted, throwing off his secular clothing and taking the cowl of the monk. Giovanni Gualberto would later found the Vallombrosan order of Benedictines.

Helmets and swords are trampled underfoot as the saint and murderer turn towards the crucifix. The artist has placed the moment of reconciliation inside the church. In doing so, he minimizes the conversion of Giovanni and focuses instead on the penitence of the criminal.

Miraculous
Objects

The Image Not Made with Hands

BGAR, KING OF EDESSA, SUFFERED FROM A TERRIBLE disease. Hearing that Jesus could perform miraculous cures, he wrote to Jesus, inviting him to Edessa, and dispatched his servant Ananias to Galilee with this letter:

"The Book of Agbar." *The Epistles of Jesus Christ and Abgarus King of Edessa*, translated by Jeremiah Jones (1693–1724).

"Abgarus, king of Edessa, to Jesus the good Saviour, who appears at Jerusalem, greeting. I have been informed concerning you and your cures, which are performed without the use of medicines and herbs. For it is reported, that you cause the blind to see, the lame to walk; do both cleanse lepers, and cast out unclean spirits and devils, and restore them to health who have been long diseased; and raisest up the dead. All which when I heard, I was persuaded […] either that you are God himself descended from heaven, who do these things, or the son of God. On this account therefore I have written to you, earnestly to desire you would take the trouble of a journey hither, and cure a disease which I am under. […] My city is indeed small, but neat, and large enough for us both."

Jesus refused the king's invitation. He promised to send one of his disciples later, after his own ascension into heaven. Then he took a towel and pressed it to his face. His image was miraculously imprinted on the cloth. He gave it to Ananias, who returned to Edessa. Receiving the letter and Christ's image, Abgar was healed and converted to Christianity.

THE USE OF ICONS IS CENTRAL TO THE DEVOTIONAL LIFE OF THE Orthodox Churches. By contrast, in the medieval western Church, images were generally considered as useful teaching aids for the illiterate. In the East, religious symbols have an authority comparable to that of the Bible.

Passed down from one generation to the next, icons remained very stable in style and subject matter. The artist's aim was not to express a new or unique vision of a scriptural character or event, but to reproduce an authoritative image.

This twelfth-century Russian icon thus stands in a long tradition. Only the face of Christ is shown, after the prototype given by Christ to Abgar. Almost identical images are being produced for Orthodox churches to this day.

In the eighth century, the theologian John of Damascus said that if you wanted to show a non-Christian what you believed, you should take him into the church and show him the holy icons. Another theologian, Theodore of Studios, wrote that just as one could "write of Christ in words," so one could "write in gold" by painting an icon. To this day, the Orthodox describe the act of painting as "writing an icon."

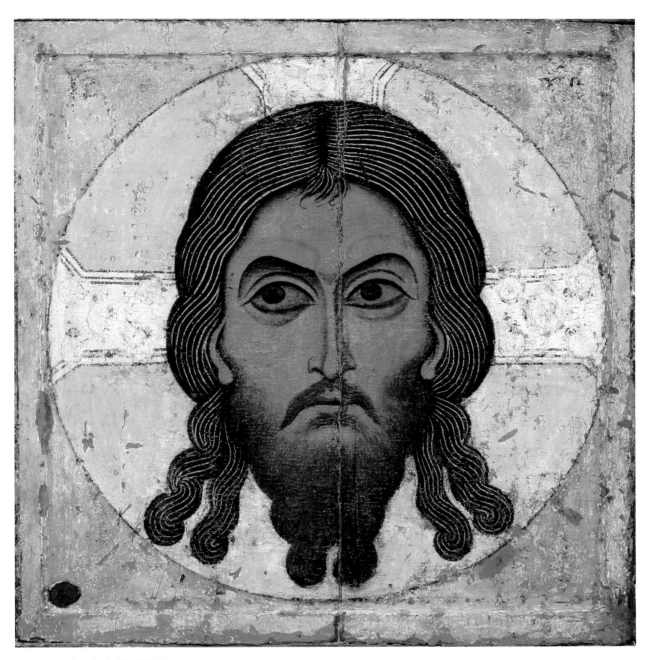

Anonymous (Russian), *The Holy Face*, 12th c.
Icon, Tretyakov Gallery, Moscow.

These icons are seen not just as artistic renderings of sacred scenes, but as images which participate in the essence of the personalities they represent. They are like windows through which one can see the eternal. The unseen archetype of the image is made available to our senses so that, contemplating an icon, we are raised to a higher level of perception.

The Mandylion, or "small towel," is an *acheiropoieic* image, one not made with human hands. The story of Abgar is one of many in which images were miraculously imprinted. These tales bolstered the arguments of those who supported a mystical understanding of icons. In the story, Christ himself provides a prototype for artists to follow.

The Invention of the Cross

The story is found in
the *Golden Legend*.

NCE THE EMPEROR CONSTANTINE LEGALIZED
Christianity and the age of persecutions came to an end,
churches began to be built throughout the empire. Helena,
the emperor's mother, went to Jerusalem to seek out relics of
Christ's Passion.

There was a man living in Jerusalem who knew where the cross of Christ had
been buried. He was not a Christian, so he feigned ignorance and refused to
share his knowledge. The empress, in fury, had him thrown into a pit, where he
languished for a week without food or water. At the end of the seven days, he
begged for mercy and agreed to show her where the cross was buried.

As they came to the place where the crucifixion had taken place, the earth trem-
bled, and a sweet smell rose from the earth. Now, many years earlier, the emperor
Hadrian had built a temple of Venus on that site. Helena ordered them to
tear down the temple and dig. Soon they came upon three crosses buried
deep in the ground.

They waited for God to give them a sign to distinguish the cross
of Christ from the other two. About noon, a funeral procession came by.
They stopped the coffin bearers and laid each cross down upon the corpse. The first
two had no effect. But when they laid the third one down, the dead man sat up,
revived from death by the precious wood.

Helena's reluctant guide was converted to the faith, and became bishop of
Jerusalem. The cross of Christ was placed in the church Helena later had built
on that spot.

*Piero Della Francesca's fresco from the church of San Francesco at
Arezzo uses sophisticated perspective to dramatize the scene. The
cross, dramatically foreshortened, echoes the posture of the dead man,
rising naked from his funeral bier. The scene is just one of a series
painted by Piero in the 1450s called "The Legend of the True Cross,"
illustrating the* Golden Legend's *account of its history.*

THIS EVENT, AND THE CHURCH FESTIVAL WHICH CELEBRATES IT
every May third, is called the "Invention of the Cross," from the Latin *invenire*, mean-
ing "to find" or "come upon." Perhaps the title is apt in its modern sense as well, for
there is much which is legendary in the tale.

There are many stories about the cross and its miraculous powers. One tells of
Adam's son, Seth, who was given a seed of the tree from the Garden of Eden, which he
planted over the grave of his father. The tree grew and flourished, until Solomon cut
it down to use it in his fine palace. Finding no use for the wood, the workmen placed
it across a stream to function as a bridge. The Queen of Sheba, when she came to visit
Solomon, had a vision in which the true nature of the tree was revealed to her. She

Piero della Francesca (c. 1420–92), *Verification of the True Cross* (detail), c. 1465.
Fresco, San Francesco, Arezzo.

[OVERLEAF]
Agnolo Gaddi (fl. 1369–96), *The Finding of the Cross.*, c. 1380s.
Fresco, Santa Croce, Florence.

bowed in awe before the bridge and told Solomon that it was destined to be the instrument by which Christ would die. Solomon took it and buried it. A pool was later excavated over the site, whose waters had miraculous healing powers. When Christ was condemned to death, the tree floated to the surface, and was used by the soldiers to make the cross on which he was crucified.

The legend of the cross, fanciful as it is, weaves together the separate stories of Adam and Christ. The former's disobedience in the garden caused humanity to fall from grace. Christ, the new Adam, restores humanity to its proper place. The cross is witness to the whole drama of human salvation.

A relic of the cross was, in fact, venerated at Jerusalem in the centuries after Constantine and Helena. Pieces of the true cross multiplied in the Middle Ages, and were valued for their miraculous power.

The Holy House of Loreto

HE CRUSADER KINGDOMS OF THE HOLY LAND WERE overrun by the Saracens. In the year 1291, angels appeared in Nazareth and spirited away the house in which Mary was born and grew up, and where the angel Gabriel had appeared to announce the birth of the Savior. The angels carried the house to Tersatto in Dalmatia, where they set it down in a field. Some shepherds came upon the house, and when they entered it, they found it smelled sweetly of incense. The Blessed Virgin appeared to a local priest in a vision and told him what the house was, and how it had come to be there. Pilgrims began to come to the house, where miraculous cures took place.

Then, in 1294, the house was again transported by angels. To the sound of ringing bells and the appearance of a great light, the inhabitants of Tersatto watched the house disappear into the air. It came to rest on the Adriatic coast of Italy, where its fame quickly spread again, attracting pilgrims from far and wide. But with the pilgrims came bandits, and the site became dangerous. For the third time the angels removed it, bringing it to the property of two brothers. They immediately began to quarrel over the holy house, so it was quickly transported for the final time, coming to rest on the hill of Loreto. There it stands to this day. And though it sits directly on the ground, with no foundation or support, the walls are sure and solid.

LORETO REMAINS ONE OF THE MOST IMPORTANT MARIAN SHRINES in Italy. A huge basilica was eventually built around the Holy House, which continues to attract pilgrims.

The collapse of the Crusader enterprise led to consternation in Europe. Access to the sacred sites of the Holy Land was no longer assured, and there was great fear that the non-Christians would destroy churches and shrines. The miraculous removal of the house by angels reflects the growing anxiety to protect the holy sites. In its peripatetic journey across the Mediterranean, the house finally finds a place where it will be safe. The angelic intervention is a sign that the house has been moved at God's command. If pilgrims can no longer go to the Holy Land, God brings the Holy Land to them.

Tiepolo's oval ceiling panel depicts the house in mid-flight. Accompanied by trumpeting angels, the Virgin Mary stands atop the house as it searches for a safe resting place. The forces of evil, personified by devils, scatter before her and her holy shrine.

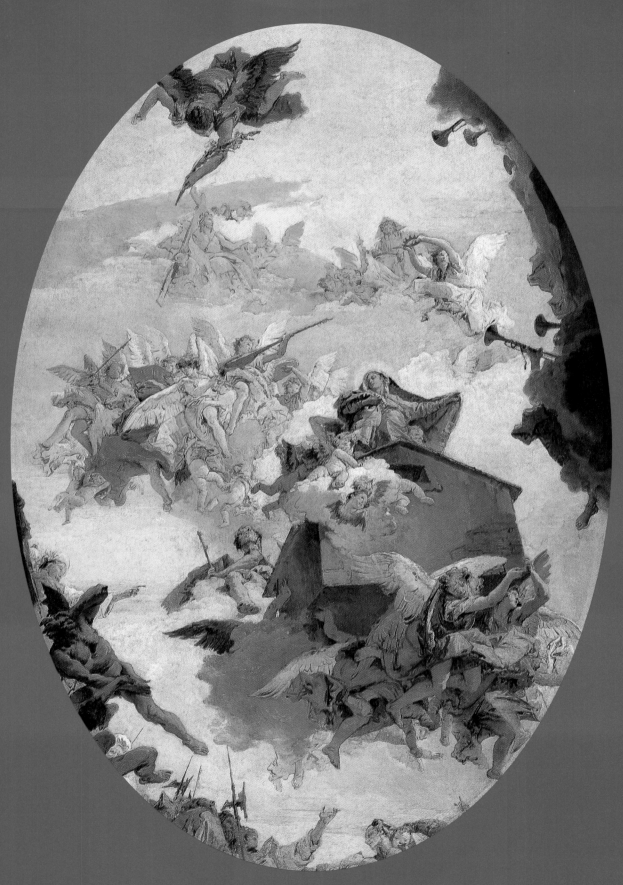

Giambattista Tiepolo (1696–1770), *Transportation of the Holy House of Loreto*, 1745.
Fresco tranferred to canvas, Accademia, Venice.

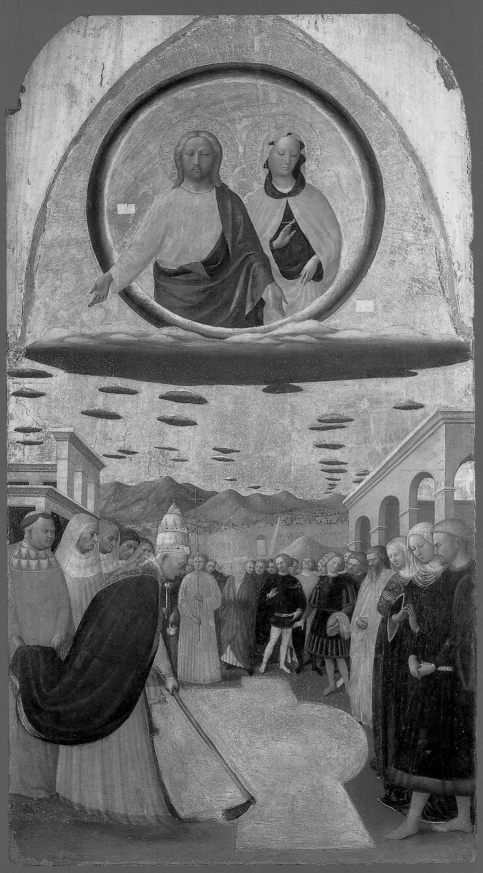

Masolino da Panicale (1383–1447), *Pope Liberius Founding the Basilica of Santa Maria Maggiore.*
Tempera on wood, Museo Nazionale di Capodimonte, Naples.

The Miracle of the Snow

HERE WAS AN ELDERLY PATRICIAN COUPLE WHO lived in the city of Rome. They had no children, and they wondered to whom they should leave their great wealth. One hot August night, they each had the same dream. The Blessed Virgin appeared, and asked them to endow a church in her honor. Snow would fall in the exact place where she wished her church to be built.

When they woke and discovered they had had identical dreams, they ran to the palace of Pope Liberius. As they described the dream, the Pope interrupted them: The Blessed Virgin had appeared to him that night as well.

A grand ecclesiastical procession was prepared, and the Pope and the wealthy couple made their way to the Esquiline Hill. There on the ground was a fine dusting of snow, glinting in the summer sun. As the crowds watched, the Pope marked out the plan of a basilica in the snow. The couple vowed to pay for the building of the new church in Mary's honor.

Masolino was a Florentine artist who entered his city's painters guild in 1423. In this panel, Christ and his virgin mother preside over the scene, hovering above the dark storm clouds. Liberius, wearing the papal triple tiara, etches the foundation of the church in the newly fallen snow with a hoe. The shape he draws on the ground perfectly matches the plan of an early Christian basilica.

THE FEAST OF OUR LADY OF THE SNOWS, OBSERVED ON THE FIFTH of August, celebrates the foundation of the Church of Santa Maria Maggiore in Rome. Dedicated to the Virgin Mary, it is one of the oldest churches in the city.

The dreams of Liberius and the wealthy couple are confirmed in this story by the wonder of snow falling in the hot Roman summer. The snow—clean, fresh, and untrammeled—is a perfect symbol for the Virgin Mary. As the Mother of God, the Queen of Heaven, she chooses the place where she will be honored.

The First Day

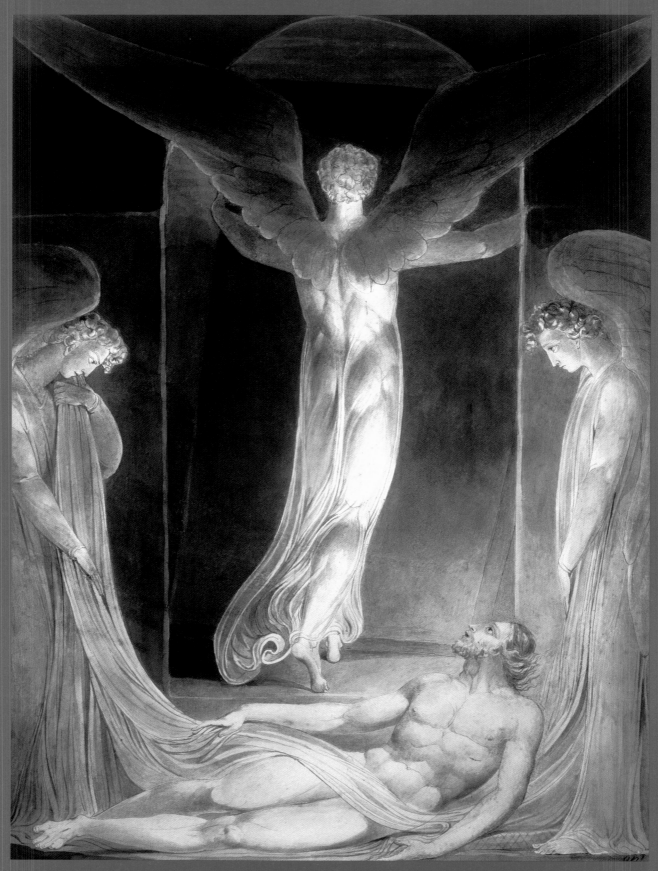

William Blake (1757–1827), *The Resurrection: The Angel Rolling Away the Stone from the Sepulchre.*
Watercolor, Victoria and Albert Museum, London.

The Resurrection

ESUS DIED LATE IN THE AFTERNOON. THE SABBATH was approaching, and there was no time to prepare his body for burial. Joseph of Arimathea, a member of the council, took the broken body, wrapped it in linen, and laid it in a rock-cut tomb. Mary Magdalene and Mary, the mother of Joses, watched as a stone was rolled across the entrance, sealing Jesus' body within. Night fell, marking the arrival of the sabbath, and quiet settled over Jerusalem.

Early in the morning of the first day of the week, Mary Magdalene, Salome, and Mary, the mother of James, went to the tomb. The sun had just risen. They carried spices with which to anoint the body of Jesus and lay him properly to rest. As they walked along, they wondered how they would move the heavy stone.

When they arrived at the tomb, the stone had already been rolled away. They went inside—the body was gone. A young man sat there, wearing a white robe.

"Do not be alarmed," he said to the women. "You are looking for Jesus of Nazareth, who was crucified. He has been raised; he is not here. Look, there is the place they laid him. But go, tell his disciples and Peter that he is going ahead of you to Galilee; there you will see him, just as he told you."

The women ran away, terrified and amazed. And they told no one, because they were afraid.

The version recounted here comes from Mark 16. The story of the resurrection appears in all four Gospels.

WITHOUT THE RESURRECTION, THERE IS NO CHRISTIANITY. JESUS, dead and buried, takes his teaching to the grave. The grand project fails, and the disciples melt away into the crowds, never to be remembered.

When, on the first day of the week, a small band of women went to the tomb and found it empty, a new movement was born. With a growing conviction that Christ had risen from death, the disciples began to go forth and preach a gospel of hope to the poor and dispossessed.

Each Gospel tells the story differently. Of the four accounts, Mark's is the simplest. The oldest manuscripts of the Gospel of Mark conclude very abruptly. The young man announces the resurrection and the women flee. The resurrected Christ does not even appear. There continues to be lively debate amongst scholars about this ending: Did the evangelist intend to stop there? Is a part missing, or has a concluding passage been purposely edited away? No one knows for certain.

William Blake was a poet, visionary, and artist. His long poems, written in the manner of prophecy, draw heavily on Christian imagery. He illustrated his words lavishly, fusing the verbal and the visual into a coherent whole. This engraving depicts the moment of resurrection from within the tomb. Attended by angels, the body of Jesus blushes to life. A third angel unseals the tomb with the wave of a hand.

The curt ending leaves the story incomplete. There is no closure; the text takes us only so far. To apprehend more, the believer has to put the book aside and experience resurrection in the world. Mark provides no finality—only a young man dressed in white who says to us: *Go. Tell. You will see him.*

Selected Bibliography

Works consulted:

Blackburn, Bonnie and Leofranc Holford-Strevens. *The Oxford Companion to the Year.* Oxford: Oxford University Press, 1999.

Brown, Raymond E., S.S., and Joseph A. Fitzmyer, S.J., and Roland E. Murphy, O. Carm., eds. *The New Jerome Biblical Commentary.* Englewood Cliffs, New Jersey: Prentice Hall, 1990.

Butler, Alban. *Lives of the Saints.* Herbert Thurston and Donald Attwater, eds. London: Burns & Oates, 1956.

Chalippe, Candide, O.F.M. *The Life and Legends of Saint Francis of Assisi.* Published electronically by Project Gutenberg: www.gutenberg.net.

de Voragine, Jacobus. *Golden Legend.* William Caxton, trans. Temple Classics: 1900. Published electronically by the Internet Medieval Sourcebook: www.fordham.edu/halsall/sbook.

Duffy, Eamon. *The Stripping of the Altars.* New Haven and London: Yale University Press, 1997.

Eusebius. *Church History.* G.A. Williamson, trans. New York: Penguin USA, 1990.

Ferguson, George. *Signs and Symbols in Christian Art.* New York: Oxford University Press, 1961.

Finaldi, Gabriele. *The Image of Christ.* London: National Gallery Company, Ltd., 2000.

Gregory of Nazianzus. "To Cledonius the Priest Against Apollinarius." *A Select Library of Nicene and Post-Nicene Fathers of the Christian Church.* Vol. VII. Grand Rapids: Wm. B. Eerdmans Publishing Company (1980): 440.

Gregory of Nyssa. *The Life of Moses.* Abraham J. Malherbe and Everett Ferguson, trans. New York and Ramsey, Ontario: Paulist Press, 1978.

Gregory the Great. *The Second Book of Dialogues Containing the Life and Miracles of St. Benedict of Nursia.* Paris, 1608. "P. W.", trans. Published electronically by the Saint Pachomius Library: www.ocf.org/OrthodoxPage/reading/St.Pachomius.

Origen. Ronald E. Heine, trans. Washington, D.C.: The Catholic University of America Press, Inc., 1989.

The Epistles of Jesus Christ and Abgar, King of Edessa. Jeremy Jones, trans. William Howe: London, 1820. Published electronically by the Saint Pachomius Library: www.ocf.org/OrthodoxPage/reading/St.Pachomius/index.

The Little Flowers of Saint Francis. Thomas Okey, trans. London: Everyman Library, J.M. Dent & Sons, Ltd. 1944.

Pelican, Jaroslav. *The Spirit of Eastern Christendom (600–1700).* Vol. 1, *The Christian Tradition: A History of the Development of Doctrine.* London and Chicago: University of Chicago Press, 1974.

Quenot, Michel. *The Resurrection and the Icon.* Michael Breck, trans. Crestwood, New York: St Vladimir's Seminary Press, 1997.

Roberts, Rev. Alexander, D.D. and James Donaldson, LL.D., eds. *Acts of the Holy Evangelist John the Theologian.* Vol. 8, Ante-Nicene Fathers. Edinburgh: T & T Clark, 1980.

Roberts, Rev. Alexander, D.D. and James Donaldson, LL.D., eds. *Gospel of Pseudo-Matthew.* Vol. 8, *Ante-Nicene Fathers.* Edinburgh: T&T Clark, 1980.

Vasari, Georgio. *The Lives of the Artists.* Julia Conaway Bondanella and Peter Bondanella, trans. Oxford and New York: Oxford University Press, 1991.

Wieck, Roger S. *Painted Prayers: The Book of Hours in Medieval and Renaissance Art.* New York: George Braziller, Inc., in association with The Pierpont Morgan Library, 1997.

Web sites:

Art Gallery of Toronto
www.ago.net

The Catholic Encylopedia
www.newadvent.org/cathen

Internet Medieval Sourcebook
www.fordham.edu/halsall/sbook.html

Kunsthistorisches Museum, Vienna
www.khm.at

Louvre Museum, Paris
www.louvre.fr

Metropolitan Museum of Art, New York
www.metmuseum.org

National Gallery of Art, Washington
www.nga.gov

National Gallery, London
www.nationalgallery.org.uk

St. Pachomius Library
www.ocf.org/OrthodoxPage/reading/St.Pachomius

Art Credits

[PAGE 1]
Pietro Perugino (1448–1523), *Nativity*, 1519.
Oil on wood, Galleria Nazionale, Perugia.

[PAGES 2–3]
Michelangelo Merisi da Caravaggio (1573–1610)
The Incredulity of Saint Thomas, 1602.
Oil on canvas, Neues Palais, Potsdam.

ACKNOWLEDGEMENTS

My thanks to Lena Tabori who sat in her office one day and said to me, "What could you do a hundred of?" Thanks also to my editor, Katrina Fried, for helping shape the book and make my text more accessible to a general audience. I am grateful to Lois Keen who read some early versions of the texts and said, "I would buy this book." Finally, thanks are due to the people of the Church of the Good Shepherd, Roosevelt Island, New York, who've heard an awful lot of miracle stories over the past four months. —C.C.

The publisher also wishes to thank Jessica David at Art Resource for her generous assistance.

Published in 2004 by Welcome Books®
An imprint of Welcome Enterprises, Inc.
6 West 18th Street
New York, NY 10011
(212) 989-3200; Fax (212) 989-3205
www.welcomebooks.com

Publisher: Lena Tabori
Editor: Katrina Fried
Designer: Gregory Wakabayashi
Project Assistant: Sara Lustig
Copyeditor: Mark Burstein

Distributed to the trade in the U.S. and Canada by
Andrews McMeel Distribution Services
U.S. Order Department and Customer Service Toll-free: (800) 943-9839
U.S. Orders-only Fax: (800) 943-9831
PUBNET S&S San Number: 200-2442
Canada Orders Toll-free: (800) 268-3216
Canada Orders-only Fax: (888) 849-8151

Library of Congress Cataloging-in-Publication Data on File

ISBN 1-932183-28-0

Printed in Singapore

First Edition

1 3 5 7 9 10 8 6 4 2